For my daughter, who loves to tinker and explore.
I can't wait to see what you create.

ACKNOWLEDGEMENTS

I GREATLY APPRECIATE the Rocky Nook team, who works hard to ensure every book is excellent. A special thank you Scott Cowlin, Ted Waitt, Joan Dixon, and Maggie Yates, who worked diligently with me throughout the entire process of writing, editing, layout, and production.

I greatly appreciate my wife and children and want to thank them for putting up with me as I worked on this book. Book projects take months of time and effort to complete, and this one required more hands-on labor than any other book I've written. I spent lots of late nights and long weekends building projects. Thank you for lending me your helping hands time and time again.

INTRODUCTION

DIY STANDS FOR Do It Yourself. The DIY and maker movement has grown quite large over the years and now has its own magazines, YouTube channels, and MeetUp groups. DIY-ers know the joy of building projects with their hands and putting them to use in the real world. I wrote this book specifically for DIY enthusiasts who love photography and love working with their hands.

I've personally built and used every project in this book. As a professional photographer for 20 years, I can confidently say that the projects demonstrated here will help you produce professional imagery. I know, because I've published and sold images produced from these projects.

I've tried to give enough instruction to build each project. That said, I have made some assumptions with respect to your skillset. In some cases, I won't give specific dimensions because a project needs to be customized for your needs or specific camera. In other cases, I am a bit vague on screw sizes or specific tools since there can be a lot of leeway when building these projects.

I'm assuming most DIY-ers have at least a little bit of mechanical ability, but if you ever have questions about a specific project, feel free to shoot me an email or contact me via social media and I'll get back to you right away.

—Mike Hagen

CONTENTS

CONTENTS

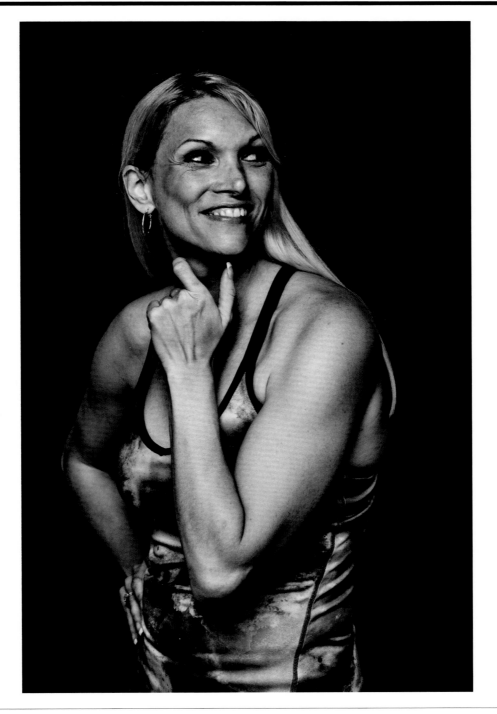

1

LIGHTING EQUIPMENT

CHAPTER 1

Lighting equipment can be some of the more expensive gear you purchase for your photography. For most photographers, the thought of outfitting their studios with a bunch of new equipment like softboxes, continuous lights, and background lights can seem overwhelming. This chapter is written to help you create inexpensive lighting equipment that produces excellent results. I'll cover a number of projects related to LED lighting, fluorescent lighting, and speedlight modifications. I'll also cover some specialized projects, such as a light saber and using a projector to create backdrops.

1. LED STRIP LIGHT PANELS

THESE LED PANEL LIGHTS are wonderful to use in the studio. They are really lightweight and can be incorporated into all types of lighting scenarios. I encourage you to build at least two units.

They are constructed with LED strip lighting that you purchase in rolls. These are readily available from all kinds of sources such as Amazon, eBay, and your local big-box retailer. They are designed to be installed underneath cabinets or along stairwells, but with a little ingenuity, you can repurpose them for very capable studio lighting.

You can make these light panels as big or as small as you want, just make sure your mount is strong enough to hold the weight of the panel. For this project, I made a smaller lighting kit for easier portability.

Parts List (Figure 1.1)

- LED strips with included power supply
- Glue (Gorilla Glue or similar)
- Soldering iron
- Solder
- 24-gauge wire
- Wire strippers
- Flat panel approximately 12″ to 24″ on each side
- L-bracket and screws/bolts
- Wrench to fit bracket mounting bolts
- Electric drill
- 1/4″ drill bit
- White gaffer tape
- Fine-tipped pliers
- Wire cutters

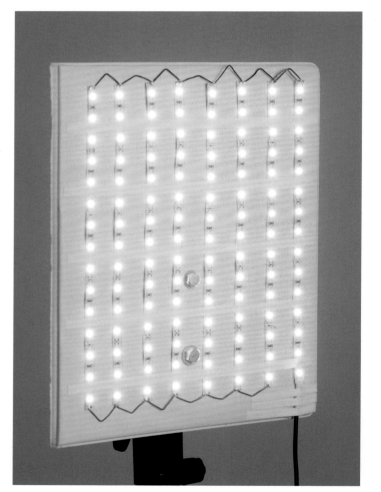

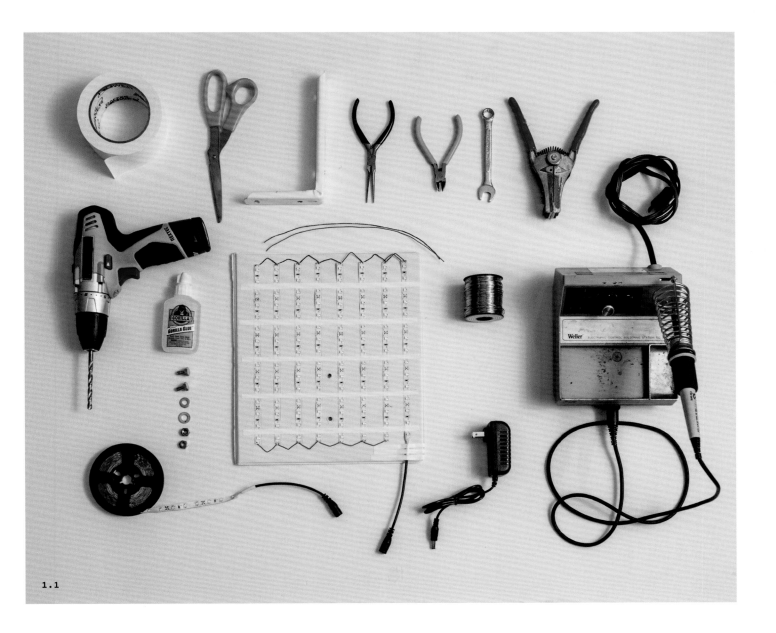

1.1

Construction Steps

1 Prepare your flat panel by cleaning the surface. I used the front of a 3-ring binder, but you can use anything that is relatively rigid with a smooth surface. The LED lights will warm up during use, so make sure your mounting surface can handle the warmer temperature.

2 Cut the LED strips according to the manufacturer's instructions. The strips I purchased were designed to be cut every 3″ or so, and the manufacturer had specific instructions for how to do this. I cut the length of each strip to be about 2″ shorter than the width of my panel in order to allow enough space for soldering wires to the ends of the strips.

3 Apply the strips to the flat panel by applying a line of glue to the back of each strip, then aligning them on the flat panel. Space each panel approximately 2″ apart. I used skinny lengths of gaffer tape to hold down the LED strips while the glue cured (**Figure 1.2**).

4 Cut the 20-gauge wire into 2″ lengths, then strip off approximately 1/4″ of insulation from each end.

5 Solder the wire from each length of LED to the next, being careful to always keep the correct polarity. In other words, solder + to + and − to − as shown in **Figure 1.3**. To make soldering easier, I fastened all negative wires on one side of the panel and all positive wires on the other side of the panel (**Figures 1.3** and **1.4**).

6 Drill holes in the middle of the flat panel for your L-bracket. Using screws or bolts, mount the L-bracket to the flat panel, as shown in **Figure 1.5**.

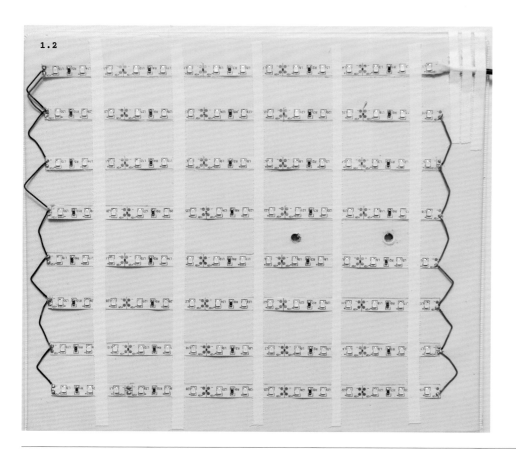

1.2

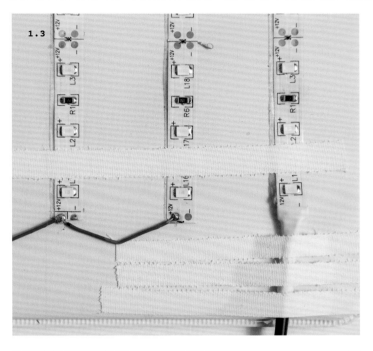

1.3

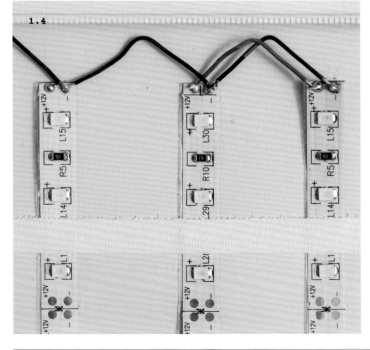

1.4

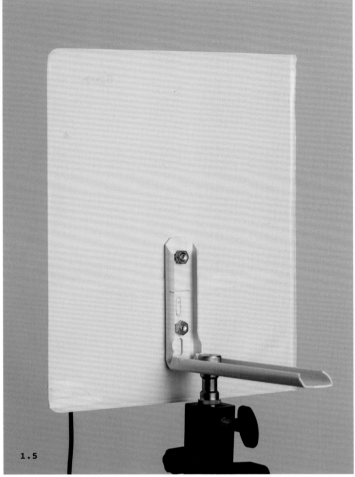

1.5

7 Connect the power supply to the lights.

8 Mount the flat panel to a light stand (**Figure 1.6**), and you're ready to take pictures (**Figure 1.7**).

Tips & Cautions

- When you buy your LED strips, pay close attention to the color temperature. Most companies sell a variety of color temperatures, so make sure you are getting one that matches other lighting you already own. For example, if you want to integrate these LED lights with your flashes, then you'll want daylight (5600K) color corrected LEDs.

- This light works great for photography or for video. Most LED strips will operate under variable voltage as well, so if you are adept with electronics, you could hook up a rheostat to control brightness.

- These LEDs operate at 12V DC, so you can also hook up a battery pack to make these panels completely portable.

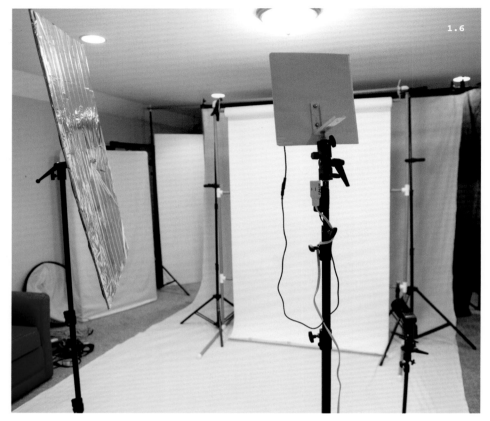

1.6

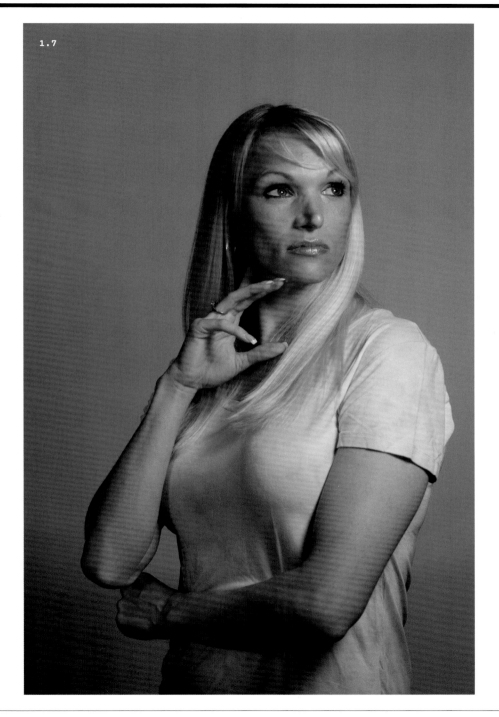

1.7

2. LED CHRISTMAS LIGHT BACKGROUND

I LOVE THIS DIY SOLUTION for a background—it provides a really neat look for studio portraiture. The key to making this background look good is to use a wide aperture lens such as a 50mm f/1.8, 50mm f/1.4, or an 85mm f/1.8. You can also get this look with 70–200mm f/2.8 lenses and 300mm f/2.8 lenses, but you need the Christmas lights to be farther away.

Construction Steps

1 Prepare the background. I suggest using a solid black or solid white background so the lights stand out from the background (**Figure 2.2**). However, you can get interesting effects using other colors and tones of backgrounds/backdrops.

2 Hang the lights in front of the background. There are a variety of ways to do this, but the easiest is to drape the lights over a horizontal boom arm, as shown in **Figure 2.2**. You can also use a backdrop stand or a C-stand to support the lights.

3 Using your wide aperture lens, set the aperture wide open to f/1.4 or f/1.8. This will allow the Christmas lights to blur in a beautiful manner (**Figure 2.3**).

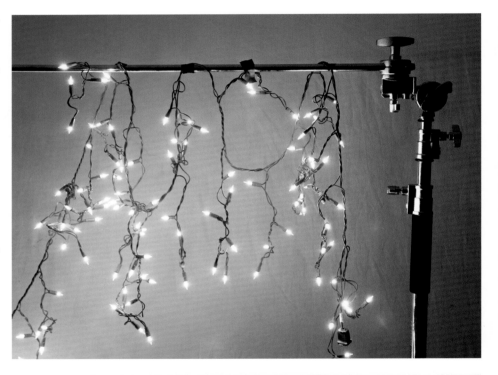

Parts List (Figure 2.1)

- Christmas lights, preferably with dark-green or black wire
- Gaffer tape or other method for hanging lights, such as spring clamps
- Cross bar (C-stand or backdrop stand)

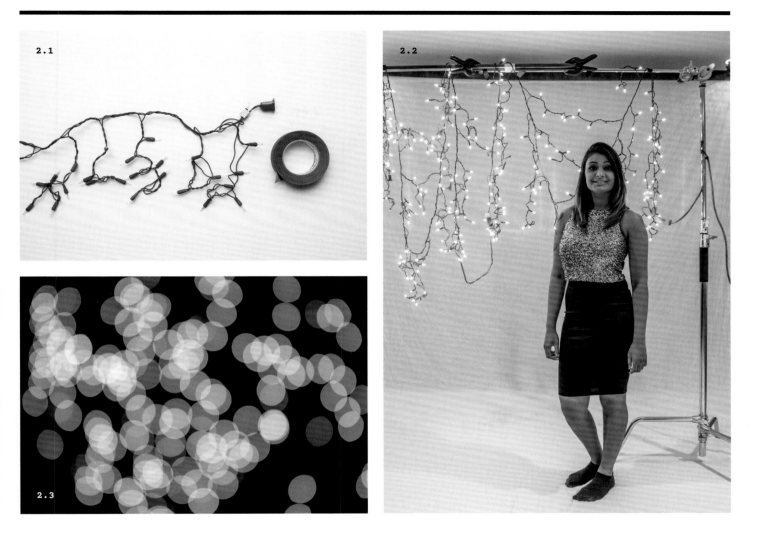

4 Position your subject at least six feet away from the Christmas lights.

5 Set up your studio lights for the effect you want (**Figure 2.4**).

6 Focus on your subject and take your photograph (**Figure 2.5**).

Tips & Cautions

- Experiment with the pattern of the lights. Try randomizing the lights in patterns and rows. You'll have to take some test shots and rearrange the lights until you like the pattern they create.

- The farther away your subject is positioned from the lights, the bigger the blurs will be in the background. If you have the room, place your subject 10 feet, 20 feet, or farther away from the background. Remember: the farther away from the background your subject is, the more lights you'll need to fill the space that your camera's angle of view will capture behind your subject.

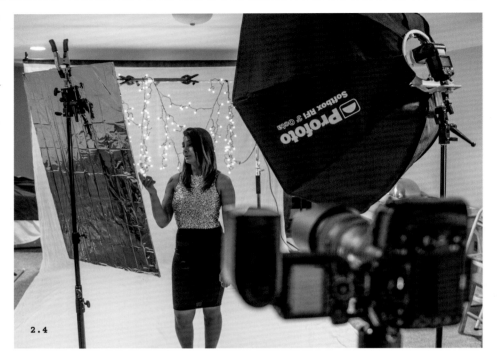

2.4

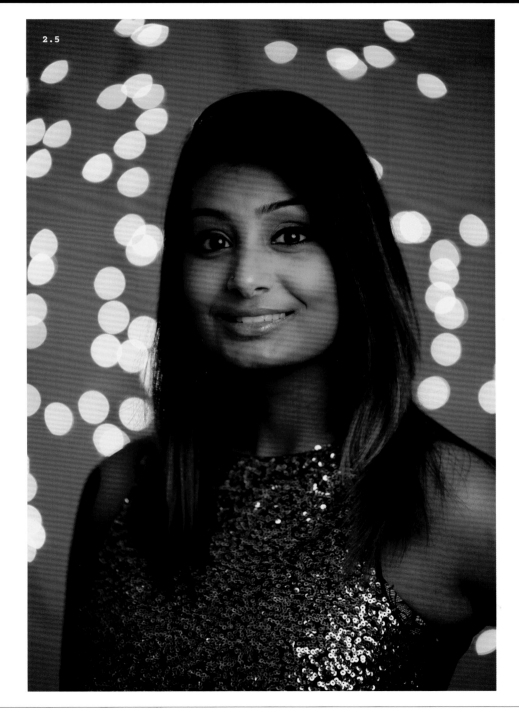

2.5

3. LED CEILING PANELS

THE LED REVOLUTION has arrived at the local hardware store and we photographers stand to benefit the most. Just about all lighting fixtures now have LED options in addition to incandescent or fluorescent options.

For this project, I purchased an LED flat panel light from my favorite warehouse shopping club. The panel light cost about $20, and it works perfectly for studio portraiture and video lighting. Also, the light is dimmable, which dramatically increases its versatility.

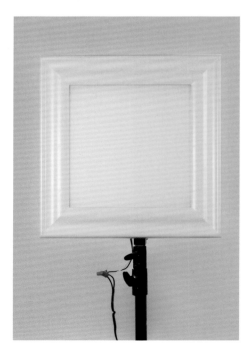

Construction Steps

1 Connect the wires from the light panel to the outlet cord as shown in **Figures 3.2** and **3.3**. You can do this with the wire nuts. Alternatively, you can solder the wires together and use shrink tubing to protect the junction.

2 Remove the back mounting panel from the light fixture.

3 Use an angle bracket to mark the hole patterns. Drill holes in the mounting panel to match the angle bracket (**Figure 3.4**).

4 Attach the angle bracket to the light fixture mounting panel using bolts, nuts, and washers (**Figure 3.5**).

5 Attach the mounting panel to the back of the lighting fixture. Make sure to thread the wiring through the large hole in the back of the panel (**Figure 3.6**).

Parts List (Figure 3.1)

- LED Flat Panel Light Fixture
- Plug-in lamp dimmer cord
- Surplus power cord from an old lamp
- Wire strippers
- Wire nuts (2)
- Angle bracket
- Bolts, washers, and nuts to attach bracket
- Electric drill
- 1/4" drill bit

6 Mount the LED light panel to a light stand using a standard 1/4"-20 brass light stand stud (**Figure 3.7**).

7 Plug the power cord into the dimming switch, as shown in the bottom of Figure 3.7.

8 Take your photos (**Figures 3.8** and **3.9**).

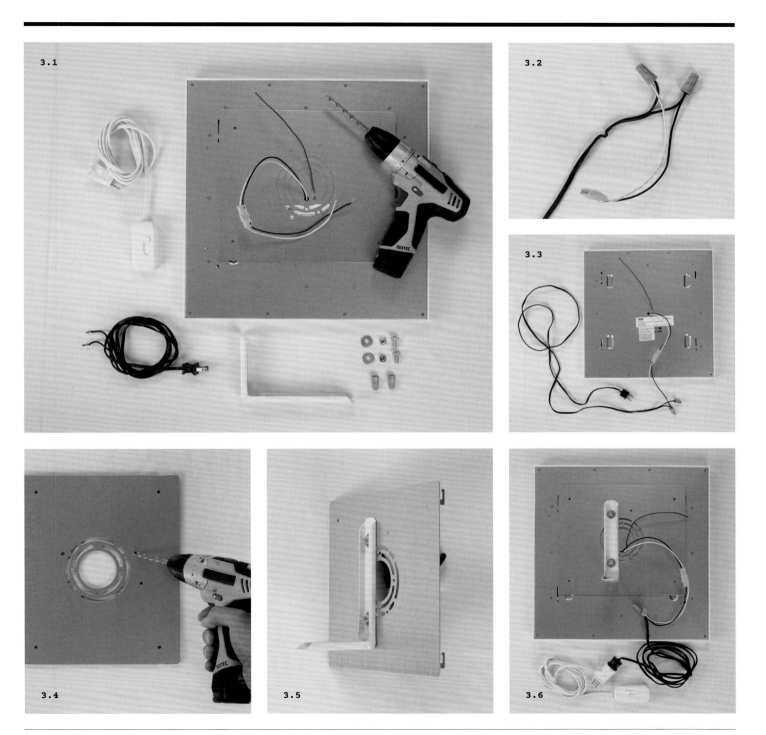

3.1

3.2

3.3

3.4

3.5

3.6

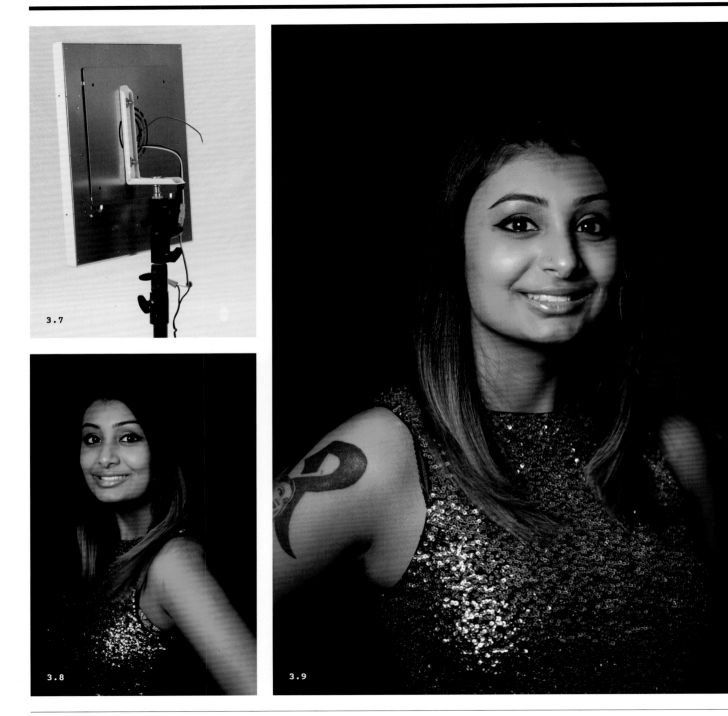

3.7

3.8

3.9

Tips & Cautions

- You can mount many of these lights on a rack to create a larger light source. Since they draw such low power (14 watts), you can control all the lights together with a dimming switch that is usually rated to 200 or 300 watts.
- Use this panel for a variety of lighting arrangements including split lighting (**Figure 3.10**) or clamshell lighting (**Figure 3.11**).

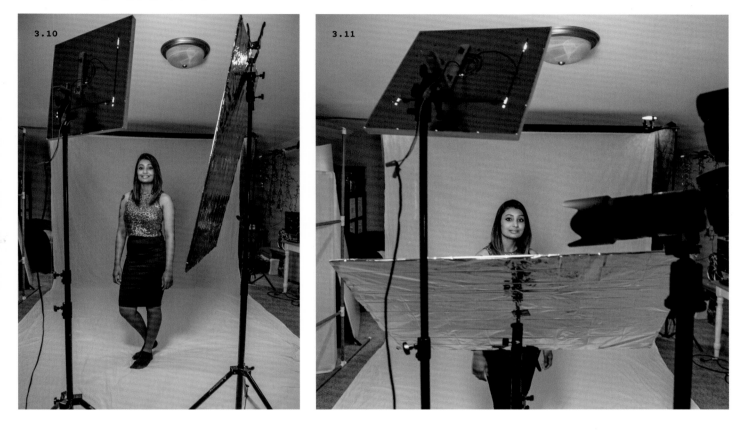

3.10

3.11

4. LED 48" TUBE SHOP LIGHT BANKS (KINO FLO)

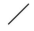

KINO FLO LIGHTING SYSTEMS makes really great studio lighting fixtures that are heavily used in the commercial video and photography world. Its light banks are highly controllable and produce beautiful results, but cost near $1,000 each. This project will show you how to build your own similar lights that will produce professional quality results at a fraction of the cost.

Most hardware stores and big-box warehouse stores sell LED tube shop lights. They are more expensive than fluorescent light fixtures, but they last a lot longer and draw even less power. For this project, I don't recommend using the fluorescent tube fixtures since they are much heavier and less durable. I purchased the LED shop lights from a big-box warehouse shopping club for $29.99 each.

Construction Steps

1 Cut two small pieces of plywood into approximately 5"x12" panels.
2 Lay both light fixtures face down on the floor approximately 4" apart.

Parts List (Figure 4.1)
- 48" LED Shop Light (2)
- 3/8" plywood
- Skill saw
- Felt tip pen
- 1/4" bolts (8)
- 1/4" nuts (8)
- 1/4" washers (2)
- 1/2" diameter galvanized conduit or pipe
- Conduit hanger (2)
- Hacksaw or reciprocating saw
- Measuring tape

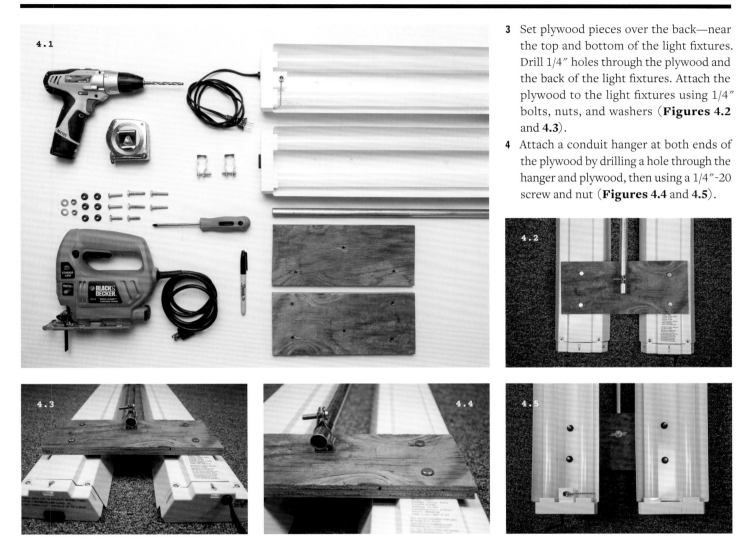

3 Set plywood pieces over the back—near the top and bottom of the light fixtures. Drill 1/4″ holes through the plywood and the back of the light fixtures. Attach the plywood to the light fixtures using 1/4″ bolts, nuts, and washers (**Figures 4.2** and **4.3**).

4 Attach a conduit hanger at both ends of the plywood by drilling a hole through the hanger and plywood, then using a 1/4″-20 screw and nut (**Figures 4.4** and **4.5**).

5. Measure a length of conduit a few inches longer than the distance between the conduit hangers. Cut the conduit with a hacksaw. Mount the conduit in the two conduit hangers (**Figure 4.6**).

6. Use a photographic super clamp (**Figure 4.7**) to mount the LED light on a light stand, as shown in **Figures 4.8** and **4.9**.

7. Take pictures!

Tips & Cautions

- There's no reason why you can't mount even more LED light banks to a plywood sheet. Consider mounting them in a square pattern or a triangle pattern for a really cool look. Cut a big hole in the plywood so you can shoot through the lights to create a ring light effect.

- Most of these lights are not dimmable, so you'll be limited by the amount they give out at full voltage. They are very bright and allow you to shoot full-length body shots with no problems.

- You can shoot images with just one bank of lights (**Figures 4.8** and **4.10**) or with two banks of lights (**Figures 4.9** and **4.11–4.13**).

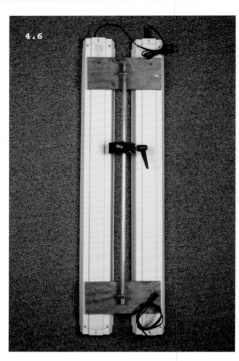

4.6

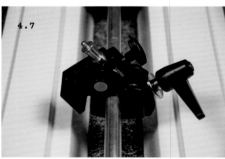

4.7

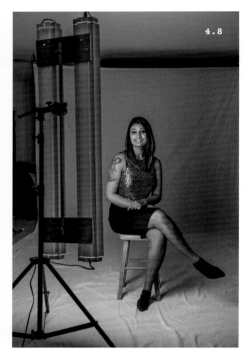

4.8

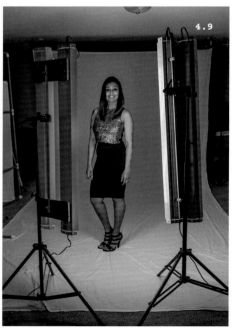

4.9

5. LED CAN LIGHTING WITH VARIABLE OUTPUT

LED RECESSED CEILING can lights are available now at most hardware, retail, and price club membership stores. I like these lights because they are dimmable, durable, and easy to use.

There are limitless ways to arrange these lights in patterns. I recommend either a grid or a circle, but you might also experiment with other shapes like a square, an x-pattern, etc.

Construction Steps

1 Measure and cut a piece of plywood to approximately 24″x30″, as shown in **Figure 5.2**.
2 Lay out the can lights, and trace circles onto the surface of the plywood (**Figure 5.3**).
3 Next, cut mounting holes for each of your can lights. Use your drill and 1/2″ drill bit

Parts List (Figure 5.1)

- Dimmable LED can lights (6-10 units)
- Plug-in lamp dimmer cord
- Surplus power cord
- Wire strippers
- Wire nuts
- Wire cutters
- Heavy-duty angle bracket
- Electric drill
- 1/4″ drill bit
- 1/2″ drill bit
- Reciprocating saw or saber saw
- Circular saw
- 3/8″ plywood
- Wood screws
- Pencil
- Measuring tape

to create the pilot hole. Then insert the blade of your reciprocating saw to cut out the larger hole (**Figure 5.4**).
4 Mount all six LED can lights to the plywood. The easiest way to do this is to use wood screws through the flanges of the can lighting. Drill three 1/4″ holes in the flange (**Figure 5.5**), then use wood screws to attach the lights to the plywood (**Figures 5.6** and **5.7**).
5 Prepare the electrical wires by cutting off the sockets with wire cutters. Then, strip ends of the wires and use wire nuts to connect to each can light, as shown in **Figures 5.8** and **5.9**. Wire all positive and negative ends of wires together and connect to power cord.
6 Mount a metal shelving bracket to the back of the plywood, as shown in **Figure 5.10**.
7 Mount the light panel to a light stand as shown in **Figure 5.11**.
8 Plug the light panel into a wall outlet, or into a dimmer switch, and take pictures (**Figure 5.12**)!

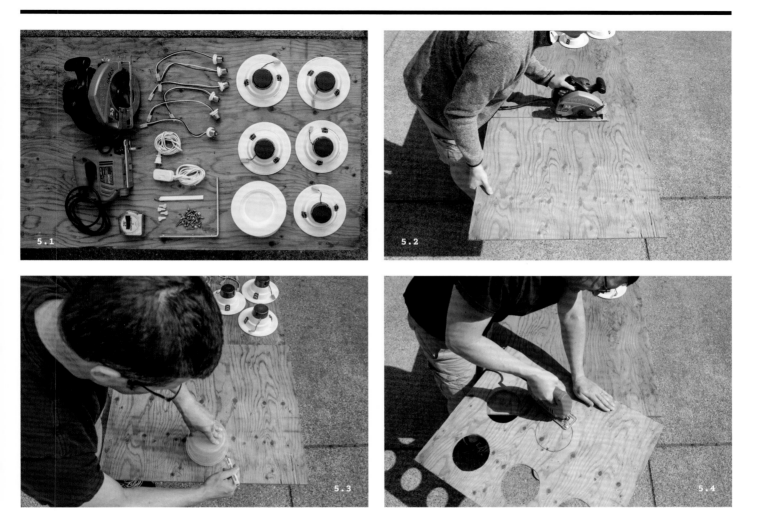

5.1

5.2

5.3

5.4

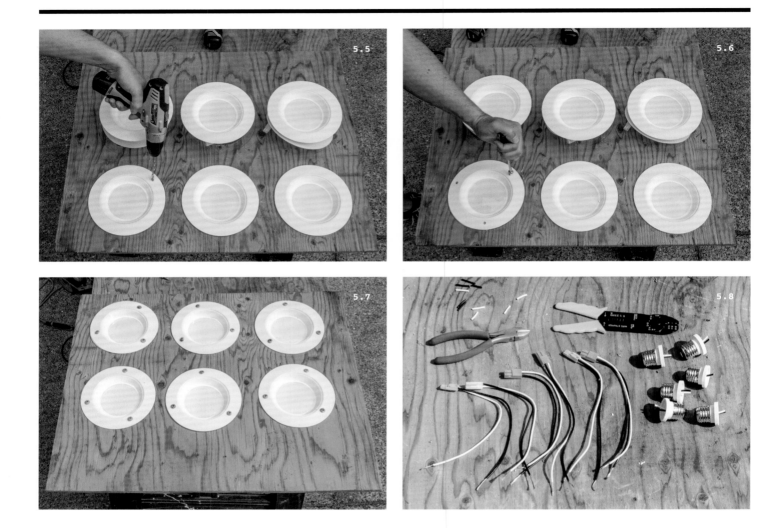

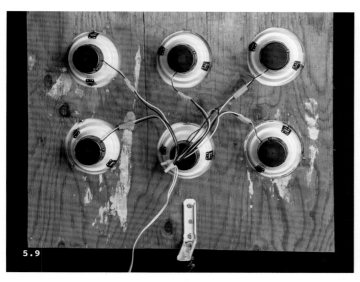

5.9

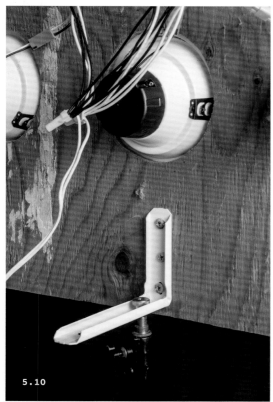

5.10

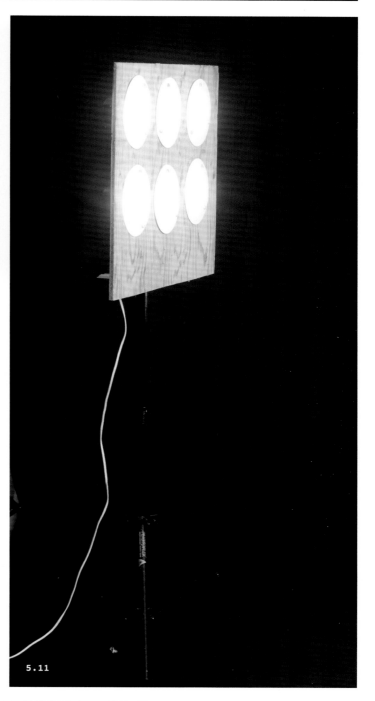

5.11

5.12

Tips & Cautions

- Consider using a diffusion material like corrugated plastic in front of the lights. This will soften the light and produce a more even shadow on the background.
- Use a reflector to brighten up the shadows. In the BTS (behind-the-scenes) photo shown in **Figure 5.13**, I'm using the DIY California Sunbounce reflector shown in project 52.

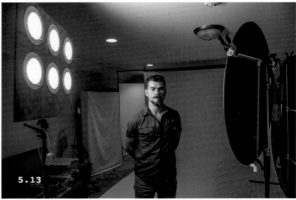

5.13

6. LED UTILITY LIGHTS FROM A HARDWARE STORE

THESE ARE SOME of the easiest and simplest lights to use for your DIY home studio. Since they are designed to be used on constructions sites, they are exceedingly durable and stand up to all kinds of abuse from weather, temperature, and use.

Using these lights is easy, because you simply just screw them on a light stand and begin taking photos. They can be difficult to use because they don't have any built-in diffusion, so you have to figure out mounting systems for your reflectors and diffusion tools.

Construction Steps

1 Remove the lower bracket with a socket set or wrenches.
2 Mount the bracket to a light stand with a standard 1/4″-20 bolt. You can also use standard brass light stand adapters to screw the lights onto a light stand (**Figure 6.2**).
3 Bounce light from the utility light onto a photographic umbrella (**Figure 6.3**) or a reflector. I suggest using something like the reflectors described in Chapter 5.
4 Take pictures (**Figure 6.4**).

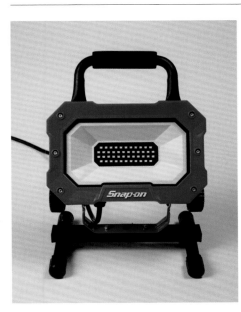

Parts List (Figure 6.1)
- LED utility light
- Socket set or wrenches

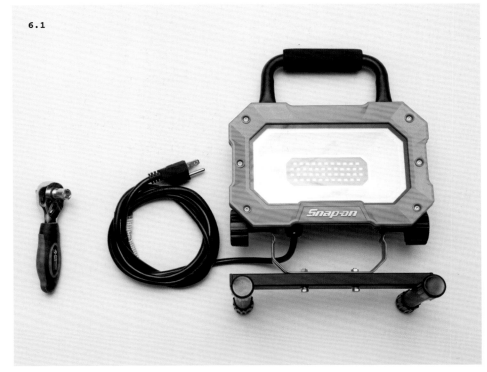

6.1

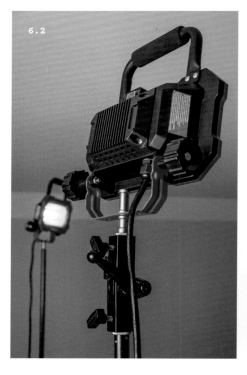

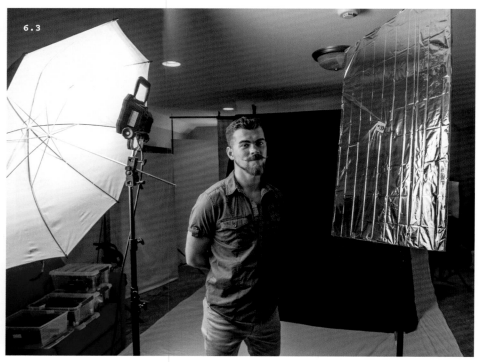

Tips & Cautions

Most LED lights will note their color temperature somewhere in the specifications. Make sure you understand what color temperature you are purchasing so that you can match it to the other lights you'll be using.

6.4

7. FLUORESCENT (CFL) OR LED SPIDERLIGHTS

SPIDERLIGHTS ARE A famous product sold by Westcott that use six big fluorescent bulbs. The retail price for the Spiderlight TD6 model is about $425, but this project will show you how to make a similar set of lights for less than $60 *including* the light bulbs and fixtures.

Construction Steps

1 Remove the reflector/shield from the utility light and cut away most of the reflector, leaving just the screw-base (**Figure 7.2**). Tape over the sharp edges for safety (**Figure 7.3**). You can also file down the edges to eliminate the sharp edges.

2 Reattach the screw-base of the reflector to the light socket as shown in **Figure 7.4**.
3 Screw together the light bulb splitters so you have a total of four light bulb sockets (**Figure 7.5**). Install four LED light bulbs.
4 Screw the four-bulb light into the main utility light clamp (**Figure 7.6**).

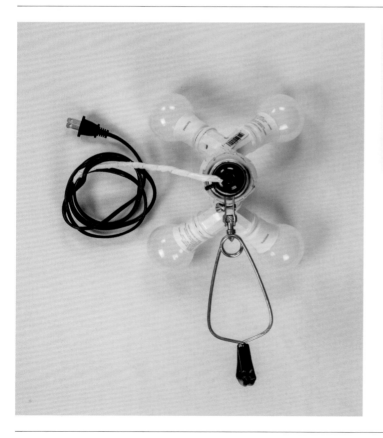

Parts List (Figure 7.1)

- LED screw-in light bulbs (4)
- Utility light clamp
- Twin-socket lamp adapter (3)
- Metal cutting shears or scissors
- Metal file or gaffer tape
- Light stand
- Photographic umbrella
- Umbrella bracket

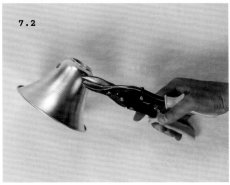

7.2

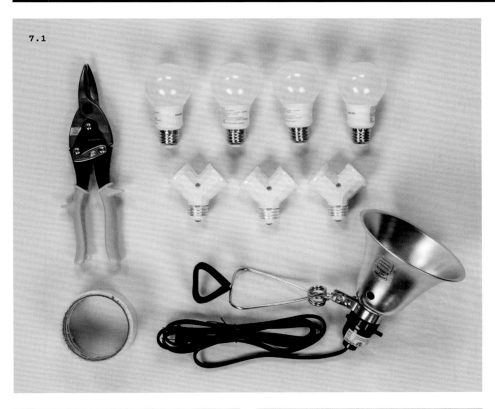

7.1

7.3

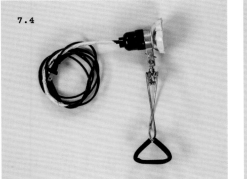

7.4

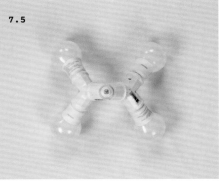

7.5

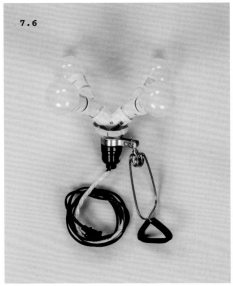

7.6

5 Mount the umbrella bracket and umbrella to the light stand, as shown in **Figure 7.7**. The easiest way to do this is to rest the light on top of the umbrella shaft while using the clamp to secure it to the light stand.

6 Take the picture. **Figure 7.8** shows the quality of light for most of the upper body. **Figure 7.9** demonstrates the look without a reflector, while **Figure 7.10** shows the look with a reflector.

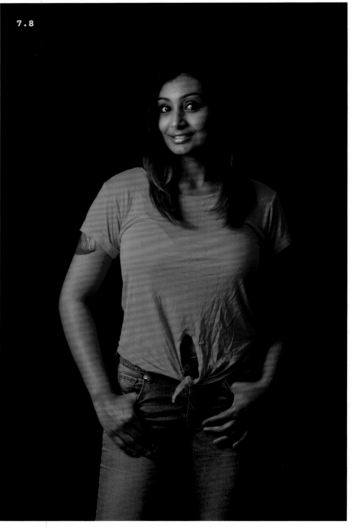

7.8

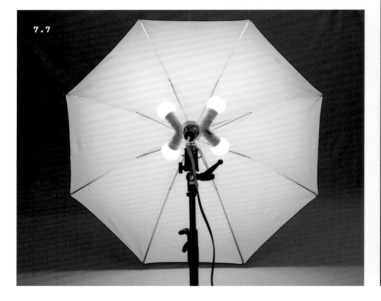

7.7

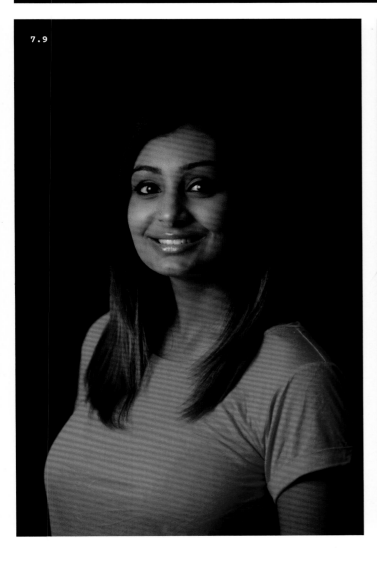

7.9

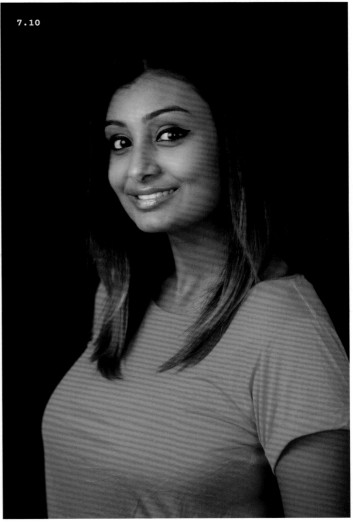

7.10

Tips & Cautions

- If you purchase dimmable **LED** light bulbs, you can install a rheostat inline with the power cord to make adjustable-brightness lighting. These light bulbs are more expensive, but provide a lot more flexibility.
- Pay attention to the color temperature of your **LED** lights. The bulbs I used for this project were a very warm 2700K. If you want to combine your **LED** lighting system with your flashes/strobes, then you'll need to select 5400K bulbs.

8. FLUORESCENT OR LED TUBE STRIP LIGHT

STRIP LIGHTS ARE very useful for studio and product photography in which you want a single vertical line of light. Typical applications for strip lights include bottle photography or anything highly reflective where you want clean lines extending from the top to the bottom of the product.

Strip lights also work really well for portrait photography and can produce very interesting catch lights in the eyes. This project is similar to the Kino Flo (project 4), but uses a single bank of LED shop lights rather than two or three banks.

Construction Steps

1 Attach a conduit hanger at both ends of the light fixture by drilling a hole through the hanger and into the metal fixture (**Figure 8.2**). Then, use a 1/4″-20 bolt and nut to affix the hanger to the LED light, as shown in **Figure 8.3**.
2 Measure a length of conduit a few inches longer than the distance between the conduit hangers. Cut the conduit with a hacksaw (**Figure 8.4**).

Parts List (Figure 8.1)

- 48″ or 24″ light bank (fluorescent or LED)
- 1/4″-20 bolt (2)
- 1/4″ nuts (2)
- 1/4″ washers (4)
- 1/2″-diameter galvanized conduit or pipe
- Conduit hanger (2)
- Hacksaw
- Measuring tape

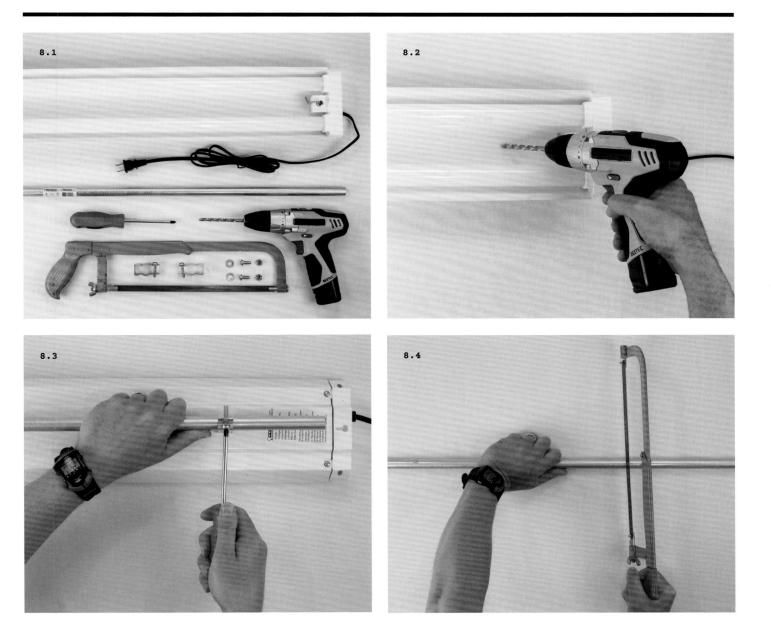

3 Mount the conduit in the two conduit hangers, as shown in **Figures 8.5** and **8.6**.

4 Use a photographic super clamp (**Figure 8.7**) to mount the LED light on a light stand, as shown in **Figure 8.8**. You can also mount the light vertically—the resulting image will be lit like **Figure 8.9**.

5 Take pictures (**Figure 8.10**)!

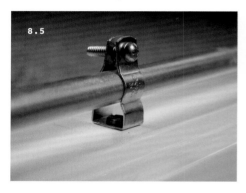

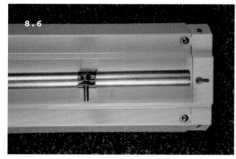

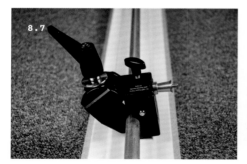

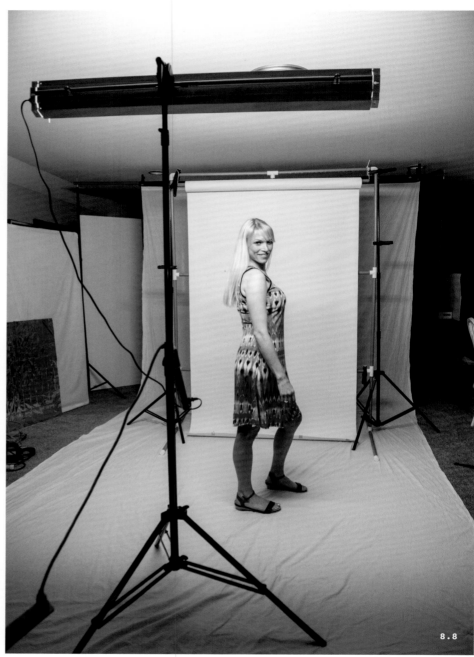

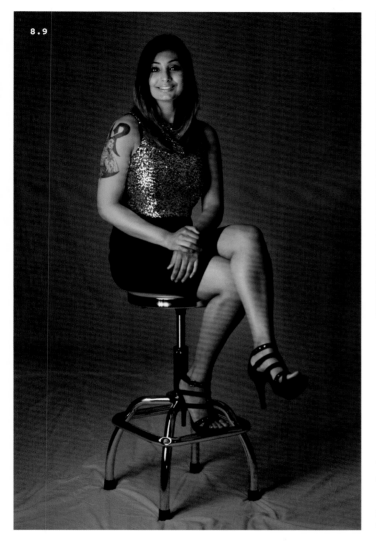

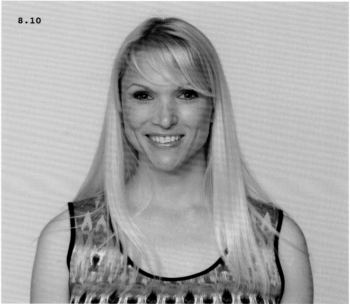

Tips & Cautions

If you want a cleaner catch light, you can cover the front of the LED shop light with a diffusion material such as tissue paper, translucent fabric, or white corrugated plastic.

9. SPEEDLIGHT: STAINLESS STEEL BOWL BEAUTY DISH

PORTRAIT PHOTOGRAPHERS LOVE using beauty dishes because of the specific look they generate in their images. A beauty dish produces an edgy, crisp light that shows a lot of detail on a subject's face. It can be used to accentuate high cheekbones, curves, and texture.

This project will save you hundreds (yes, hundreds) of dollars over a commercially available beauty dish and is almost equally as durable. I've made this one out of a giant stainless steel bowl and mounted it with a very strong metal bracket. You shouldn't be afraid of taking this project on the road.

Construction Steps

1. Mount a flash to your bracket and set it on the back of the stainless steel bowl (**Figure 9.2**). Using a felt tip pen, mark the position of the bracket mounting holes and the position of the flash head.
2. Cut out the back of the bowl and drill 1/4″-diameter holes for the bracket, as shown in **Figures 9.3** and **9.4**.
3. Use nuts and 1/4″ bolts to fasten the bracket to the back of the bowl, as shown in **Figures 9.5** and **9.6**.
4. Attach the flash to the bracket on the beauty dish as shown in **Figure 9.7**.

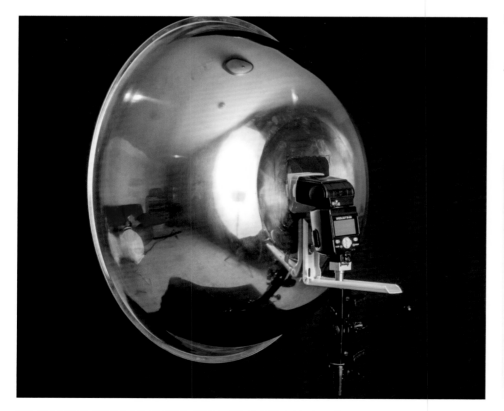

Parts List (Figure 9.1)

- 24″ Stainless Steel or aluminum salad/mixing bowl
- Flash mount bracket or angle bracket
- 1/4″-20 bolts, 1/2″ long (4)
- 1/4″-20 bolts, 4″ long (2)
- 1/4″-20 nuts (6)
- Metal cutter (saber saw or other tool that will cut stainless steel)
- Felt tip pen
- Steel wool (optional)
- White spray paint and stainless steel primer (optional)
- CD cakebox top

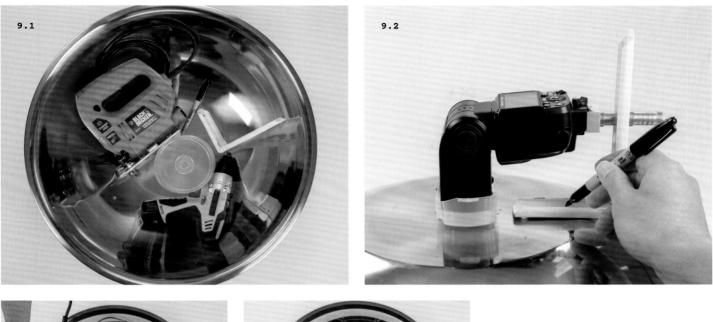

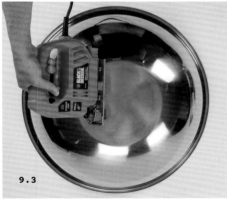

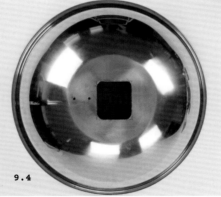

5 To make the inner reflector, use the top of a CD cakebox case and the small metal cut out from the back of the stainless steel bowl (**Figures 9.8** and **9.9**). Use gaffer tape to attach the small metal plate to the inside of the CD cakebox top, as shown in **Figure 9.10**.

6 Use gaffer tape to attach the cakebox reflector case to the inside of the beauty dish, as shown in **Figure 9.11**.

7 Mount the beauty dish bracket to a light stand, as shown in **Figures 9.12** and **9.13**.

8 Take a picture (**Figures 9.14** and **9.15**).

9.8

9.9

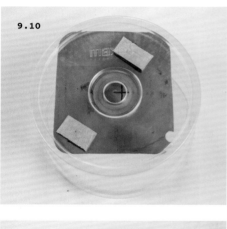

9.10

9.11

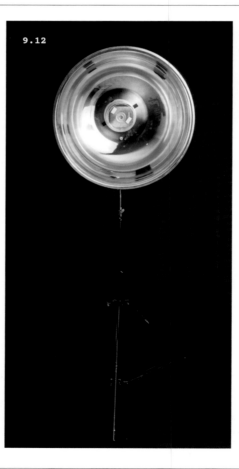

9.12

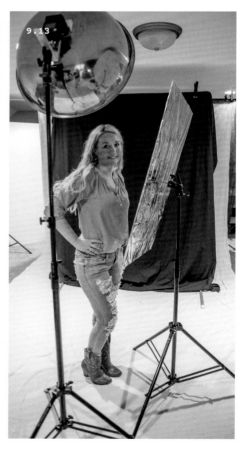

9.13

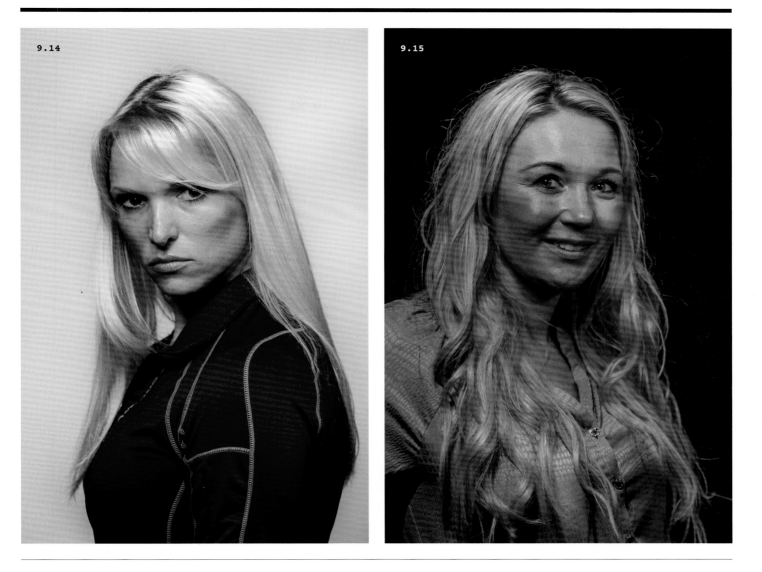

9.14

9.15

Tips & Cautions

- It is very difficult to position a beauty dish correctly. The key is to get the height set just right so that you can get a catch light in the eye. If you position it too high, you lose the catch light. If you position it too low, you lose the light shaping capability on the face.
- Photographers commonly use reflectors in conjunction with beauty dishes. You can position the reflector to the side, or underneath the dish like a clamshell lighting setup.

- Since the light from the beauty dish can be somewhat harsh, you might consider covering the front surface with a very thin diffusion cloth or with tissue paper. This will help prevent shine on your subject's face.
- Some photographers like the look of a white beauty dish. If you prefer a white reflective surface, then rough up the interior of the bowl with steel wool, and apply a stainless steel primer coat. Finally, paint the surface with a matte white spray paint.

10. SPEEDLIGHT: CARDBOARD AND FOIL RING FLASH

RING FLASHES ARE commonly used in the fashion industry to create a glamorous look. The traditional approach to using them is to position the subject close to a wall, then get very close to the subject's face with the camera and flash. The resulting shadows from the ring flash surround the subject and make them pop from the background. Ring flashes create a really cool catch light in your subject's eye, so many photographers like to get very close to the subject to maximize the look.

This ring flash project uses cardboard and aluminum foil to produce a really nice-looking effect. To shoot with this setup, hold the ring flash with your left hand, while holding the camera with your right hand.

Construction Steps

1 Cut out a donut-shaped circle from the cardboard sheet. Make the outer diameter about 13″ and the inner diameter about 4″, as shown in **Figure 10.2**.
2 Cut out a 3″x16″ strip of cardboard, as shown in **Figure 10.3**.
3 Form this strip into a circle with the same diameter as the inner circle of the donut. Tape the circle closed as shown in **Figure 10.4**.
4 Cut a 3″x42″ strip of cardboard. About mid-length, cut a hole the same size as your flash head (**Figure 10.5**).
5 Tape both the inner ring and the outer ring strips to the donut shape, as shown in **Figure 10.6** and **10.7**.
6 Affix aluminum foil to the inside of the ring flash using tape (**Figure 10.8**).
7 Cover the front of the ring flash with tissue paper, then insert your flash (**Figure 10.9**).
8 Hold the ring flash by the speedlight in your left hand, and insert the lens of your camera through the inner circle while holding the camera with your right hand.
9 Take the picture (**Figure 10.10**)!

Parts List (Figure 10.1)

- A few cardboard sheets, one at least 42″ wide
- Scissors or a razor blade
- Tape
- Flash (speedlight)
- Tissue paper
- Aluminum foil

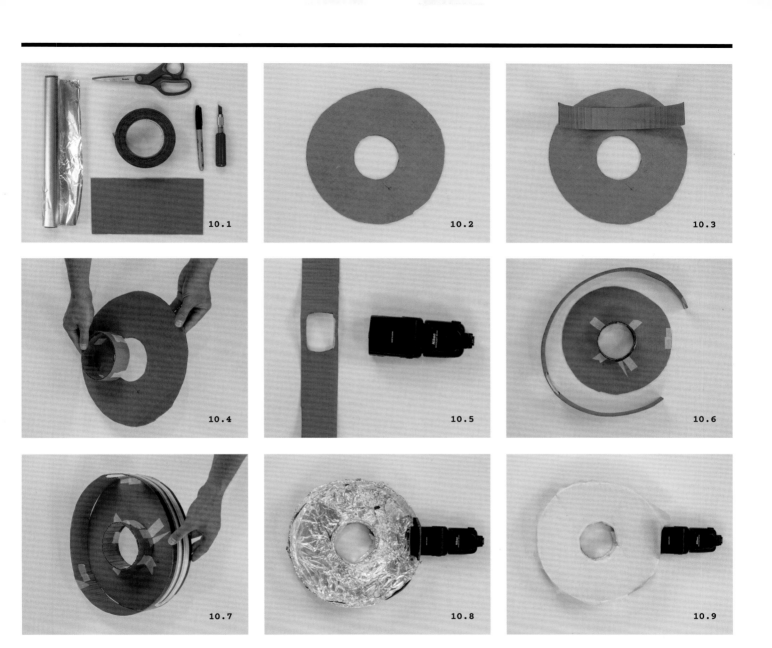

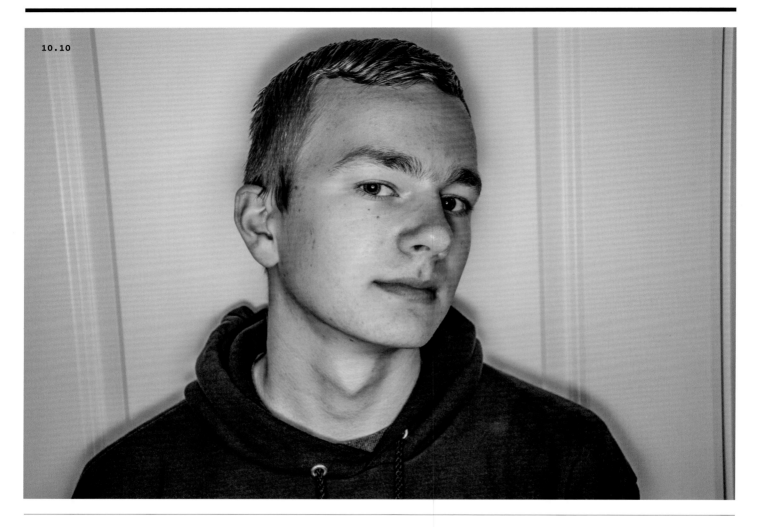

10.10

Tips & Cautions

- I triggered this ring flash using the Nikon wireless flash system, but you can also trigger it with a dedicated TTL cable running from the camera's hot shoe to the speedlight.

- The difficult thing with these ring flashes is that you lose a lot of light power because the flash has to send light all around the circumference of the modifier. Therefore, you'll need to be pretty close to the subject, and use a high ISO and a big aperture for this project to work.

- The larger your ring flash, the bigger the catch lights. Don't be afraid to increase the dimensions of the flash system to suit your needs. If you aren't able to build a larger ring flash, then be sure to get very close to the subject and position the subject very close to the background.

11. SPEEDLIGHT: SIX-FLASH RING LIGHT

THIS PROJECT ONLY works if you have a bunch of flashes. I own quite a few small strobes, so I was able to tape them together to produce this very powerful ring light. If you don't own six flashes, you can purchase inexpensive speedlights on Amazon.com for about $25 each. Putting them all together in this arrangement results in very powerful ring flash for a "low" price of about $150. A commercially available ring flash from Metz or Quantum costs $400 to $1,000.

Construction Steps

1 Cut the top and bottom off of a can, as shown in **Figure 11.2**. You can also use a 4″-diameter section of PVC pipe.
2 Arrange the flashes around the edge of the can (**Figure 11.3**).
3 Use tape to attach the flashes to the can. I suggest wrapping tape around all six flashes (**Figure 11.4**), then using skinny strips of tape to wrap around the can (**Figures 11.5** and **11.6**), securing the flashes.
4 Set up all flashes so they are triggering using the same technology (e.g., radio trigger, Nikon CLS, Canon wireless).
5 Place the camera lens through the center of the ring as shown in **Figure 11.7**, and take the picture.

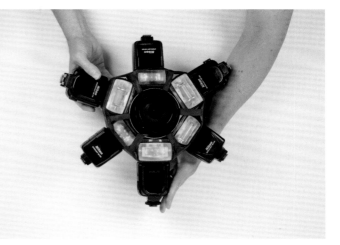

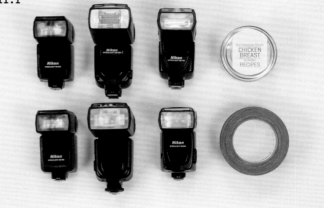

11.1

Parts List (Figure 11.1)

- Six flashes
- 4″-diameter can or PVC pipe
- Gaffer tape

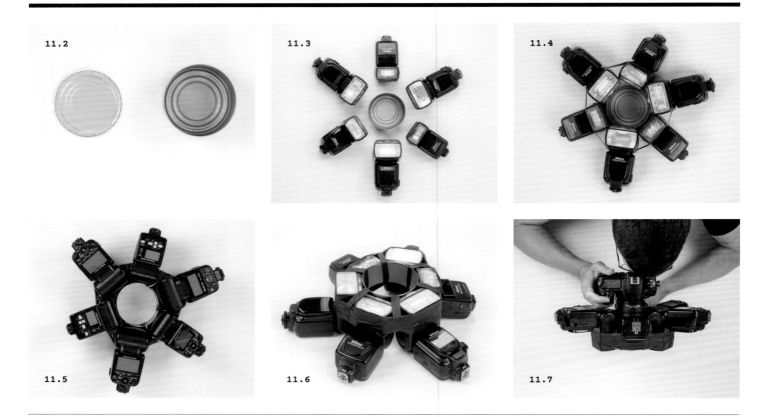

11.2

11.3

11.4

11.5

11.6

11.7

Tips & Cautions

- Make sure all the flashes are triggered using the same technology. For example, if each flash will be triggered in the camera's proprietary wireless system, then each flash should be set to the same channel and group. If each flash is being triggered as a standard slave, then set all flashes and the master to function in the same way. Similarly, if you are triggering all flashes with the Nikon or Canon wireless system, each flash needs to be configured in the same way.
- You'll most likely handhold the camera while using this setup. It is possible to place one of the flashes on a light stand, but I'd caution against this since there will be a lot of torque and stress on that one flash's base. Also, most flashes have tilting heads, so that base flash might not be strong enough to hold the entire ring flash without flopping over backward.

- This ring flash can be very powerful. My suggestion is to start out with all the flashes set to minimum power (e.g., 1/128 power) and see where your exposure lands. If you need more power, then increase all the flashes by one stop until you get the power you need. I shot all six flashes at 1/128 power for the images shown in **Figures 11.8**, **11.9**, and **11.10**.

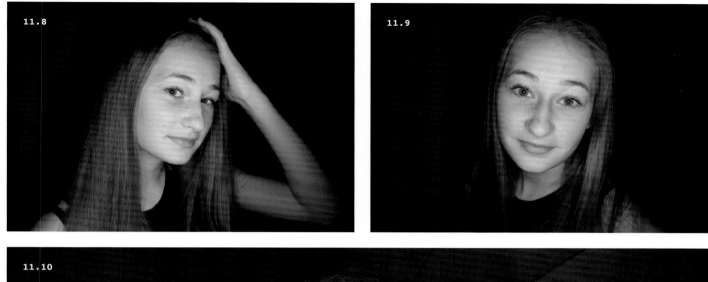

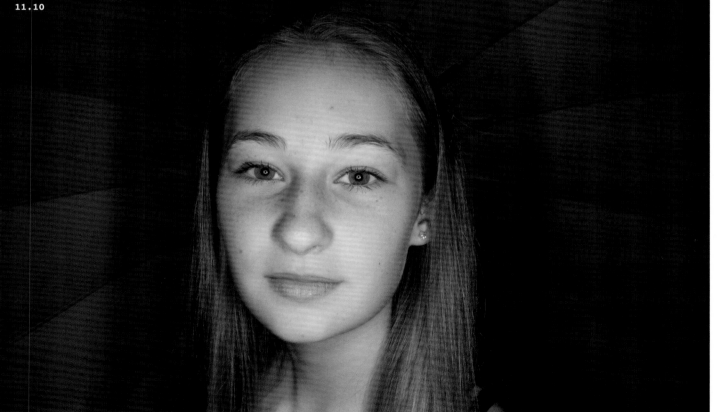

12. SPEEDLIGHT: BUBBLE WRAP SPEEDLIGHT DIFFUSER

THIS MIGHT BE one of the easiest projects in the book. If you have leftover clear bubble wrap from a packing box, then you'll be able to convert it into a nice diffusion tool. This diffuser can produce very nice looking light, and it's almost free! For this project, I used a similar product called plastic drawer liner. It is translucent and works great for this purpose. It is also slightly more durable so it will last longer in your camera bag.

When I photographed with this tool in my studio, I was blown away with the light quality. Look at **Figure 12.2**: You won't believe it was taken using this little diffusion project!

12.1

Parts List (Figure 12.1)

- Bubble wrap or plastic sheeting
- Tape or self-adhesive hook and loop
- Scissors

Construction Steps

1 Cut bubble wrap or plastic sheeting 6″ wide by 16″ long (**Figure 12.3**).

2 Cut 6″ strips of self-adhesive hook and loop fastener material (**Figure 12.4**).

3 Apply the hook and loop to the ends of bubble wrap/plastic sheeting, as shown in **Figure 12.5**. Make sure to place one piece on the front of the plastic wrap and one piece on the back so that the two pieces will attach to each other when you wrap the plastic wrap around the flash.

4 Wrap the plastic around the flash head as shown in **Figure 12.6**.

5 Point the diffusor up to the ceiling and take the picture.

Tips & Cautions

- **Figure 12.7** shows a similar setup using bubble wrap. I used clear tape to form the large diffusion shape and to mount the bubble wrap to the top of my flash.

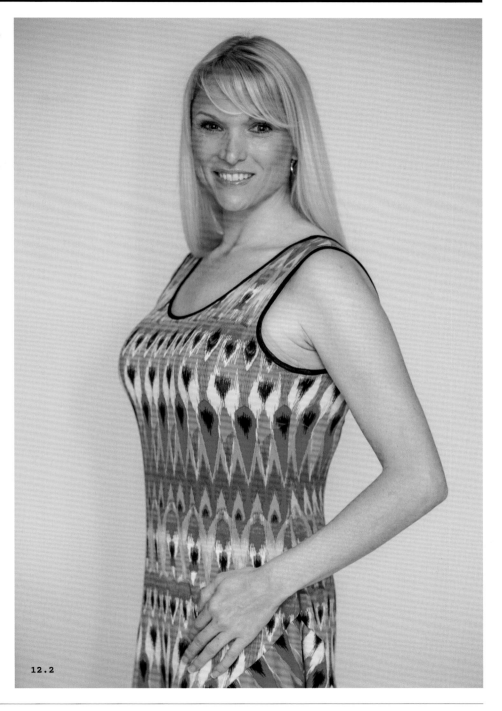

12.2

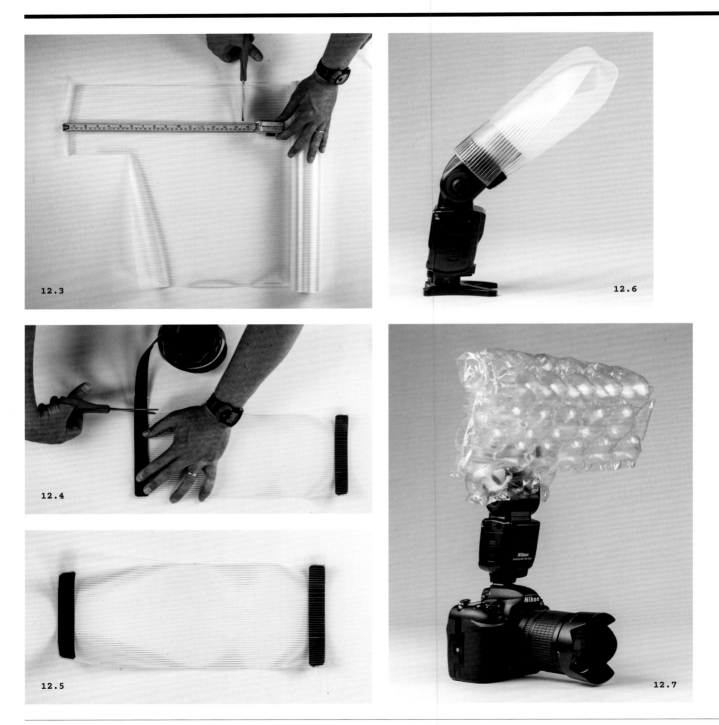

12.3

12.4

12.5

12.6

12.7

13. SPEEDLIGHT: WHITE PAPER BAG DIFFUSER

THIS VERY SIMPLE DIY project will help you create a diffuser out of a white paper bag that results in great-looking images.

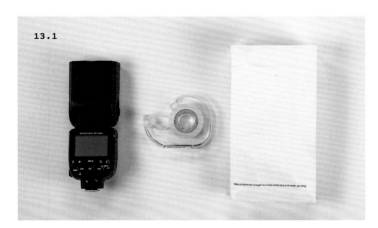

13.1

Parts List (Figure 13.1)

- White paper bag
- Clear tape

Construction Steps

1 Open the bag and place it over the head of your flash.
2 Use clear tape to secure the bag to the flash as shown in **Figure 13.2**.
3 Aim the flash towards the ceiling and take the picture (**Figure 13.3**)!

Tips & Cautions

- Make sure the bag is white and doesn't have any odd colored labels on the outside, as those will change the color of your flash.

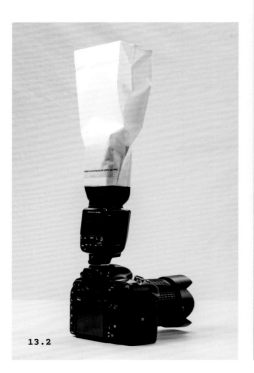

13.2

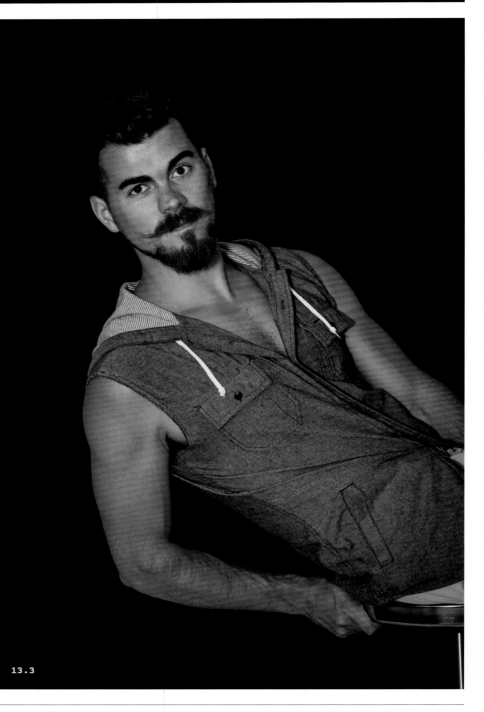

13.3

14. SPEEDLIGHT: CRAFT PAPER SNOOT

SNOOTS COLLIMATE LIGHT to produce a highly directional, crisp light. They are generally used in the studio and serve as hairlights or as a way to add a very hard edge to your portraiture.

Snoots are also designed to keep light from spilling out onto other areas of the scene. This project uses craft paper and tape to produce a very useful lighting tool.

Parts List (Figure 14.1)
- Black paper
- Transparent tape

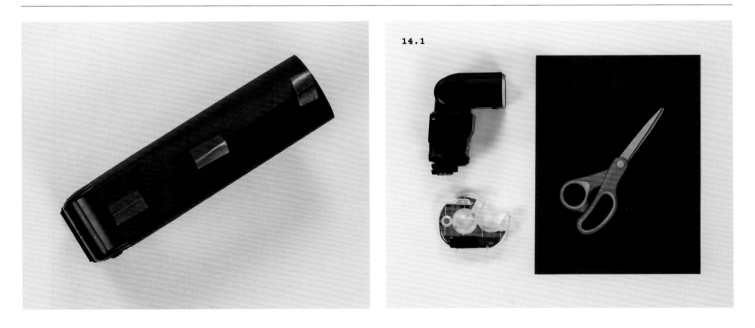

14.1

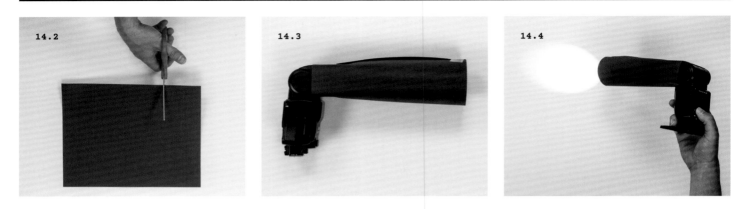

Construction Steps

1 Cut the craft paper to your desired width and length (**Figure 14.2**). For this project, I used a 9"x9" piece of paper.
2 Wrap your craft paper around the flash head and tape the snoot, as shown in **Figures 14.3** and **14.4**. You might also consider taping the snoot to the flash head to keep it from falling off during a shoot.
3 Place the flash onto a light stand and aim it at your subject (**Figure 14.5**). You can also use the snoot as a background light or as a hairlight or rimlight.
4 Take the picture! **Figure 14.6** was created by placing the snoot to the left of the camera and slightly above the subject's torso. This allowed the shadow to fall behind the subject's body.

Tips & Cautions

- Use black paper so the light doesn't diffuse out into the scene. White paper will cause the light to go all over the place, reducing the effectiveness of the snoot.
- The longer you make your snoot, the tighter the lighting pattern will be. Conversely, the shorter the snoot, the wider the lighting pattern will be.
- Beer is good. Some might say that beer combined with photography is even better! For this project, you can also use a foam beer insulator as a snoot for your flash. You'll find that the light from the snoot isn't as concentrated as other snoots, but it is an easy way to control the light using a very inexpensive product. Simply cut out the base of the cozy, and place the cozy over the flash head, as shown in **Figure 14.7**. Slide the foam cozy forward for a tighter pattern or back for a wider pattern.

- You can also make a snoot out of a potato chip can and drinking straws. The advantage of using this type of setup is that the light is very tight and very hard-edged. Cut the bottom off the can, and fill it with as many straws as will fit. Use gaffer tape around the top of the can to hold the straws in position (**Figure 14.8**). This snoot produces very tight light; use it only in specific cases where you need this effect.

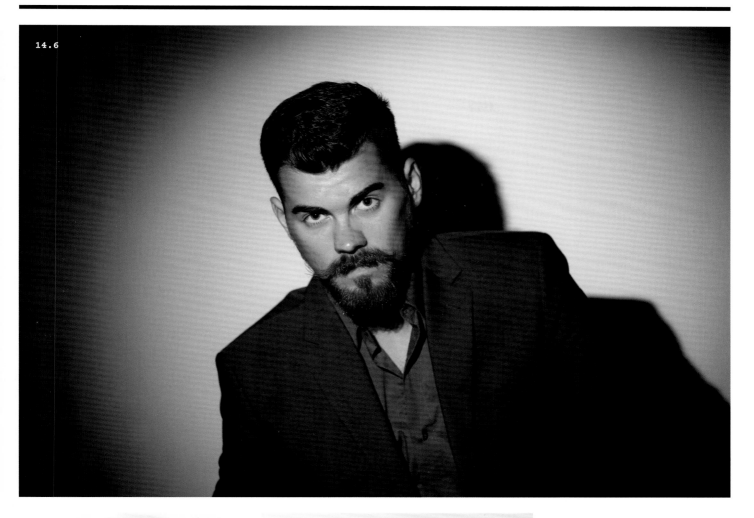

14.6

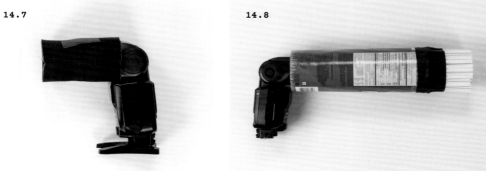

14.7

14.8

15. SPEEDLIGHT: BOUNCE PANEL

SOMETIMES WHEN YOU are shooting an event by yourself, you need another set of hands to help you out. This DIY project shows you how to create an off-camera reflector board that mounts to your camera for easy portability.

The idea is to create the look of an off-camera flash without the bulk of a separate light stand. Usually, lighting looks better when it is located off-camera, and this project moves the flash just enough off-axis to give a compelling look to your images.

Construction Steps

1 Find a white panel about 12″ square. For this project, I cut off the front cover of a 3-ring binder, as shown in **Figure 15.2**.
2 Screw one end of the articulating magic arm into the base of the camera. Then, use the clamp to hold onto the white panel (**Figures 15.3**).
3 Angle the flash head towards the white panel, with the panel facing towards the subject (**Figure 15.4**).
4 Take the picture (**Figure 15.5**).

Tips & Cautions

- Make sure to tighten everything nice and tight, otherwise this setup will flop around while in use.
- To cause the shadow to fall farther behind (below) the subject, position the reflector panel as high as possible.

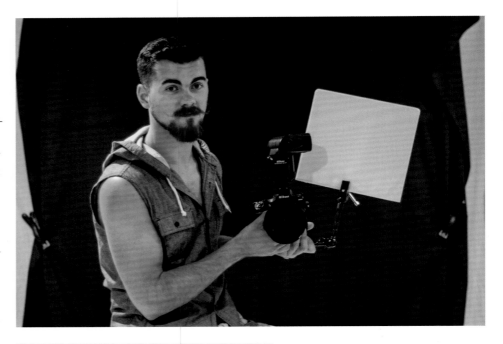

Parts List (Figure 15.1)

- Scissors
- White panel (3-ring binder)
- 11″ articulating magic arm with clamp
- Flash

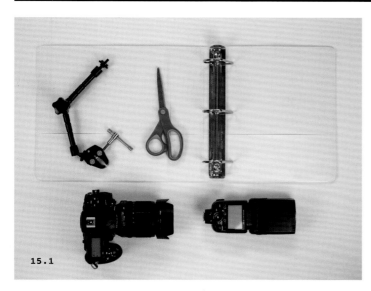

15.1

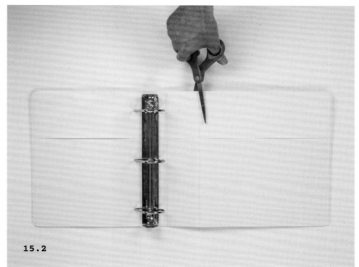

15.2

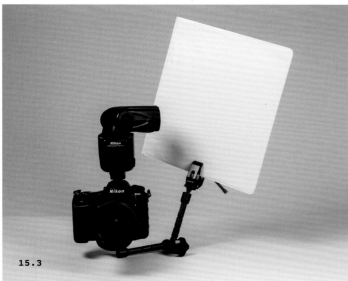

15.3

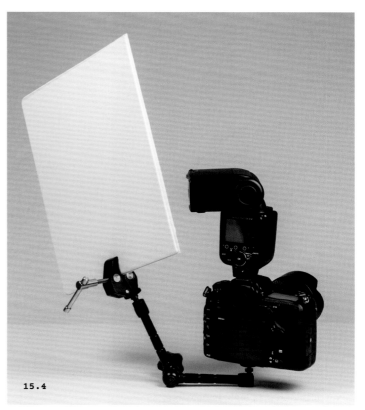

15.4

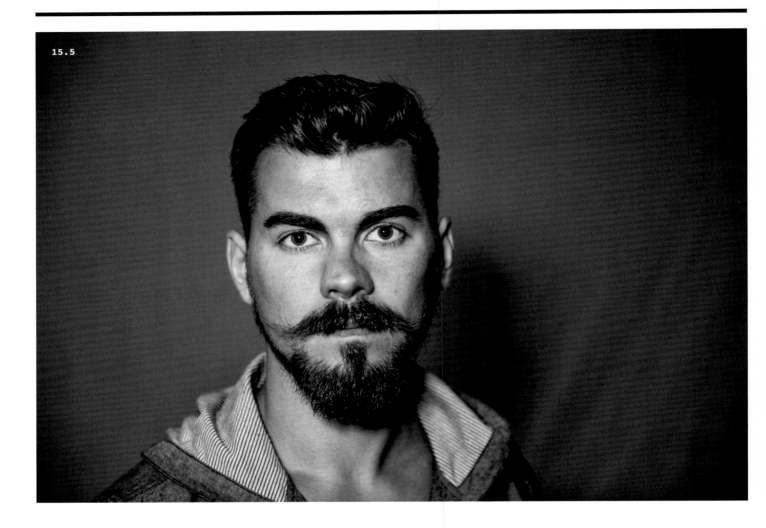

15.5

16. MILK JUG POP-UP FLASH DIFFUSER

MOST PHOTOGRAPHERS KNOW that using the built-in flash on your camera generally results in subpar images. This DIY project is designed to help you get better-looking pop-up flash photos by diffusing the light from this tiny flash. For best results, use this in an outdoor-lighting or diffused-lighting scenario.

Construction Steps

1 Empty a milk jug and wash it out (**Figure 16.2**).

2 Cut a section out of two sides of the jug (on the corner), as shown in **Figure 16.3**.

3 Trace a pattern on the plastic and cut, as shown in **Figure 16.4**. You'll end up sliding the skinny end of the plastic into the hot shoe of your camera, so measure the width very carefully so it fits tight when finished.

4 Pop up the camera's built-in flash, then insert the skinny end of the plastic diffuser into the camera's hot shoe, as shown in **Figures 16.5** and **16.6**.

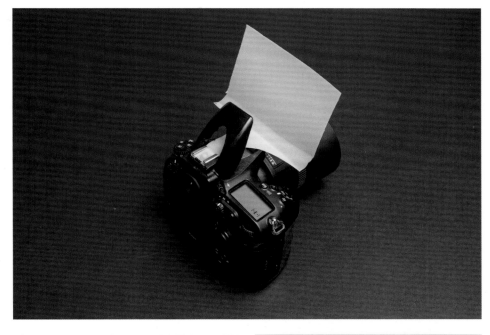

Parts List (Figure 16.1)
- Empty milk jug
- Scissors
- Felt tip pen

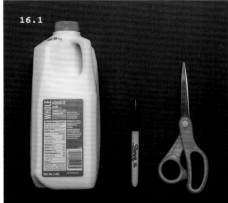

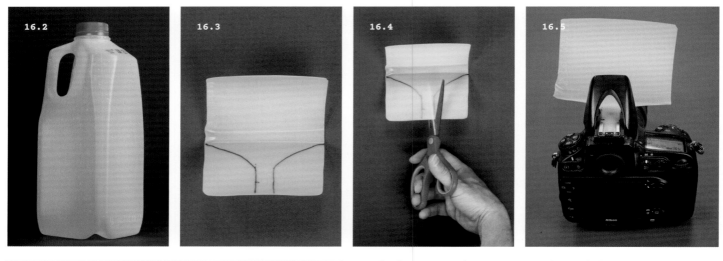

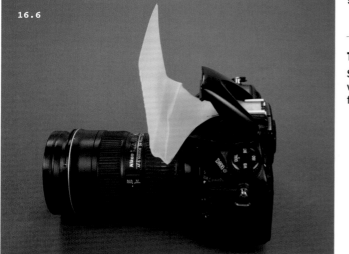

5　Take the picture. **Figure 16.7** was taken with the pop-up flash diffuser and **Figure 16.8** was taken without a flash.

Tips & Cautions

Since your pop-up flash doesn't have much power to begin with, you won't be able to use this flash diffuser from a great distance. The diffuser will absorb a lot of the flash power, so stay close to your subject.

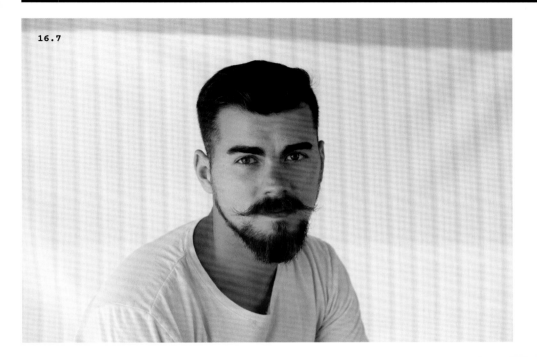

17. LED LIGHT WAND

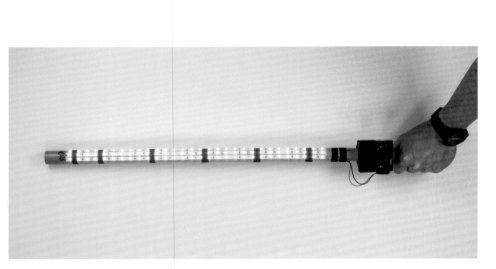

LIGHT WANDS ARE fun to use and can help produce some really interesting images. They can also produce a cool-looking straight catch light in the subject's eyes. This project uses stick-on LEDs and can be used as a main light or as a light painting tool. These are the same style of LED strips that I used to create the light panel in project 1.

17.1

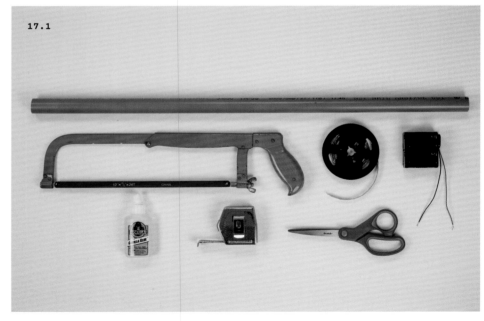

Parts List (Figure 17.1)
- Stick-on LED lights
- 12v AA battery pack
- 1"x2" wood stick or 2" diameter PVC pipe, approximately 30" long
- Gaffer tape
- Hacksaw or PVC cutting tool
- Measuring tape
- Scissors
- 24-gage wire
- Wire stripper
- Soldering iron
- Solder
- Glue (Gorilla Glue or similar)

Construction Steps

1. Cut a 30″ length of PVC pipe as shown in **Figure 17.2**. You can also use a wood dowel or similar product for the light wand.
2. Cut three LED lighting strips to 24″ lengths, as shown in **Figures 17.3** and **17.4**.
3. Adhere the three LED strips to the PVC pipe using both the adhesive backing and glue, as shown in **Figures 17.5** and **17.6**. I used gaffer tape to hold the strips in place while the glue cured (**Figure 17.7**).
4. Attach electrical connectors to the ends of the LED strips. If your LED strips didn't come with included connectors, then solder wires across the ends of the strips, making sure positive and negative poles are maintained, as shown in **Figure 17.8**.
5. Insert batteries into the 12V battery pack. Using adhesive-backed hook and loop fastening tape, affix the battery pack to bottom of the light wand. Alternatively, you can use gaffer tape to fasten the battery pack to the PVC pipe (**Figure 17.9**).
6. Cover the electrical connections with gaffer tape to protect them during use (**Figures 17.10** and **17.11**).
7. Plug in the 12V battery pack to an LED plug to power up the LEDs.

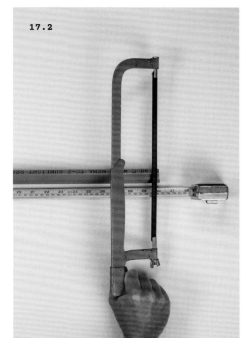

17.2

17.3

17.4

17.5

17.6

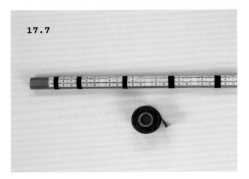

17.7

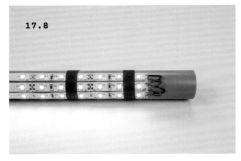

17.8

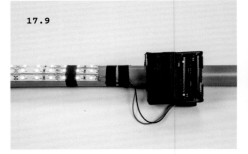

17.9

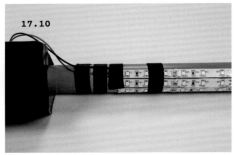

17.10

17.11

8 Pose your model with the light wand and take pictures. Include reflectors as necessary to fill in the shadows (**Figures 17.12** and **17.13**). Pose the model with interesting clothing to create a fictional character worthy of the big screen (**Figures 17.14** and **17.15**).

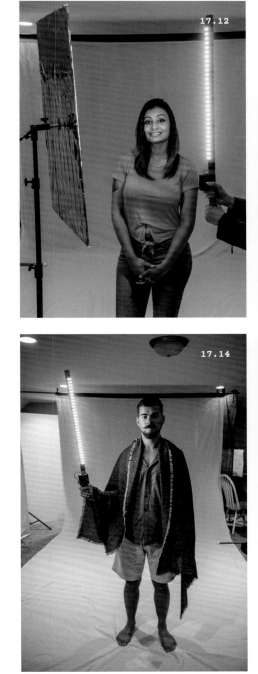

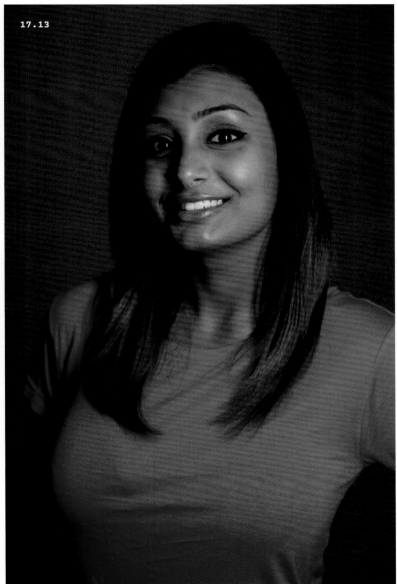

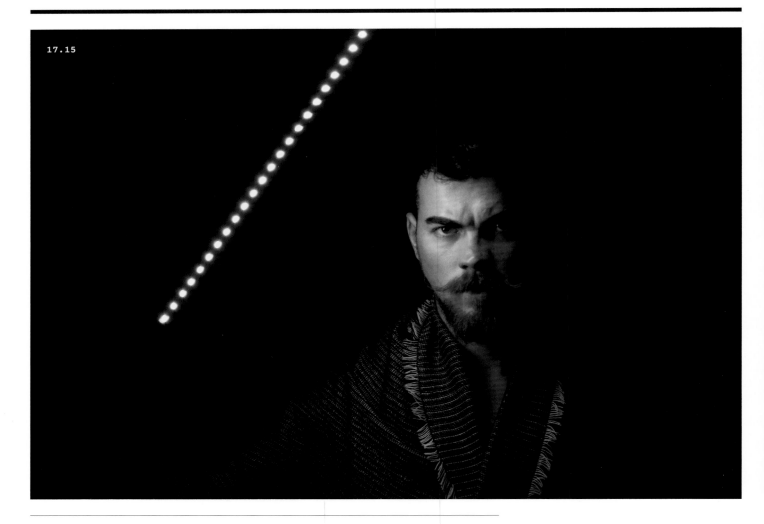

17.15

Tips & Cautions

- There are a couple of ways to construct this light wand. The first is as shown in this project. The second is by using a PVC pipe and wrapping the LEDs around the circumference from bottom to top in a spiral. The full wrap method produces something more along the lines of a light saber.
- Since this LED light wand is a continuous light source, you can use it for light painting as well. Try shooting at night with a long exposure. During the exposure, move the light wand around the subject to create a fascinating and unique photograph.

18. LIGHTBOX WITH WINDOW AND PAPER

THIS SUPER-SIMPLE DIY lightbox produces excellent results and requires almost zero money to build. A typical lightbox uses a rigid frame with white or translucent sides, like the corrugated-plastic light tent in project 49.

This lightbox uses a window on your house and a sheet of tissue paper to produce images like **Figure 18.3**.

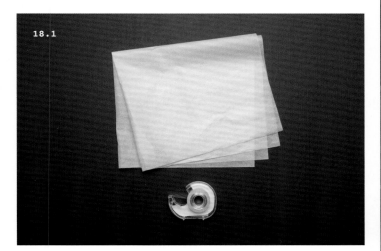

Parts List (Figure 18.1)

- Window
- Large sheet of tissue paper. White copy paper can also work in a pinch.
- Clear tape

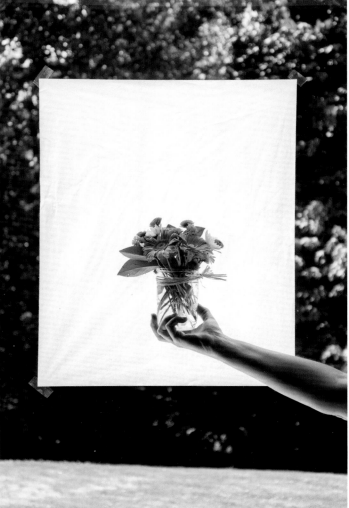

Construction Steps

1 In the Northern Hemisphere, use a north-facing window for soft, diffused light. Use a south-facing window if you want the sun to shine directly on the paper. This will produce a brighter, harsher light. Reverse these directions if you live in the Southern Hemisphere.

2 Tape a big sheet of tissue paper on the window as shown in **Figure 18.2**.

3 Position your subject in front of the paper background. You can have someone hold the subject, or you can set up a table in front of the tissue paper for easier composition.

4 When taking your photo, remember to overexpose to compensate for the bright white background (**Figure 18.3**).

Tips & Cautions

- Use a larger sheet of tissue paper if you need to photograph larger objects.
- This technique works well for 3D objects like flowers, bugs, and figurines. It doesn't work very well for photographing flat objects like artwork; those objects really need front lighting.

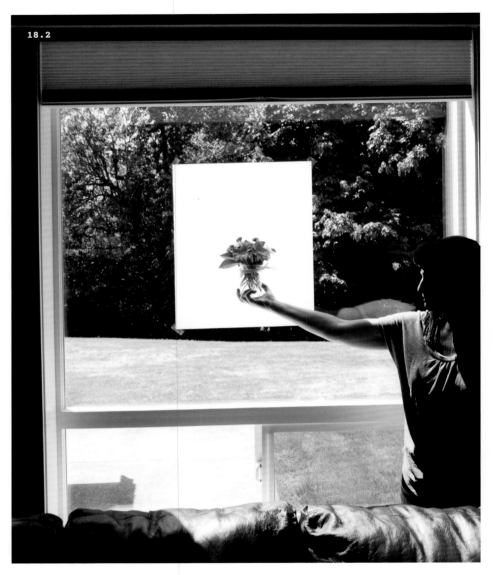

18.2

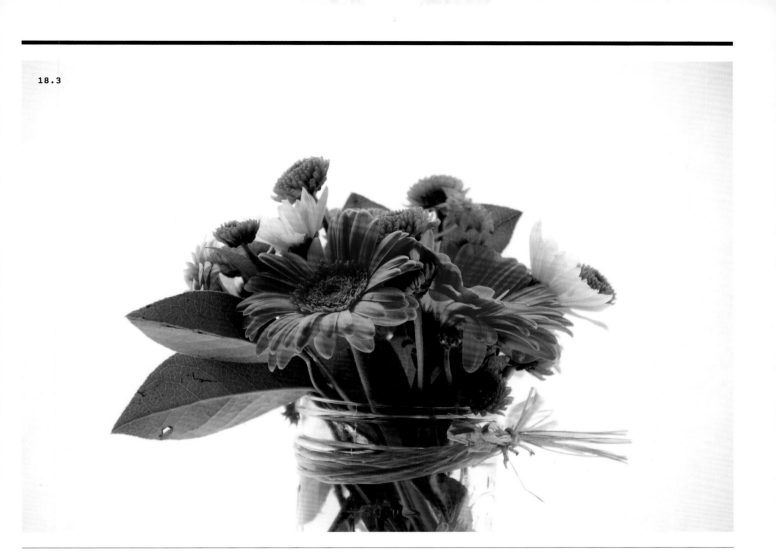

Share your best shot using a window-and-paper lightbox!

Once you've captured a great shot using a window-and-paper lightbox, share it with the Enthusiast's Guide community! Follow *@EnthusiastsGuides* and post your image to Instagram with the hashtag *#DIYLightbox*. Don't forget that you can also search that same hashtag to view all the posts and be inspired by what others are shooting.

2

MACRO PROJECTS

CHAPTER 2

Equipment for macro photography is somewhat specialized and can be quite expensive. This chapter will show you a number of inexpensive DIY macro projects that will allow you to produce high-end images without breaking the bank. Some are lens tools and others are lighting modifiers. I've used each of these projects in my own photography business, so I know they work well. Have fun delving into the world of photographing tiny objects.

19. REVERSIBLE LENS MOUNT

MOST ENTHUSIAST AND professional photographers have at least one 50mm prime lens in their kit. New 50mm f/1.8 lenses sell for around $125. On the used market, if you luck out on eBay or at a thrift store, you can find them still mounted on older film cameras for very low prices. I purchased the example lens I used in this project for $10 from a local thrift store—that included both the Pentax camera and the 50mm lens.

The approach for this macro project is to simply mount a 50mm lens backwards on the camera body with a reversing ring. This instantly turns the lens into a close-focus lens. This technique also works with most any lens, including zoom lenses. It doesn't matter what brand of lens you use since you'll be screwing the lens onto a reversing mount. In this example, I mounted a Pentax 50mm lens on a Nikon DSLR camera.

You can buy reversing rings at almost every camera store. You can also purchase them at most of the popular eCommerce sites.

Construction Steps
1 Screw the reversing ring onto the front of the lens, as shown in **Figure 19.2**.
2 Mount the reversing ring to the camera (**Figure 19.3**).
3 Set the aperture using the lens's aperture ring.
4 Meter the scene in manual exposure mode, then take the photograph (**Figure 19.4**).

> **Parts List** (Figure 19.1)
> - 50mm prime lens with manual aperture control ring
> - Reversing ring

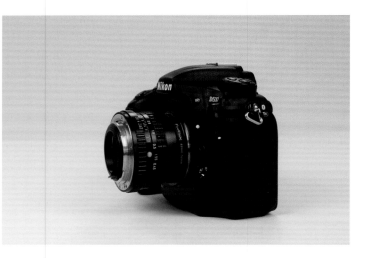

19.1

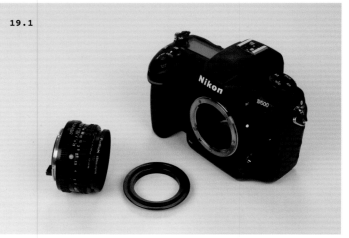

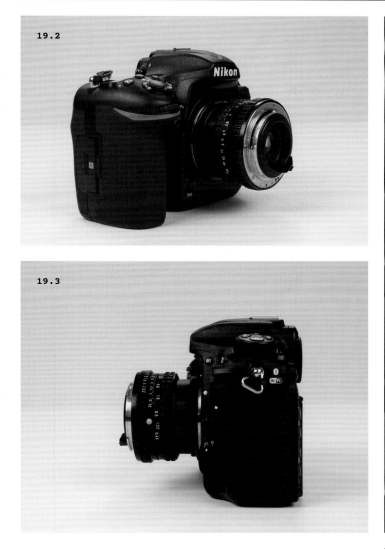

19.2

19.3

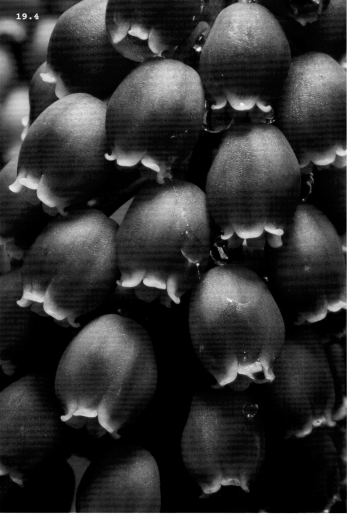

19.4

Tips & Cautions

- Just about everything in this scenario requires manual exposure. Set aperture and focus manually. Set the camera's exposure control to manual. Adjust the shutter speed and aperture manually.
- Your working distance with this setup is pretty much fixed, so I recommend focusing by moving the camera forward and backward. You might also use live view mode to get a better read on critical focus.

20. FREE-LENSING

THE CONCEPT HERE is that you don't mount the lens to the camera at all. Quite literally, you hold the lens in front of the camera and take pictures. The goal is to allow ambient light to spill into the camera to create interesting effects and diffraction. This approach also allows you to use any lens from any manufacturer on any camera.

Construction Steps

1 Remove the lens from the camera, and hold it in front of the lens mount, as shown in **Figures 20.2** and **20.3**.
2 Compose your image while looking through the viewfinder or while using the live view feature.
3 Take pictures while purposely trying to induce partial focus, lens flare, and other optical aberrations. **Figure 20.4** shows partial focus with the right eye in focus and the left eye out of focus.

Tips & Cautions

- Set aperture and focus manually. Set the camera's exposure control to manual. Adjust the shutter speed and aperture manually.
- Live view can be helpful to see the lens flare and diffraction in real time. Some photographers like to hold the setup down at waist level with the flip screen out, like an old twin lens reflex.
- Getting everything (exposure, focus, composition, flare, model's expression) working together can be quite a balancing act. Keep on trying and remember that you might have to take 25 to 50 shots before you get a keeper.

Parts List (Figure 20.1)

- Manual lens
- DSLR or mirrorless camera body that allows full manual control

20.1

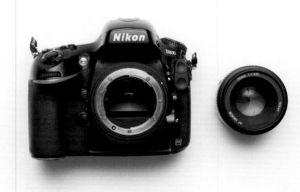

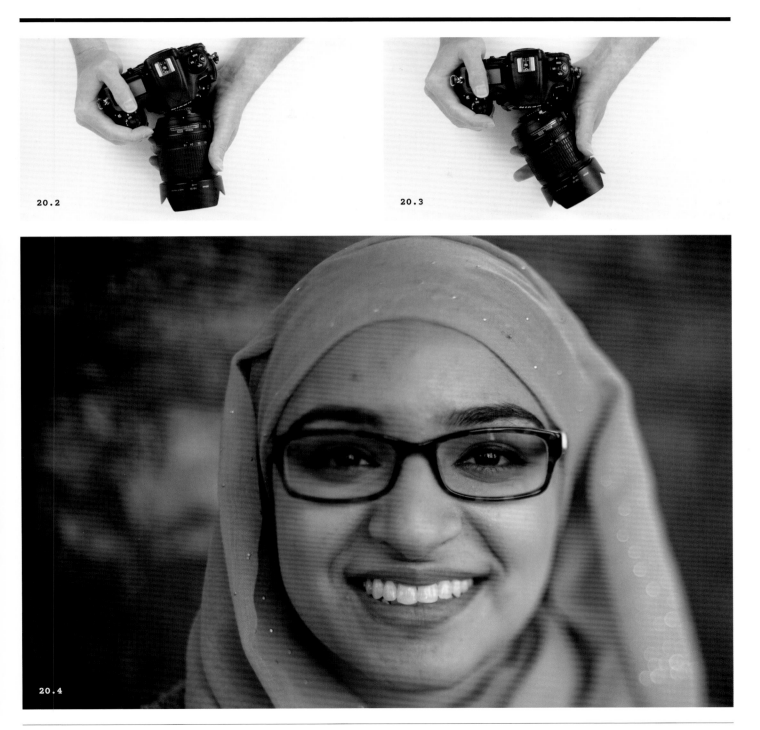

20.2

20.3

20.4

21. DIY BELLOWS

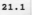

A BELLOWS SYSTEM gives you the option to create a tilt-shift effect and selective focus effect without having lens flare. This project utilizes a toilet plunger, but you can use any type of bellows including automobile CV joint covers, shock absorber rubber, or black cloth over a Slinky.

Construction Steps

1. Cut off the handle from the plunger. Cut the bellows to your desired length, anywhere from 2″ to 4″ depending on how much range of motion you want (**Figure 21.2**).
2. Drill a 1.5″-diameter hole in the lens cap, as shown in **Figure 21.3**.
3. Glue the lens cap onto the end of the bellows with Gorilla Glue or Super Glue (**Figure 21.4**).
4. Mount the lens to the front of the bellows, as shown in **Figure 21.5**.
5. Hold the bellows in front of the camera body while taking photos (**Figure 21.6**).
6. Take the picture (**Figure 21.7**). To focus closer, relax the bellows. In other words, the lens will give you more magnification the farther it is from the camera body.

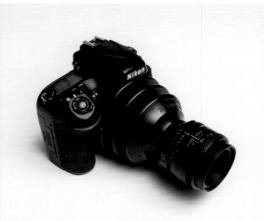

21.1

Parts List (Figure 12.1)

- Bellows-style toilet plunger
- Lens cap (base)
- Glue (Gorilla Glue or similar)
- Lens
- Drill or drill press
- 1.5″ hole saw
- Hacksaw

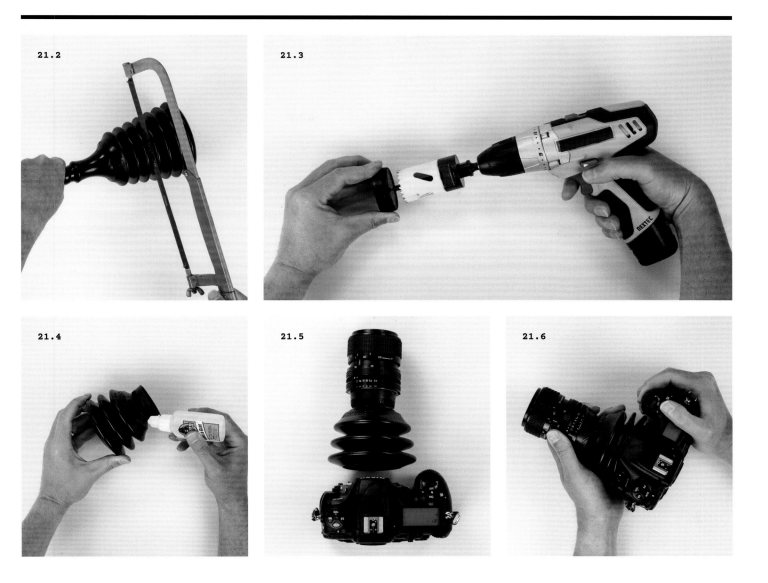

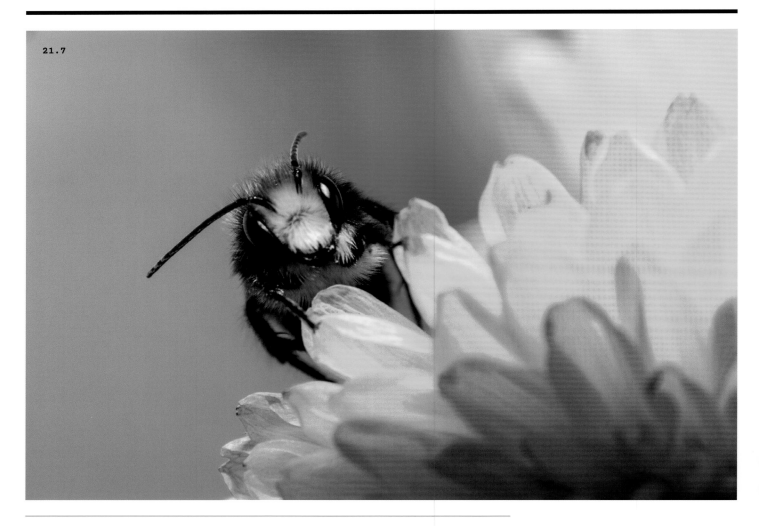

21.7

Tips & Cautions

- Set the aperture and focus manually. Set the camera's exposure control to manual. Adjust the shutter speed and aperture manually.
- For this to work properly, you'll need to hold the lens in your left hand. While moving the bellows forward, backward, up, and down.
- Since this behaves much like an extension tube, your working distance will be fairly limited. Therefore, if you are trying to shoot portraits, you'll need your subject to be close to the camera.
- Make sure the glue dries and fully cures before you mount the lens to the apparatus. You don't want to get glue on your lens!

22. UTILITY VISE MACRO FOCUSING SYSTEM

RAIL FOCUSING SYSTEMS are widely used for critical focusing in macro photography. A very nice setup costs $400 to $800, while an inexpensive focusing rail runs $45 or so. This project uses a utility vise to serve as your focusing rail. You can purchase a vise from the hardware store for about $20, but most DIY-ers already have a vise in the garage.

The end product isn't very lightweight, so I don't anticipate you'll be hiking with this setup, but it's great for home use. One of the keys is to find a vice that doesn't have a lot of slop in the screw mechanism. If you have a vise in your garage, I encourage you to find a way to shim the runners so you don't get side-to-side or forward/backward slop when moving the camera. Since the entire purpose of this project is accurate focusing, any extra movement in the system can really mess you up. That's why professional systems cost so much!

Construction Steps

1 Start by roughing up the top of the bolt and the surrounding surface of the vise with a file. The purpose is to give the liquid metal epoxy a good surface to grip.

2 Wipe down the surfaces of the vise and the bolt with rubbing alcohol or solvent to remove any grease or oil.

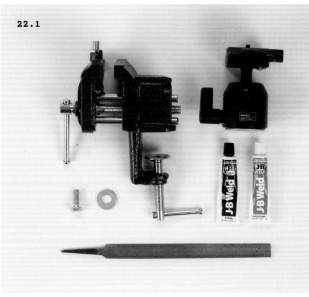

22.1

Parts List (Figure 22.1)

- Vise
- Liquid metal (J-B Weld or similar)
- Ball head
- 3/8" or 1/4"-20 bolt (depending on ball head base screw size), approximately 3/4" long
- File
- Rubbing alcohol or other solvent

3 Mix liquid metal epoxy on a piece of cardboard. Spread liquid metal on the cleaned top of the vise and head of the bolt, then attach the bolt to the vise (**Figures 22.2** and **22.3**). Be sure to center the bolt so the camera's weight will be balanced over the vise. Over the next 15–30 minutes, keep applying liquid metal around and over the joint between the vise and bolt. The goal is to create a strong bond between the various pieces. You might have to work with this over the course of a few hours, being careful that the liquid metal doesn't drip onto other surfaces. Let the liquid metal set for at least 24 hours.

4 Mount your ball head to the screw on the top of the vise, as shown in **Figure 22.4**.

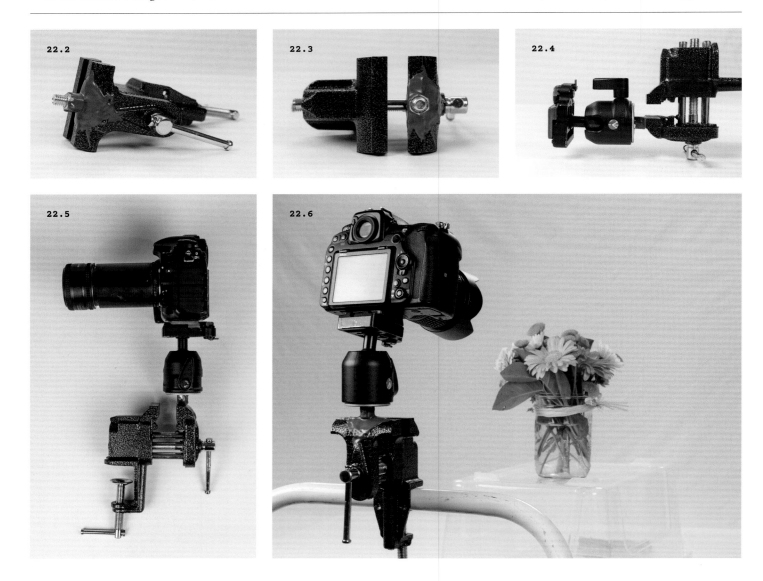

22.2

22.3

22.4

22.5

22.6

5 Mount your camera to the ball head (**Figure 22.5**), and then mount the vise to a bracket or bar near the subject you're photographing (**Figure 22.6**). Begin taking photos as you rotate the screw on the vise.

Tips & Cautions

- Be sure to test the strength of your bond before using the setup over a hard surface. If you didn't do a good job of mixing and applying the liquid metal epoxy, then there's a high probability the bolt will break off, taking your camera with it!
- The general approach is to set up the camera with the vise all the way open, with the focus on the part of the subject closest to you. Take a picture, then rotate the vise shaft one turn, so the camera moves slightly closer to the subject, then refocus and take another picture. Repeat this process until you've focused and shot images all the way down the length of the focus rail. When finished with the sequence of photographs, you'll use image-stacking software (Adobe Photoshop, Helicon Focus) to put all the images together for a final single image. **Figures 22.7** and **22.8** illustrate the effect. Figure 22.7 is a single image taken at f/11. I photographed a series of images, and then stacked them together in Photoshop to get the extended depth of field you see in Figure 22.8.

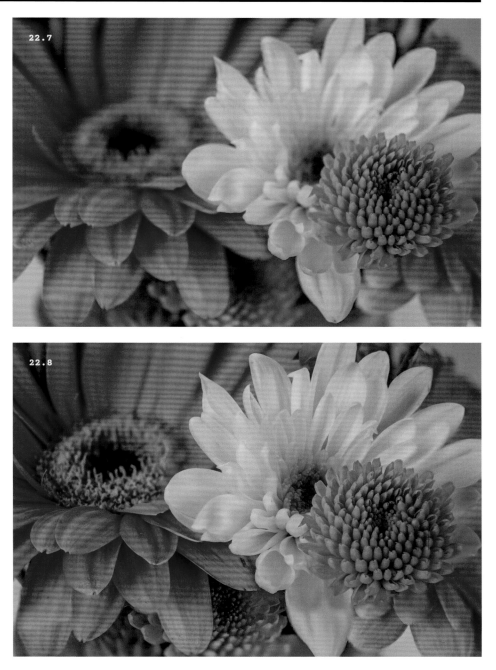

22.7

22.8

23. FIELD MACRO LIGHTBOX

LIGHTING FOR MACRO subjects can be one of the more difficult aspects to macro photography. Getting everything to work together while also being portable and repeatable can be a real challenge. This project is simple, portable, and durable, and it produces excellent quality light for your macro subjects.

Construction Steps

1 Trace the outline of the flash head on one end of the plastic washbasin.
2 Drill a hole inside the outline. Cut out the shape of the flash head with the reciprocating saw (**Figure 23.2**).
3 Insert the head of the flash into the lightbox (**Figure 23.3**).
4 Place the plastic diffusion dome over flash head on the inside of the lightbox, as shown in **Figure 23.4**. This keeps the flash from falling out, while also providing additional diffusion for your photographs.
5 Take pictures (**Figure 23.5**) by holding the lightbox with your left hand and operating the camera with your right hand.

Parts List (Figure 23.1)

- 8-quart white plastic washbasin
- Electric drill
- 3/8″ drill bit
- Felt tip pen
- Reciprocating saw or saber saw
- Flash/speedlight with plastic diffusion dome

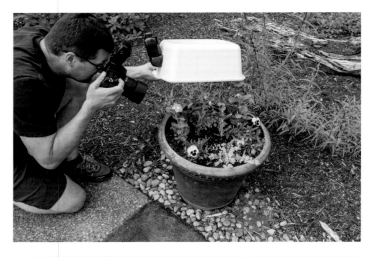

23.1

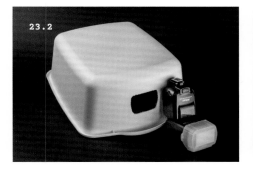

23.2

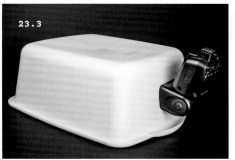

23.3

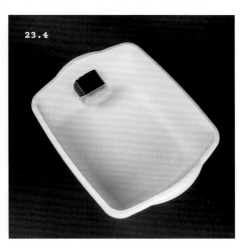

23.4

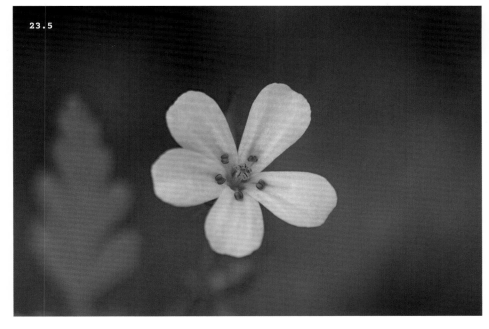

23.5

Tips & Cautions

- You can trigger the remote flash in a variety of ways, including a dedicated TTL cable, wireless trigger, or your camera's built-in wireless flash control protocol.
- Hold the diffusion box over the top of your subject for the best lighting. If you're photographing insects, keep the diffusion box a bit in front of the bug so you can get nice catch lights in the eyes. Feel free to experiment with positioning the softbox to the left, right, top, bottom, front, and back of the subject.

24. MACRO FLASH BRACKETS

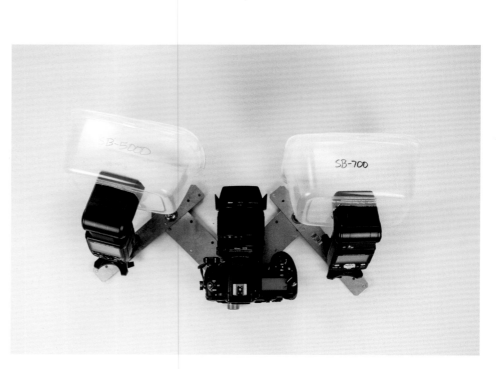

THIS IS A very useful tool for handheld macro photography. It allows you to walk around in the field without having to hold the flashes. The bracket's arms are adjustable to move the flashes forward and backward. The ball heads allow you to precisely position the orientation of the flashes, as well.

I purchased the brackets for this project at my local big-box hardware store. The galvanized pieces were very inexpensive and the total price for the brackets and screws was about $5. I found the mini ball heads on Amazon.com for about $6 each. I already had the quick-release camera mount in my kit, but you can buy quick-release clamps on eBay and Amazon for less than $15 each. Total cost of this setup will be around $30, but a commercially available flash bracket setup will cost between $60 and $200.

Construction Steps

1 Screw the flat brackets onto the angle bracket using 3/8″ or 1/4″ bolts, washers, lock washers, and nut (**Figure 24.2**). Using washers on top and bottom will allow for easy rotation of the flat bracket. Adding a lock washer will prevent the setup from getting loose during use in the field.

2 Mount mini ball heads to the ends of the flat brackets as shown in **Figure 24.2**.

Parts List (Figure 24.1)

- Flat bracket (Simpson Strong-Tie LSTA9) (2)
- Flat angle bracket (Simpson Strong-Tie 88L) (2)
- Mini ball head (2)
- 3/8″ bolts or 1/4″-20 bolts (depending on the ball head mounting screw) (4)
- 3/8″ or 1/4″ washers (4)
- 3/8″ or 1/4″ lock washers (2)
- 3/8″ or 1/4″ nuts (2)
- Camera mounting quick release with 1/4″ mounting bolt/Allen screw
- Plastic storage containers (for this example, I used lunchmeat bins)
- White copy paper or other white diffusion material

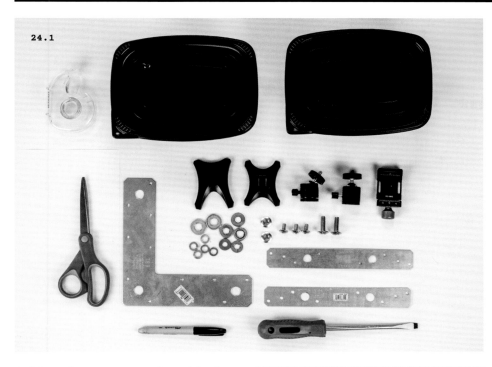

24.1

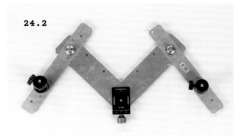

24.2

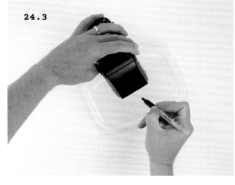

24.3

3 Mount the camera-mounting quick release on an angle bracket using a 1/4"-20 bolt (see the middle of Figure 24.2).

4 Create two flash diffusion boxes. Trace the shape of the flash head on the back of the plastic box with a felt tip pen (**Figure 24.3**), then cut out the shape with scissors or a razor blade (**Figure 24.4**). Trace the shape of the front of the plastic box on copy paper, cut it out with scissors, then attach it with clear tape as shown in **Figure 24.5**.

5 Mount flashes to the mini ball heads. You can use a plastic mounting foot from the flash manufacturer, or you can use a cold shoe. Either method works, just make sure the setup you use allows you to trigger the flashes.

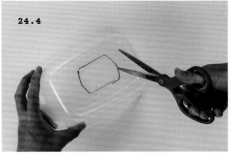

24.4

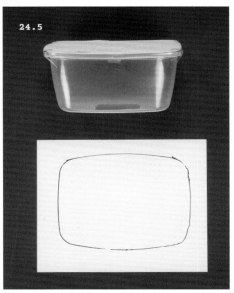

24.5

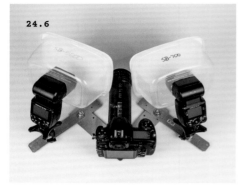

24.6

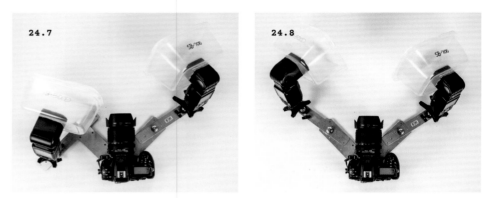

24.7

24.8

6 Mount the diffusion boxes onto the flash heads (**Figure 24.6**).

7 Mount the camera to the quick release clamp, as shown in **Figures 24.7** and **24.8**.

8 Take pictures (**Figures 24.9** and **24.10**). You can trigger the flashes with radio remotes, built-in TTL wireless control, or dedicated TTL cables.

24.9

24.10

Tips & Cautions

- You don't necessarily have to use a camera quick-release clamp to mount the camera to the system. Instead, you can just use a 1/4"-20 screw in the camera's tripod mounting screw on the bottom of the camera. This works fine as long as you don't need to quickly access the camera for another purpose.
- Using an L-bracket on the camera body will make it easier to switch from horizontal to vertical orientation on the camera. If you don't have an L-bracket, a steel angle bracket from the hardware store will allow you to mount the camera vertically.

25. PVC PIPE EXTENSION TUBE

PVC PIPE IS a very versatile material to use in all kinds of DIY photography projects. For this project, you'll need a short length of black 2″-diameter PVC drain pipe to create an extension tube for macro photography. I love this project; it's useful, durable, and inexpensive.

Construction Steps

1 Cut the PVC pipe to the desired length (e.g., 2″) with a hacksaw, as shown in **Figure 25.2**.

2 Make sure that the cuts are as close to perpendicular as possible. You'll be mounting lenses to both ends of the tube and you don't want the lens to be at an angle.

3 Apply gaffer tape to inside of pipe. This reduces internal reflections and will produce a higher contrast image.

4 Use a drill or drill press to cut out the center of the body cap to approximately a 1.5″ diameter (**Figure 25.3**). I suggest using a hole saw. Use a file or sand paper to remove any burrs along the edges of the hole.

5 Glue the body cap to one end of PVC pipe, as shown in **Figure 25.4**. You might make note of the "top" of the body cap and then mark it with white paint so it's easier to mount on the camera later on.

6 Cut out the center of lens cap base to a 1.5″-diameter using a hole saw, as shown in **Figure 25.5**. Use a file to remove any burrs along the edges of the hole.

7 Glue the lens cap base to the opposite end of the pipe. This is the side that you'll use to mount the lens, so make sure you keep the correct side of the lens cap pointed out. I suggest aligning the "top" of the lens cap before gluing it to the PVC so it is aligned with the body cap. That way, the lens will be in the correct orientation when everything is mounted on the camera.

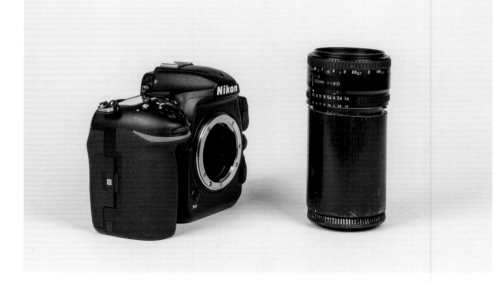

Parts List (Figure 25.1)

- 2″-diameter black PVC pipe
- Body cap
- Lens cap (base)
- Glue (Gorilla Glue or similar)
- Drill or drill press
- 1.5″-diameter hole saw drill bit
- Round file
- Gaffer tape
- Hacksaw

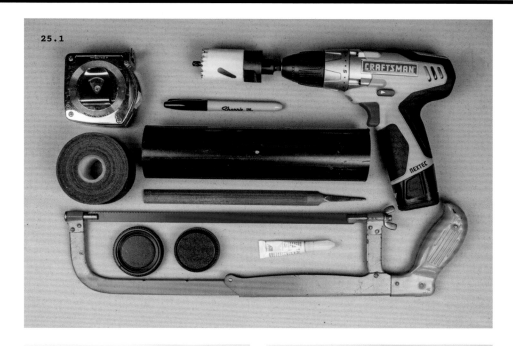

25.1

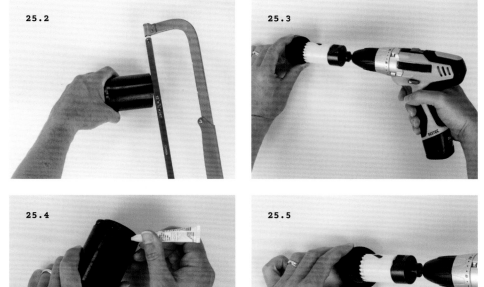

25.2

25.3

25.4

25.5

8 Mount the PVC extension tube to the camera, then mount the lens to the base cap (**Figures 25.6** and **25.7**).

9 Set the camera to manual exposure mode. Set the shutter speed and ISO manually. Set the aperture on the lens manually. Focus the lens manually.

10 Take the photo (**Figure 25.8**)!

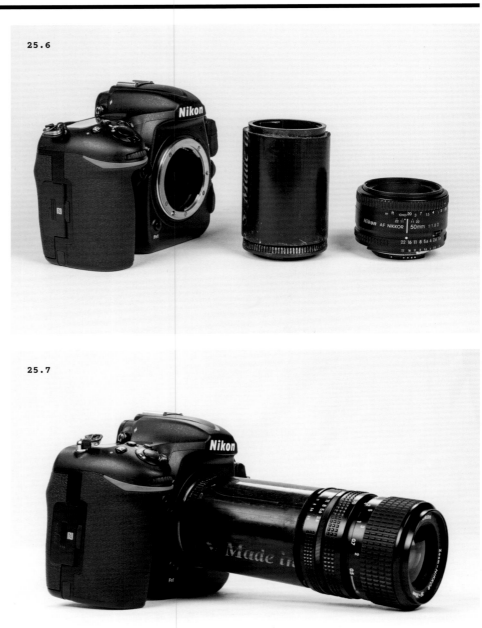

25.6

25.7

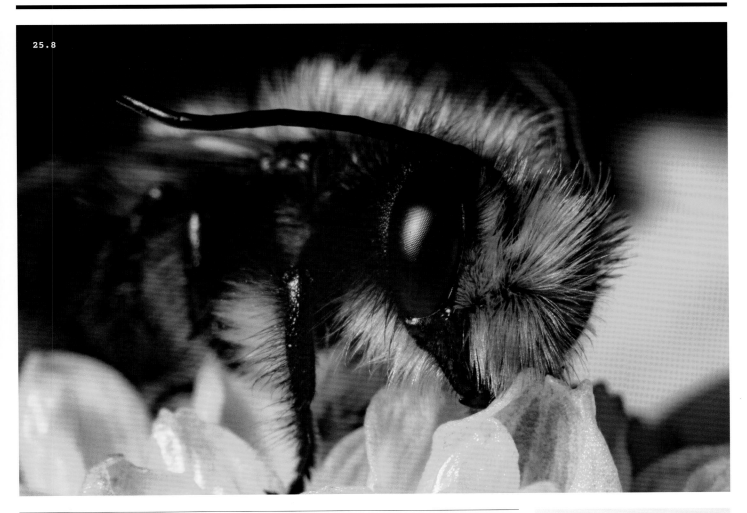

25.8

Tips & Cautions

- Since this method is so inexpensive, I made multiple lengths of extension tubes (**Figure 25.9**). I suggest making 1", 2", 3", and 4" tubes. The longer the tube, the more magnification.
- An extension tube significantly reduces the amount of light that reaches the camera. Therefore, it might be difficult to focus when using smaller apertures. I recommend setting focus with the lens set to the largest aperture (i.e., f/2.8), then stopping down when it is time to take the shot.
- Since you are using body caps and lens caps for this project, your lenses won't lock into place like a regular lens on the camera. Therefore, be careful when using this setup that you don't inadvertently rotate the extension tube (or lens) while shooting, because it might fall off.

25.9

26. POTATO CHIP CAN MACRO FLASH DIFFUSER

THIS SIMPLE AND straightforward project will help you create beautiful light for your macro photography. I'll show two styles of light diffusion using a potato chip can.

Construction Steps for Horizontal Diffusion

1 Using scissors or a razor blade, cut out approximately 1/3 of the side of the potato chip can, as shown in **Figure 26.2**.

2 Cover the opening with tissue paper and tape it to the sides of the can (**Figure 26.3**).

3 Insert the head of the flash into the end of the potato chip can, as shown in **Figure 26.4**.

4 Take pictures (**Figure 26.5**)!

Parts List (Figure 26.1)
- Potato chip can/tube
- Scissors or razor blade
- Tissue paper
- Tape

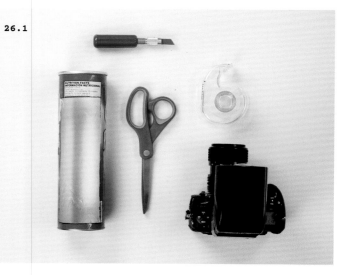

26.1

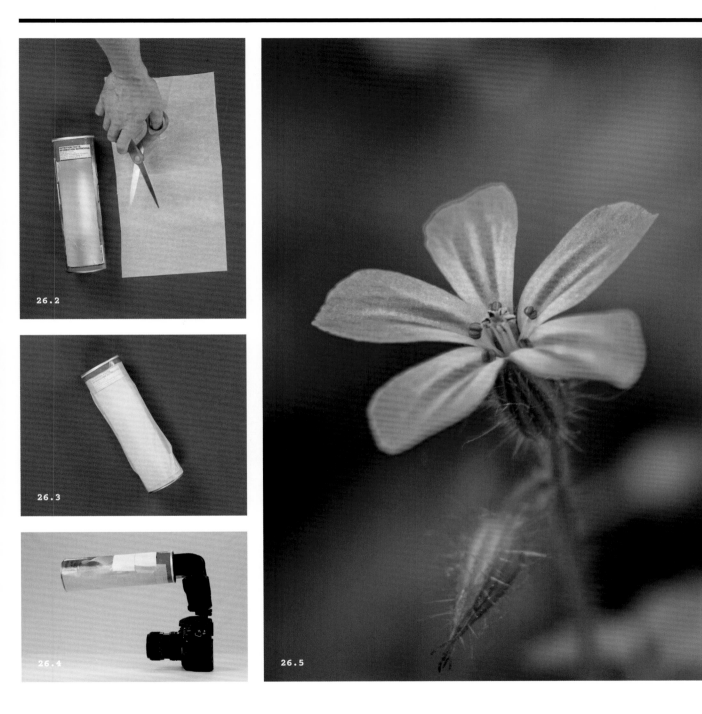

26.2

26.3

26.4

26.5

Construction Details for Oval Diffusion

1 Trace the shape of the flash head onto the side of the potato chip can, then cut out a hole from the potato chip can with a razor blade.
2 Trace the shape of the diffusion area on the can. You'll want to make this a large oval shape after it is cut out in order to maximize surface area (**Figure 26.6**).
3 Cut out the diffusion shape on the can with a razor blade, then cover the diffusion area with tissue paper and tape the paper to the potato chip can, as shown in **Figure 26.6**.
4 Mount the flash and the potato chip diffuser to the camera.
5 Take photos (**Figure 26.7**)!

Tips & Cautions

For a more durable diffusion source, you can use part of a plastic milk jug in place of tissue paper.

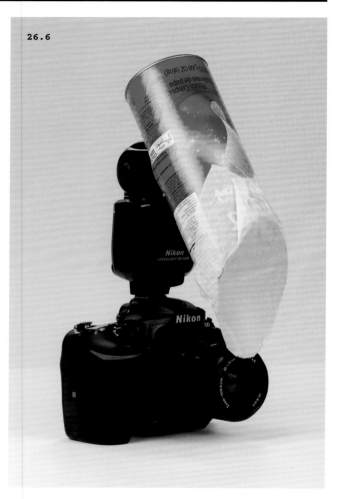

26.6

26.7

3

SUPPORT PROJECTS

CHAPTER 3

Most photographers already own a tripod and some even own a monopod. In this chapter, I'll show you some alternative ideas for supporting your camera that work well and are easy on the wallet. You can find many of these projects as commercially available products, but this chapter will show you how to multi-purpose many of the things you already own into very useful camera support tools.

27. TREKKING POLE MONOPOD

HIKERS ALWAYS WANT their gear to perform double duty. The more purposes a tool serves, the fewer tools you'll need to carry. This DIY project provides a way to lighten your load by leaving a tripod or monopod at home. This trekking pole monopod is a solid camera support for photography and video.

Construction Steps

1. Disassemble and remove the wrist strap and adjusting mechanism from the trekking pole handle.
2. Drill a 1/4″ hole into the top of the trekking pole handle, as shown in **Figure 27.2**.
3. Insert a 1/4″ bolt into the underside of the handle where the wrist strap was mounted (**Figure 27.3**).
4. Reassemble the wrist strap system to the trekking pole.

Camera mounting options:

- Screw on a quick-release clamp that fits your camera (**Figures 27.4** and **27.5**). This is my favorite method because it is very lightweight, but still secure. If you use an L-bracket on your camera, then you can easily switch between vertical and horizontal compositions.
- Leave the bolt by itself and screw that into the bottom of your camera.
- Screw on a mini ball head to the 1/4″-20 bolt and then mount your camera to the ball head.

Parts List (Figure 27.1)

- Trekking pole
- 1/4″-20 bolt
- Electric drill
- 1/4″ drill bit
- Quick-release clamp

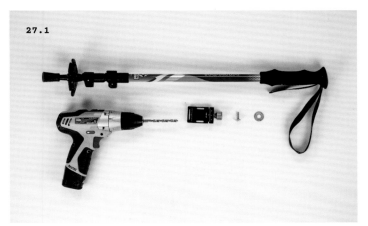

27.1

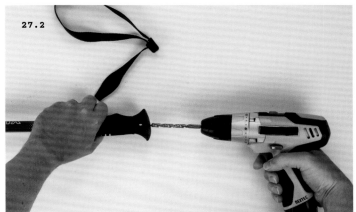

27.2

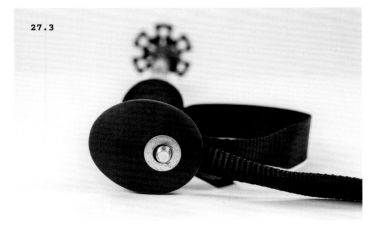

27.3

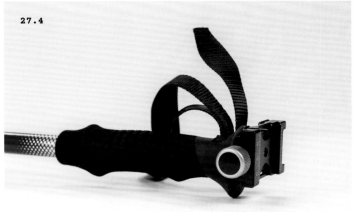

27.4

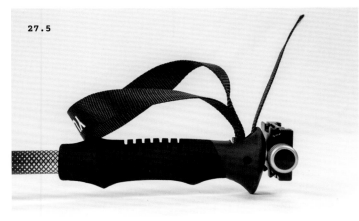

27.5

Tips & Cautions

Each trekking pole manufacturer has a slightly different approach to mounting wrist straps to the handle. Pay attention to your specific model to make sure you don't damage the wrist strap adjusting mechanism when drilling a hole in the top of the handle.

28. STRING MONOPOD

THIS IS ONE of the lightest-weight camera support systems you'll ever use. The concept is to use a string or a cord as the support. But, rather than the camera resting on top of a monopod, you pull "up" on the string to provide stability. This design uses a cord tensioner to adjust the length of the cord near the camera, rather than requiring you to bend down to adjust the length near your foot.

Construction Steps

1. Thread an aluminum cord tensioner onto the 550 paracord (red item in **Figure 28.2**).
2. Thread a plastic toggle-spring cord lock onto the paracord (black plastic piece on the left side of Figure 28.2).
3. Create a wrist loop on one end of the paracord and use the plastic toggle-spring cord lock for adjustments. Tie an overhand knot in the end of the cord to prevent the cord from pulling out of the plastic cord lock.
4. Create a loop next to the aluminum cord tensioner and attach one of the mini carabiners in the loop (gold carabiner at the top of Figure 28.2).
5. Create a loop using an overhand or figure-8 knot below the aluminum tensioner. Attach the second mini carabiner to this loop (black carabiner at the bottom of Figure 28.2). This carabiner will be used to clip to your belt loop on your pants, as shown in **Figure 28.3**.

Parts List (Figure 28.1)

- 1/4"-20 eye bolt or camera quick-release plate with finger tightening screw
- String or 550 paracord, 84" long
- Mini carabiner (2)
- Aluminum cord tensioner
- Plastic toggle-spring cord lock

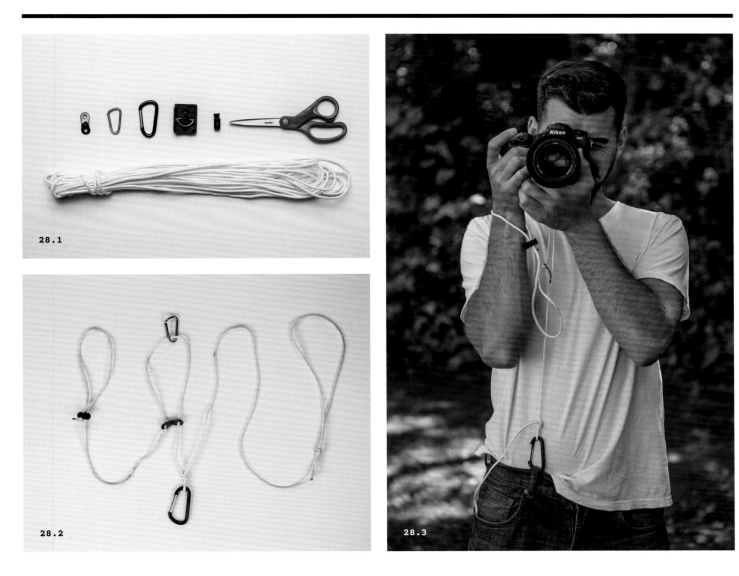

28.1

28.2

28.3

6 Tie a large loop for your foot at the bottom of the paracord, as shown on the far right side of Figure 28.2.

7 Screw an eye-bolt to the camera's tripod screw hole or mount a tripod plate with a built-in D-ring.

8 Clip the top carabiner to the eye-bolt or D-ring on the bottom of the camera, as shown in **Figure 28.4**.

9 Place the wrist loop over your wrist, as shown in **Figure 28.5**. The aluminum tensioner makes it very easy to adjust the overall length of the cord, whether it is being used with your foot or your belt loop. **Figure 28.6** shows you how to use this setup with your foot.

Tips & Cautions

If you already have a Manfrotto tripod mounting plate that uses a finger screw, then you can simply tie the cord to the bottom of the plate. Alternatively, lots of Arca Swiss tripods have wrist strap mounting points, and you can use those as spots to tie the cord.

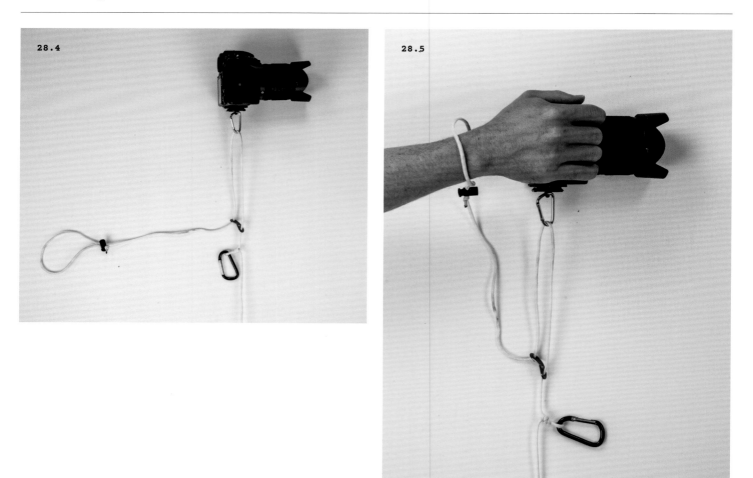

28.4

28.5

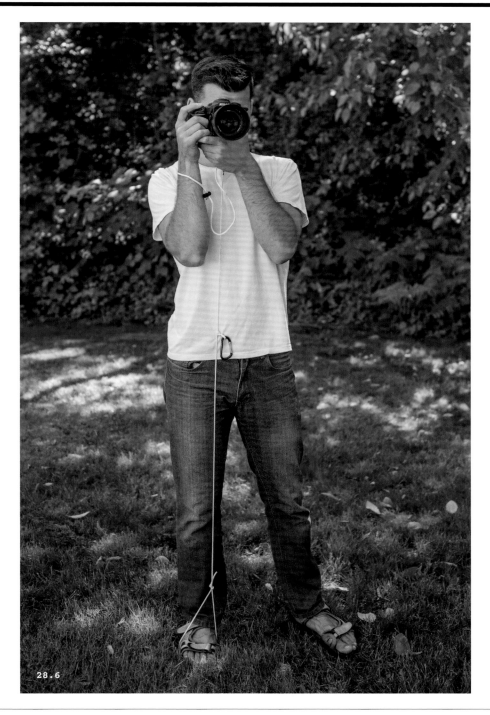

28.6

29. AERIAL PHOTOGRAPHY MONOPOD

A DRONE IS the most common tool these days for getting an aerial perspective on your scene. However, there are many times when a drone isn't practical (such as over crowded areas or in zones where their use is expressly prohibited). In these cases, I suggest using an aerial photography monopod.

The solution described here is a long extension pole with a ball head on the end. You can then attach your camera to the end of the pole, raise it into the air, and take your photographs. The foundation of this system is a telescoping extension pole like the kind a painter or window washer might use.

Parts List (Figure 29.1)

- Extension pole 15' or 20'
- Three-piece extension pole kit
- Hose clamp, 1/2" to 1.25"
- 3/8"-16 hanger bolt, 3" long
- 3/8" washer
- Tripod head
- Saw
- Electric drill
- 1/8" drill bit
- 3/8" washer
- File or sandpaper
- Wood glue
- Screwdriver
- Pliers

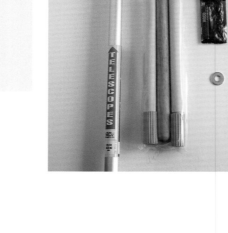

29.1

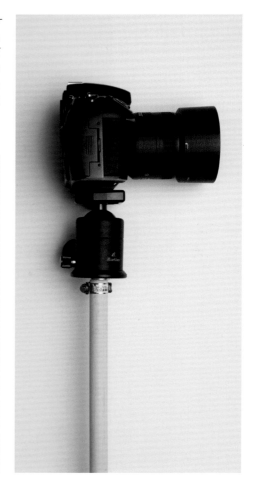

Construction Steps

1. Cut the threaded end off of the wood dowel with a saw, as shown in **Figures 29.2** and **29.3**.
2. File down the edges of the dowel to remove any wooden slivers.
3. Mark the center of the dowel with a straight edge and pencil (**Figure 29.4**).
4. Drill a pilot hole with a 1/8″ drill bit.
5. Using a 3/8″ drill bit, drill the hole to the depth of the hanger bolt so the machine threads will be exposed above the top surface of the dowel (**Figures 29.5**, **29.6**, and **29.7**).
6. Install a hose clamp so the wood won't split when you insert the hanger bolt (**Figure 29.8**).

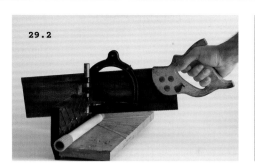

29.2

29.3

29.4

29.5

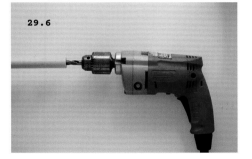

29.6

29.7

29.8

7 Use a set of pliers to install the hanger bolt. Be careful not to use the pliers on the top end of the hanger bolt or you might smash the machine threads (**Figure 29.9**).

8 Install the 3/8″ washer over the end of the hanger bolt (**Figure 29.10**). Consider gluing the washer to the dowel with epoxy to keep in in place for future use.

9 Thread the ball head onto the end of the dowel, as shown in **Figure 29.11**. Tighten it snugly so the base won't rotate when you use the system out in the field.

10 Screw the dowel extension onto the end of the telescoping paintbrush pole.

11 Extend the pole to full length, attach the camera, and raise the system into air for taking the photo (**Figure 29.12**).

12 Take the picture (**Figure 29.13**)!

Tips & Cautions

- When using this system in the field, I recommend attaching the camera to the ball head first, then extending the monopod to the desired height.
- Set the camera to manual exposure and manual focus before lifting it into position.
- Trigger the camera using the self-timer and then program the menu for multiple shots with a one- or two-second delay in between images. This allows you to move the camera around to get different compositions without having to bring the camera back to the ground to re-trigger the shutter.
- Another way to trigger is using a wireless remote. You can tape the remote transmitter on the handle, then push the button with your thumb whenever you need to take a shot.

- You can also trigger your raised camera to use a WiFi-based control system like the Camranger. This gives you a live view of what the camera is seeing and allows you to trigger whenever you want. You can connect the Camranger system to a tablet or to your smartphone. If using with your smartphone, you can mount the phone to the monopod and trigger the shutter with your thumb.

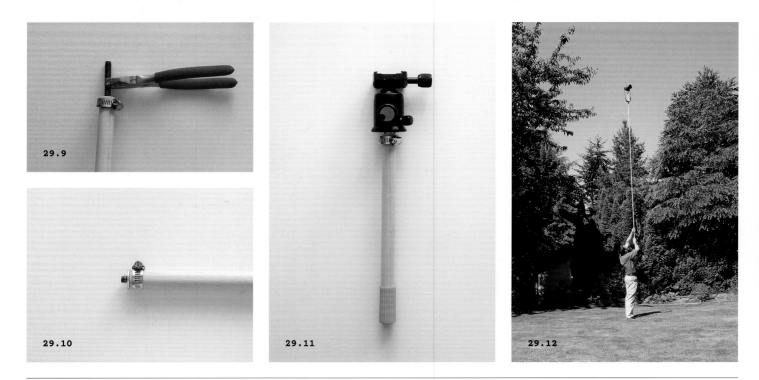

29.9

29.10

29.11

29.12

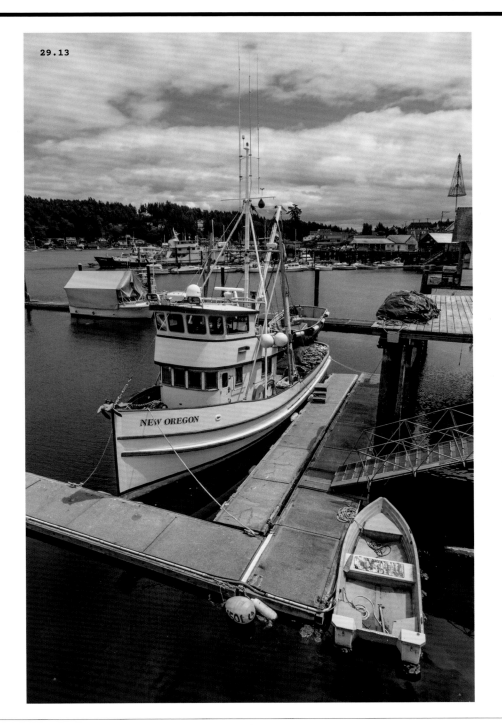

29.13

30. UTILITY CLAMP MOUNT

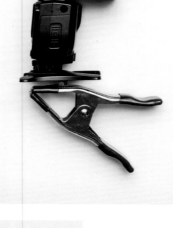

I LOVE THIS tool and use it quite often for holding cameras, flashes, mini magic arms, gels, gobos, super clamps, and everything else photographic. It's very simple to make and at about $1.50, it's very inexpensive! I suggest using a metal clamp so it will be more durable over time. I've made this type of mount using nylon clamps, and they've cracked.

Construction Steps

1 Drill a hole in the desired location on the clamp (**Figure 30.2**). I recommend one on the top towards the front, one on the top farther back, and a third along the side. Multiple holes will give you the most options for mounting mini ball heads or flashes. Some clamps come with 1/4″ holes already drilled in the handle.

2 Insert a 1/4″-20 bolt into the back side of the handles so the threaded portion extends out.

3 Put a lock washer on the top side of the bolt, then screw down the nut to tighten everything (**Figure 30.3**).

4 Mount a ball head (**Figure 30.4**) or a flash to the clamp, then place the clamp where you need it on the set.

Parts List (Figure 30.1)
- 4″ metal utility clamp
- 1/4″-20 bolt
- 1/4″-20 nut
- Electric drill
- 1/4″ drill bit
- Lock washer

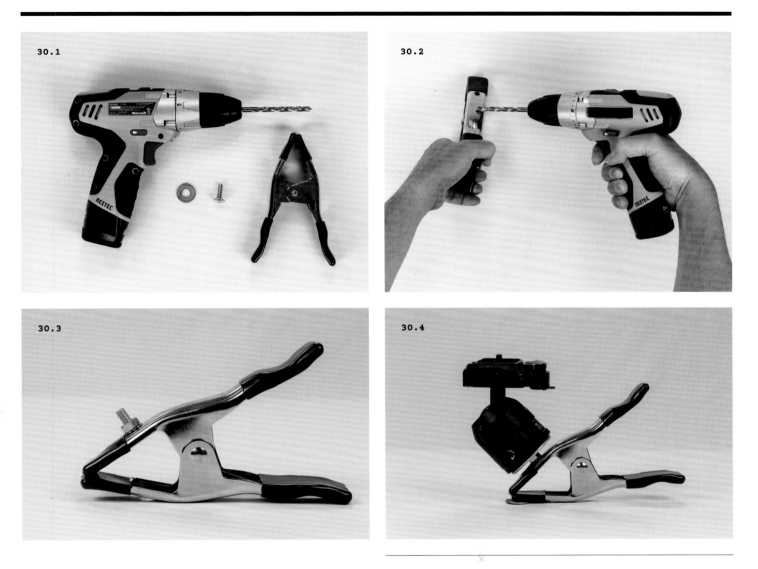

30.1

30.2

30.3

30.4

Tips & Cautions

I don't recommend mounting a heavy DSLR or mirrorless camera on this clamp since it probably won't securely hold it in position.

31. KITCHEN TIMER TIMELAPSE HEAD

TIMELAPSE SEQUENCES ARE a neat way to tell stories with your photography. The general premise for timelapse is to set your camera to take a photograph every few seconds for a long period of time. After the sequence of images is finished, you splice them together in specialized software to form a short movie clip. Common timelapse subjects include clouds moving across the sky or city traffic moving through stoplights.

An easy way to step up your timelapse game is to include camera motion into the timelapse. For this project, I'll show you how to rotate a camera with a simple kitchen timer. Like for most projects in this book, you can buy motion units specifically designed for this purpose, but this build utilizes a timer anyone can purchase from Ikea for under $10.

Parts List (Figure 31.1)

- Ikea Ordning Timer
- 1/4"-20 bolt
- 1/4"-20 nut
- Electric drill
- 1/4" drill bit
- 1/2" drill bit
- 3/8" drill bit
- 3/8" to 1/4" grommet

Construction Steps

1. Remove the bottom rubber ring with a small flat screwdriver or your thumbnail. The goal is to gain access to the three screws that hold the base together.
2. Remove the three screws on the bottom of the timer (**Figure 31.2**) and separate the timer mechanism from the metal casing. Take off the lower metal portion of timer.
3. Drill a 3/8″ diameter hole in base of the timer, as shown in **Figure 31.3**.
4. Screw a 3/8″ to 1/4″ grommet into place on the bottom of the metal casing. Alternatively, you can place a 3/8″ or 1/4″ nut inside the casing and then close it (**Figure 31.4**) by re-inserting the mini screws.

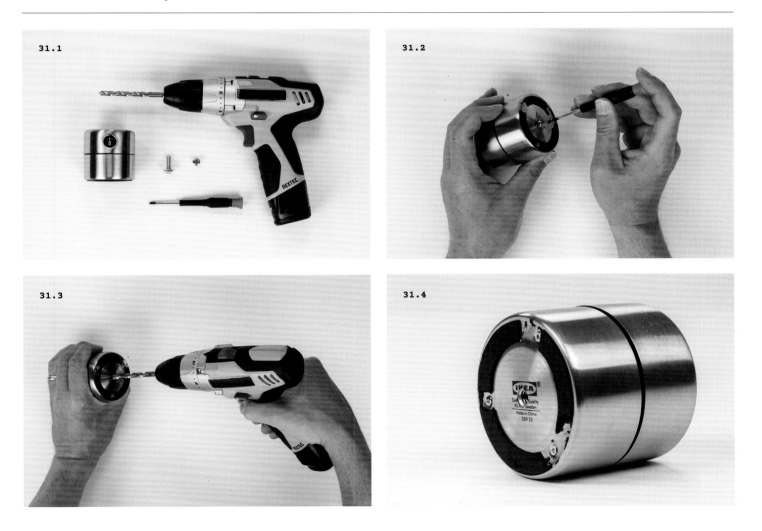

31.1

31.2

31.3

31.4

5 Remove the timer cap by simply pulling it off the base.

6 Drill a hole in the cap, but note that it shouldn't be centered (**Figure 31.5**). The cap has a slot in the middle that rotates the timer mechanism, as shown in **Figures 31.6** and **31.7**. You don't want to break or interfere with that slot. It's okay if the camera rotates slightly off center for your timelapse sequences; you won't even notice in the final sequence.

7 Insert a 1/4″-20 bolt through underside of the cap (**Figure 31.8**). Lock it into place with a 1/4″-20 nut.

8 Reinstall the cap onto the timer base.

9 Mount the camera directly to the bolt (**Figure 31.9**), or use a mini ball head for more flexibility.

Tips & Cautions

- Be careful when you take off the top of the timer so you don't dump out the timer mechanism!
- This isn't a very strong setup, so you'll struggle with using a large DSLR. I suggest using it with a smaller mirrorless camera, a point-and-shoot, a cell phone, or an action camera.
- Another option for connecting a camera to the top of the timer is to attach a quick-release clamp like the one used in project 27.
- To really up your game, use two timers: one for horizontal panning and one for vertical panning. Attach them using an angle bracket from the hardware store.

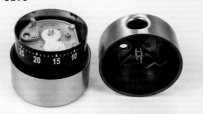

31.5

31.6

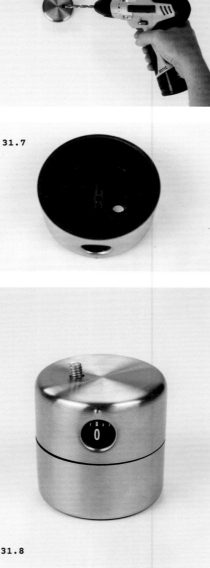

31.7

31.8

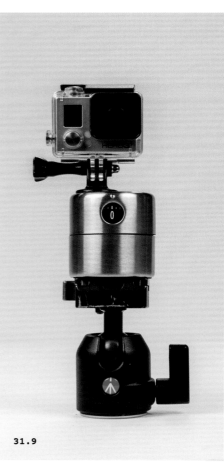

31.9

32. FRYING PAN GROUND POD

NATURE PHOTOGRAPHERS WHO shoot birds, wildlife, and macro subjects know that the best shots are taken from ground level. Often times this means putting your tripod with splayed legs into environments with mud and sand. A better solution is to use a "skid" or a low pod that allows you to get the camera system as low to the ground as possible.

This project uses a frying pan and a ball head to work as a ground pod. You can buy these types of products commercially, but my solution is much less expensive and works just as well.

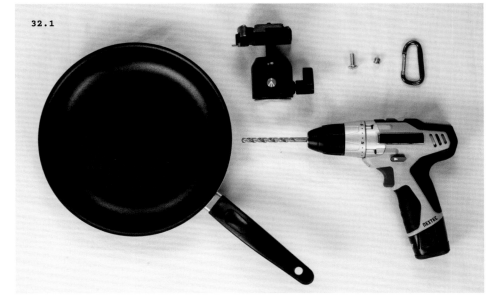

32.1

Parts List (Figure 32.1)

- 10" to 15" frying pan
- Ball head or other tripod head.
- Electric drill or drill press
- 1/4"-20 drill bit, depending on ball head mounting screw
- 1/4"-20 bolt with a rounded head
- 3/8" to 1/4" grommet
- Mini carabiner

Construction Steps

1 Drill a hole in the center of the frying pan (**Figure 32.2**).
2 Insert a bolt through the hole in the bottom of the pan, facing upward. You might consider using silicone sealant around the bolt to prevent moisture from seeping in from the bottom of the pan when it's in use.
3 Screw on the ball head. Use the 3/8″ to 1/4″ grommet if your tripod head requires a 3/8″ mounting screw (**Figures 32.3**, **32.4**, and **32.5**).
4 Attach a mini carabiner to the handle (**Figure 32.6**). If the handle doesn't have a hole, then create one with the electric drill and a 1/4″ drill bit.
5 Place the camera on the ball head, and take the picture (**Figure 32.7**).

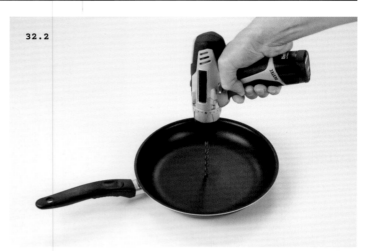

32.2

Tips & Cautions

- I like to remove the handle from the pan just to make it easier to pack. However, some people like to keep the handle as a way to move the pan around on the ground. Since it is so easy to remove the handle, you might as well leave it on until after you've used the system a few times to figure out what will be useful to you.
- Consider drilling another hole in the side of the frying pan so you can insert a mini carabiner and attach it to the outside of your pack.

32.3

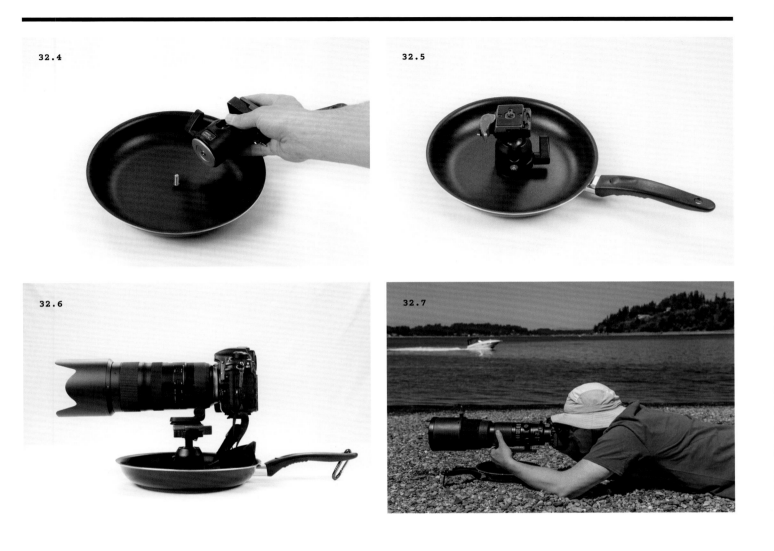

32.4

32.5

32.6

32.7

33. TRIPOD RAIN UMBRELLA MOUNT

THERE ARE A number of ways to affix an umbrella to a tripod. In the golfing industry, there are commercial products designed to attach to your golf bag pushcart. These basically clamp to the cart handle and hold your umbrella. These are actually a decent solution for photography, and they cost anywhere from $5 to $25. Instead of clamping your umbrella to your golf cart, simply clamp it to a leg of your tripod.

Another solution is to use a photographic articulating magic arm with clamps on both ends. If you buy the compact 11″ models (like the ones used in project 15), you'll find that they are barely strong enough to hold up the weight of a big umbrella. I encourage you to use smaller umbrellas with the 11″ magic arms. These cost about $20 to $50. A full-size articulating arm will run $125 to $200, but will easily hold the weight.

This project is a third method for attaching an umbrella to a tripod: by creating a bracket that attaches underneath the ball-head and on top of the tripod base.

Construction Steps

1 Unscrew the ball head from your tripod.
2 Place one of the holes from the metal bracket over the tripod center screw, then reattach the ball head over the top of the tripod as shown in **Figure 33.2**.
3 Using two magic arm clamps, attach the shaft of the umbrella to the metal bracket.

Tips & Cautions

- Consider filing down the corners of the metal bracket so they won't scratch your skin or damage any of your camera bags.
- You can mount the bracket pointed upwards or downwards to work with longer or shorter umbrellas.

Parts List (Figure 33.1)

- Metal bracket (Simpson Strong-Tie A66)
- Magic arm clamps (2)

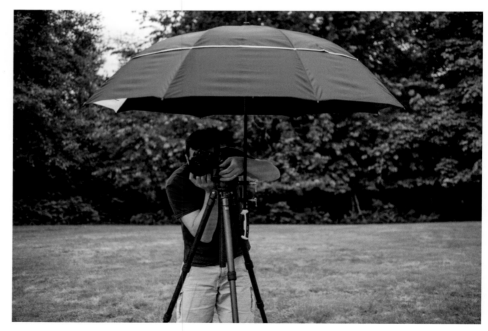

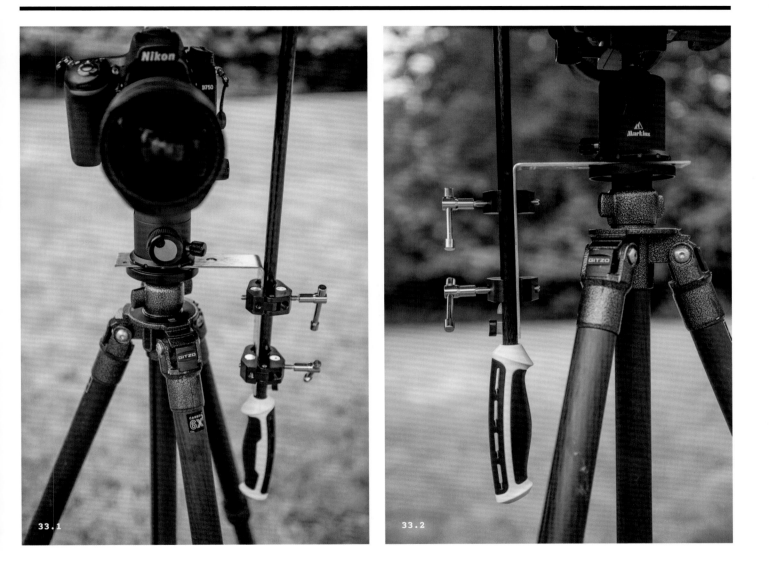

33.1

33.2

34. DENIM JEANS BEANBAG

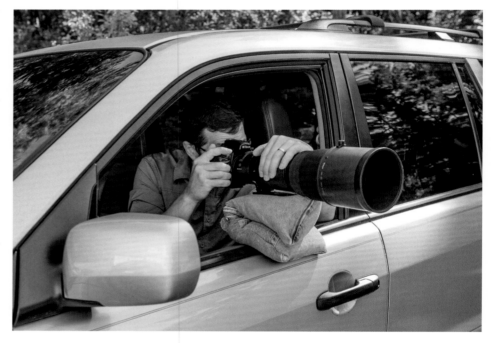

I RECOMMEND USING denim for this project because it is very durable. You can also use any other material you have laying around the house, but remember that if you are taking the beanbag on a trip, you'll want it to stand up to the rigors of your destination.

For this project, you'll need to cut up a pair of denim jeans. You can use your own or you can purchase a used pair from the local thrift store.

Construction Steps

1 Use a felt tip pen to mark the location on the legs and waist where you'll cut for the beanbag. **Figure 34.2** shows the approximate locations for the marks. You'll want mark just below the pockets.

2 Cut off the legs and waist of the jeans with a pair of scissors, as shown in **Figures 34.3** and **34.4**.

3 Turn the jeans inside out, then sew the legs and waist closed with a sewing machine (**Figure 34.5**).

4 Turn the jeans right side out by pulling the fabric through the zipper (**Figure 34.6**).

Parts List (Figure 34.1)

- Uncooked beans, corn kernels, or rice. If you want the product to weigh less, use something like buckwheat hulls or foam beans.
- 1 pair of jeans
- Scissors
- Sewing machine and thread
- Felt tip pen

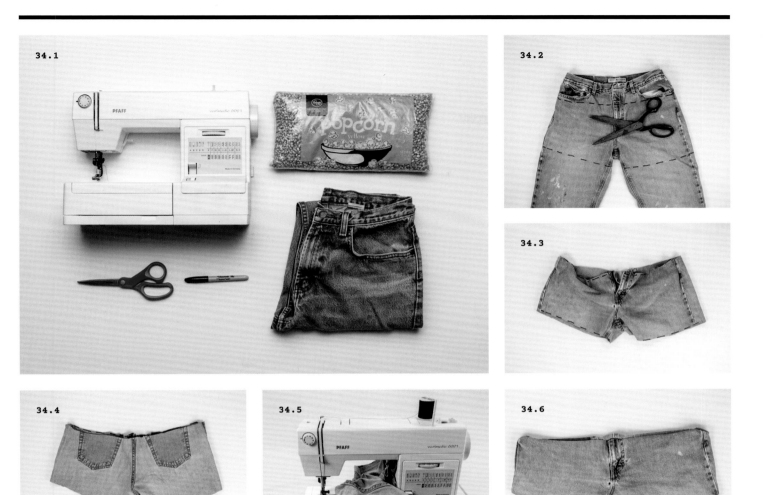

34.1

34.2

34.3

34.4

34.5

34.6

5 Fill the bag through the zipper with beans, rice, or popcorn, as shown in **Figure 34.7**. You can always add stuffing to make the bag firmer, or remove stuffing to make the bag more floppy.

6 Zip the bag closed, and use it to stabilize your camera when you take pictures. When using the bag (**Figure 34.8**), you can fold it over on itself or you can hang it straddling the doorframe.

34.7

Tips & Cautions

- Jeans with a high waist work better for this project because they have longer zippers. Some women's low-cut jeans have very short zippers and will be difficult to turn into this style of beanbag.
- Denim is a very thick material and can be quite difficult to sew using a traditional sewing machine, especially when sewing through seams and zippers. Take your time, use a thick needle, and be very patient.
- Make sure the zipper is unzipped when you cut off the waist; otherwise you risk cutting off the zipper head, making it difficult to zip the beanbag up after it's been filled.

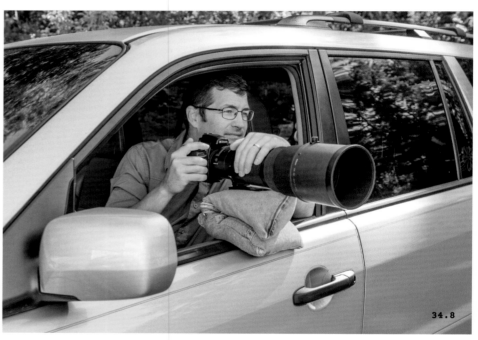
34.8

4

LENS PROJECTS

CHAPTER 4

You don't need to spend a lot of money to create special effects with your lenses. With a little ingenuity and sweat equity, you can produce some very compelling images using simple DIY lens and filter modifications. In this chapter I'll show you how to create star filters, split images, ethereal looks, and pinhole photography using very inexpensive supplies. Don't be afraid to be creative! Try shooting with other everyday objects for interesting effects: Use sunglasses as a filter to induce flare and alter the colors in your scene for an avant-garde or even grungy fashion look; or create double images in a single frame by using a mirror to reflect the subject into the photograph or to reflect something in the background into the photograph.

35. SOFT FILTER

35.2

THIS IS A fun and easy way to create soft portraits and ethereal macro shots. Photographers have been using variations of this style of filter for years, so it is a time-proven technique that will give your photography a different look. This is a simple project that requires some petroleum jelly and any old, clear filter.

Construction Steps

1 Smear a light coating of petroleum jelly around the edges of filter. Leave the middle of the filter clean if you want the center area of your image to be sharp (**Figure 35.2**). Smear petroleum jelly over the entire filter if you want the entire image to be soft (**Figure 35.3**). Heavier application of jelly will result in a softer look, while a lighter application will result in a sharper look.

2 Mount the filter to the lens and take photographs (**Figures 35.4** and **35.5**).

3 Use rubbing alcohol to remove excess petroleum jelly on the surface of the filter. Vary the shape and patterns of your smear to create swirls or radials (**Figure 35.6**).

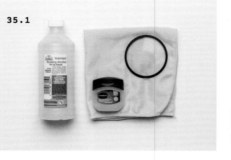

35.1

35.3

Parts List (Figure 35.1)

- UV, haze, or clear filter
- Petroleum jelly
- Rubbing alcohol
- Tight mesh rag

35.4

Tips & Cautions

- Don't smear petroleum jelly on the front element of your lens. If you do get any residue or oil on the front element, make sure to use a professional lens cleaning solvent.
- Depending on the size of the open petroleum jelly aperture on the front filter, you might not be able to use auto-focus. Either switch to manual focus or pre-focus before screwing on the filter.
- Using a similar technique, you can create patterns on a UV filter that create a star effect under the right circumstances. The key to creating the star pattern is smear-ing the petroleum jelly in just the right way, and then using a background with small points of light. Smear petroleum jelly in cross-patterned lines from edge to edge across the UV filter (**Figure 35.7**). Leave the middle of the filter uncoated so the subject is in clear focus.

35.5

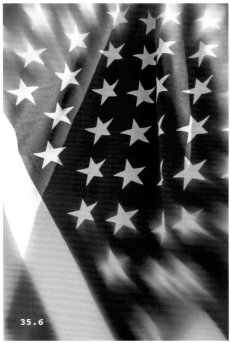

35.6

35.7

Share your best shot using a DIY soft filter!

Once you've captured a great shot using a DIY soft filter, share it with the Enthusiast's Guide community! Follow *@EnthusiastsGuides* and post your image to Instagram with the hashtag *#DIYSoftFilter*. Don't forget that you can also search that same hashtag to view all the posts and be inspired by what others are shooting.

36. SPLIT IMAGE DOUBLE EXPOSURE FILTER

THIS IS AN easy method for creating double exposures in your camera in a way that prevents each half of the image from being washed out. Effectively, this method masks half of the frame during each of the exposures to allow the subject to be fully exposed over a "black" exposure.

I like this approach more than the traditional double exposure, because I'm able to produce images with more contrast. You can use this technique to photograph people in the studio or scenes outdoors.

Construction Steps

1 Cut a piece of black tape as long as the diameter of your filter.
2 Apply the tape exactly along the diameter of the filter, leaving one half covered and the other half open (**Figure 36.2**). Trim the edges of the tape so it fits nicely around the circumference of the filter.
3 Set up your camera for multiple exposures from the menu system. Set it to take two frames in the multiple exposure sequence.
4 Mount the filter to the lens and rotate the filter so one side of the frame is obscured (**Figure 36.3**).
5 Compose the scene through the viewfinder so something interesting is in the exposed side of the frame, and take first photo.
6 Rotate the filter so the opposite side of the frame is obscured.
7 Recompose the scene so something interesting is in the second half of the frame and take a second photo. The double exposure is now complete and the resulting image should have two exposures on one image, like those shown in **Figures 36.4**, **36.5**, and **36.6**.

Parts List (Figure 36.1)

- UV, haze, or clear filter
- Black gaffer tape or electrical tape
- Scissors

36.1

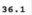

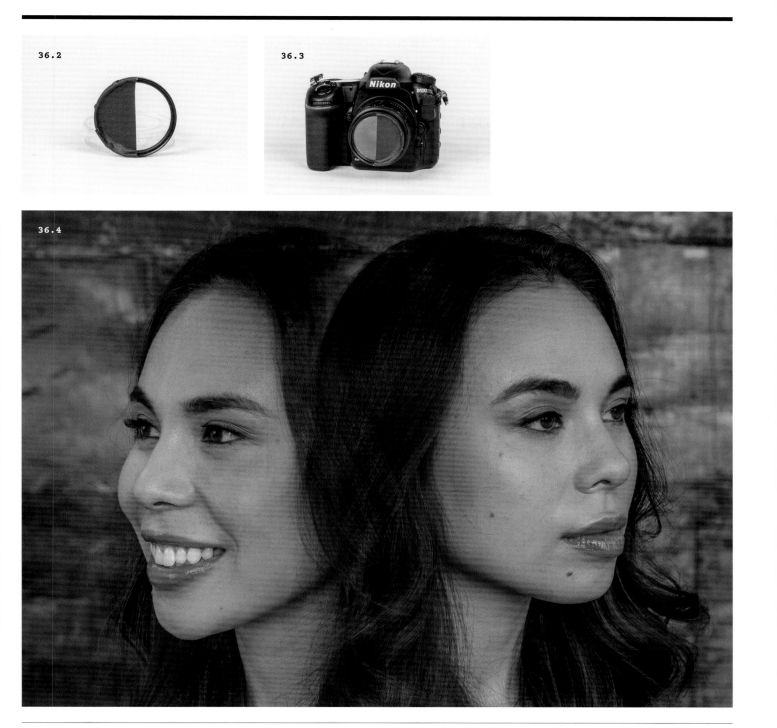

36.2

36.3

36.4

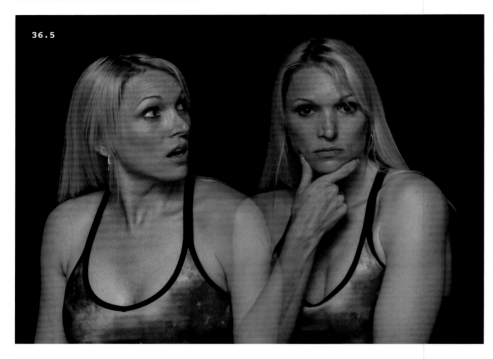

36.5

Tips & Cautions

- You'll need to move your autofocus sensor to the unblocked side of the frame for each exposure. Basically, rotate the filter so the left of the frame is obscured, then move the AF sensor to the right side of the frame. Repeat this process for the second exposure.
- The double-exposure effect can be top/bottom, left/right, or even diagonal. Experiment with the placement of the tape to see what interesting compositions you come up with.
- You might need to move the centerline of the tape left or right in order to fully obscure the frame to get full masking in between frames. If the tape is not far enough over the centerline, you won't get the correct effect.
- A smaller aperture (f/8, f/11, f/16) results in better definition in the mask between the frames, while a larger aperture (f/1.4, f/2.8) results in a softer blur between images.

36.6

Share your best shot using a DIY split image double exposure filter!

Once you've captured a great shot using a DIY split image double exposure filter, share it with the Enthusiast's Guide community! Follow *@EnthusiastsGuides* and post your image to Instagram with the hashtag *#DIYSplitImage*. Don't forget that you can also search that same hashtag to view all the posts and be inspired by what others are shooting.

37. SANDWICH BAG AND WATER BOTTLE ETHEREAL FILTERS

PLASTIC SANDWICH BAGS are very useful in photography. I've used them as impromptu rain covers, mud shields, and even as storage for memory cards in a pinch. Plastic water bottles can also be used for a variety of purposes in your camera kit. This project shows you how to use bags and plastic bottles to produce interesting ethereal filter effects for your portraiture and outdoor photography.

Parts List (Figure 37.1)

- Plastic sandwich bag or water bottle
- Scissors or knife
- Felt tip pens

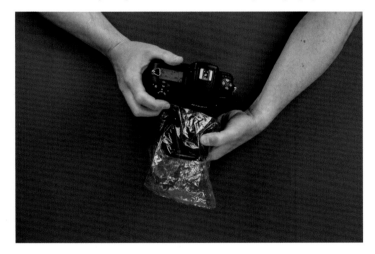

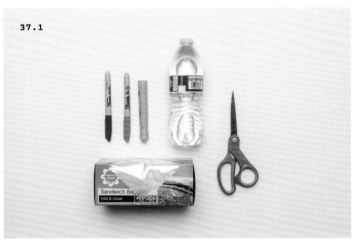

37.1

Plastic Baggie Construction Steps

1 Cut or rip a hole in the bottom of the plastic bag (big enough to fit your lens through).

2 Place the bag over the lens (**Figure 37.2**).

3 Move the bag around until you see a pleasing, blurry, ethereal look to the image, then take a photo (**Figure 37.3**).

4 For more creative effects, color the baggie with felt tip pens. Use red, green, blue, or other hues for the effect you're after.

37.2

37.3

Plastic Water Bottle Construction Steps

1 Cut off the top section and the neck of a plastic water bottle, as shown in **Figure 37.4**.
2 Place the bottle over the front of the lens.
3 Take a picture (**Figure 37.5**).

Tips & Cautions

This technique works great in the studio to create some wonderful lighting effects. Use with continuous lighting (as opposed to strobes) so you can see what the effect of the filter will be in real time.

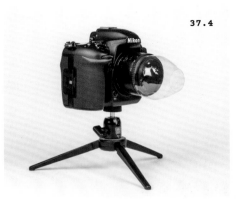

37.4

Share your best shot using a DIY ethereal filter!

Once you've captured a great shot using a DIY ethereal filter, share it with the Enthusiast's Guide community! Follow *@EnthusiastsGuides* and post your image to Instagram with the hashtag *#DIYEtherealFilter*. Don't forget that you can also search that same hashtag to view all the posts and be inspired by what others are shooting.

37.5

38. BOKEH SHAPES

THIS TECHNIQUE USES shape cutouts in front of your lens to produce beautiful bokeh shapes in the background. This approach works great for producing hearts, lighting bolts, diamonds, moons, stars, and just about anything else you can imagine.

Bokeh is defined as the quality of the shape of the out of focus areas in your image. A "nicer" bokeh is represented as smoother and blurrier out of focus areas in your photo. This technique takes advantage of your lens's bokeh and replaces points of light in the scene with the shape you've cut into the black paper.

This technique works best with lenses that have very large apertures. The least expensive choices here are the 50mm f/1.8 lenses from most camera manufacturers. Better still would be f/1.4 or f/1.2 lenses, because these will produce more pleasing and larger bokeh shapes. This technique will work with other lens apertures like f/5.6, but the key to getting the shapes to appear is to set up your shot so the background is far enough behind the subject to appear blurry.

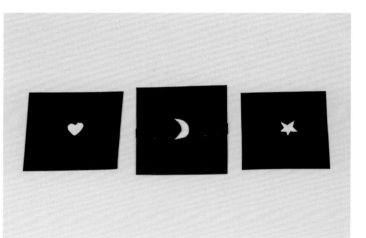

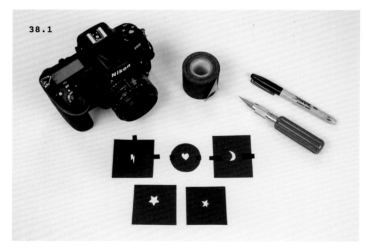

38.1

Parts List (Figure 38.1)
- Black art or construction paper
- Scissors
- Razor blade
- Felt tip pen or pencil
- Tape

Construction Steps

1 Cut out a square from your black paper to the same diameter as the front of the lens (**Figure 38.2**).

2 Draw the shape you desire in the middle of the square paper. Make the largest dimension of the shape approximately 6–8mm.

3 Tape the square onto the front of the lens, being careful to keep the shape in the center of the lens, as shown in **Figures 38.2** and **38.3**.

4 Set your lens's aperture wide open (i.e., f/1.4 or f/2.8).

5 Position your subject in front of a background with points of lights. Good options for this are Christmas lights, city lights, or a busy street with automobile headlights and taillights (**Figures 38.4**, **38.5**, and **38.6**).

Tips & Cautions

These bokeh shapes significantly cut down the amount of available light transmitted through the lens, so focusing with your autofocus system can be near impossible. My suggestion is to focus manually, or focus before positioning the shape over the lens.

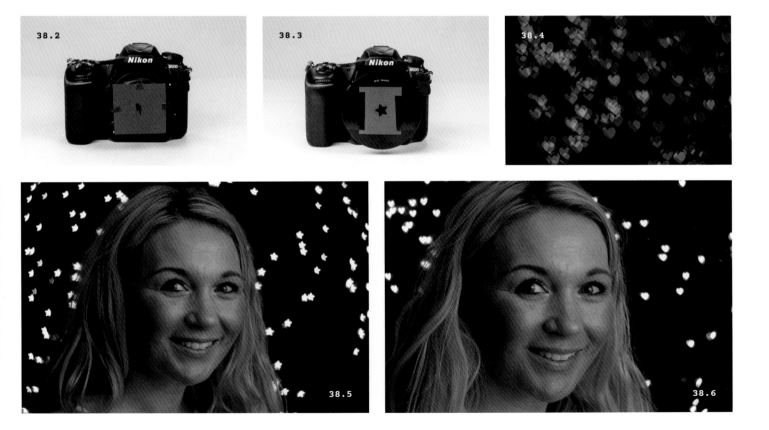

38.2

38.3

38.4

38.5

38.6

39. BODY CAP PINHOLE LENS

THIS PROJECT CREATES a classic pinhole lens for any interchangeable-lens camera you own. Pinhole cameras have a long and proud history in the world of photography. They were among the first optical systems scientists used to explore the heavens. Aristotle wrote about pinhole images in the 4th century, and astronomer Gemma Frisus used the pinhole in his darkened room to study the solar eclipse of 1544. It wasn't until the 1800s that pinhole camera obscuras were able to capture an image on photo-sensitive paper.

This project will show you how to use this centuries-old technique with your digital camera using very simple materials such as soda cans, tape, and a pin. Your pinhole images won't be sharp and focused, but that isn't the intent of this project. The purpose of pinhole photography these days is to challenge your creativity and open your mind to techniques you haven't used in the past.

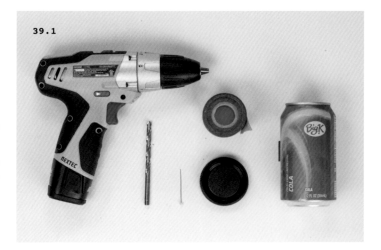

39.1

Parts List (Figure 39.1)

- Body cap
- Electric drill
- 1/2" drill bit
- Aluminum can
- Scissors or tin snips
- Pin
- Black gaffer tape or electrical tape
- Felt tip pen

Construction Steps

1 Empty an aluminum beverage (pop or beer) can.

2 Cut away the top and bottom of the can so you have a flat sheet of aluminum to work with (**Figures 39.2** and **39.3**).

3 Using scissors or tin snips, cut a 1″x1″ (square) section out of the aluminum.

4 Use a pin to create a very small (tiny) hole in the center of the aluminum square (**Figure 39.4**). Don't push the pin all the way through the aluminum; just barely pierce through both sides so the hole is almost imperceptible (**Figure 39.5**).

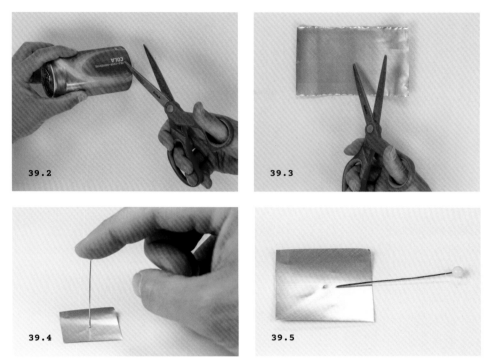

39.2

39.3

39.4

39.5

5 Remove body cap from your camera and place it on a workbench. Mark the center of the body cap with an ink pen.

6 Drill a 1/2″ diameter hole in the center of the body cap (**Figure 39.6**).

7 Place the aluminum with the pinhole over the body cap, being careful to center the pinhole on the lens cap.

8 Tape the aluminum pinhole square onto the cap using black tape along all edges, as shown in **Figure 39.7**. You won't need to do anything to the back of the body cap (**Figure 39.8**).

9 Mount the body cap to the camera (**Figure 39.9**).

10 Set the camera to manual mode to take pictures. Since the aperture is fixed, your two variables for exposure will be shutter speed and ISO. For a sunny day, I suggest starting at ISO 800 and a shutter speed of approximately 1/10 second.

39.6

Share your best DIY pinhole shot!

Once you've captured a great pinhole shot, share it with the Enthusiast's Guide community! Follow *@EnthusiastsGuides* and post your image to Instagram with the hashtag *#DIYPinhole*. Don't forget that you can also search that same hashtag to view all the posts and be inspired by what others are shooting.

39.7

39.8

39.9

Tips & Cautions

- The smaller the hole, the sharper your photos will be. I caution you against using tiny drill bits to create the pinhole—these will create holes that are far too large.
- It will be very difficult to see through the camera's viewfinder, so you will probably end up taking a photo, looking at the results in the camera LCD, then recomposing as necessary.
- The angle of view on a full-frame camera for a body cap pinhole lens is approximately the same as for a 50mm lens. On a cropped sensor camera (APS-C), the angle of view is approximately the same as a 75mm lens.
- If you are having a difficult time setting the exposure, it is probably because you haven't blocked out light from the optical viewfinder. Be sure to close the viewfinder shutter or hold your hand over the viewfinder so light entering the back of the camera doesn't influence overall exposure.
- Normally, exposures will be very long, but on newer cameras, you can use super-high ISO values like 50,000 or 100,000 to be able to handhold the camera. I've even achieved shutter speeds of 1/500 or 1/1000 second on bright sunny days, meaning you can shoot sports photography with a pinhole lens. Try it!
- Pinhole lenses can also be used in the studio. **Figure 39.10** shows an image I created using this pinhole lens along with Profoto studio strobes and a giant softbox.
- Experiment with your pinhole lens to create multi-shot images (check out *The Enthusiast's Guide to Multi-Shot Techniques* by Alan Hess). Try HDR imaging or even a panorama like the one shown in **Figure 39.11**.

39.10

39.11

5

STUDIO EQUIPMENT

CHAPTER 5

One of the misconceptions in photography is that you have to spend a lot of money in order to produce excellent images. Studio photography is no different, with much lighting and background equipment costing hundreds, if not thousands, of dollars. Commercially available backdrops, stands, and reflectors will set you back a pretty penny, but with a little bit of effort, you can create your own equipment for a fraction of the cost. Finding a great backdrop for your photograph can be as easy as hanging a king-sized bed sheet with utility clamps or gaffer tape.

This chapter is all about building your own studio equipment that will produce high-end professional results at a very low cost.

40. BACKGROUNDS: PVC BACKDROP STAND

A TRADITIONAL BACKDROP stand is constructed with two light stands and a single crossbar. This project is constructed with PVC pipe and reduces the cost from about $100 for the commercial stand to less than $25. I've designed the backdrop stand so you can disassemble it for easy transportation in a duffle bag.

Construction Steps

1 First, decide how tall you want the backdrop to be. I recommend somewhere between 7′ and 9′ tall, depending on the height of the ceiling you are working with.

2 Cut seven segments of PVC pipe (between 28″ and 36″ long) for the vertical structure. For the example here (**Figure 40.3**), I cut all the PVC sections 32″ long. When fully constructed, the total height will be about 8′ tall (32″ x 3 vertical sections =

96″). Six of the segments will be used for the right and left sides of the frame. The seventh segment will go in the middle of the frame to add stiffness.

3 Decide how wide you want the backdrop to be. I recommend 5′ to 7′ wide overall. You'll divide the total width of the stand by two in order to determine the length of each PVC horizontal segment. I used 32″ segments, which gave me a 64″ total width.

4 Cut six segments of PVC pipe for the horizontal bars, 30″ to 42″ long (**Figure 40.3**). The horizontal bars determine the

overall width of the frame. For the setup in Figure 40.3, I used 32″ lengths.

5 Cut four pieces of PVC pipe for the base feet. You can see the setup of the pieces in Figure 40.3. To keep things simple, I made these 32″ long as well.

6 Construct the backdrop, as shown in **Figure 40.3**. Starting with the base feet, attach the end caps to one end of 32″ segments, then connect the other end to a PVC T. From the feet, build upwards by connecting PVC sections and Ts.

Parts List (Figures 40.1 and 40.2)

- 3/4″ diameter PVC pipe, cut in 10′ sections (6 or 7 depending on size of stand)
- 3/4″ PVC 90 degree elbow (2)
- 3/4″ PVC Ts (8)
- 3/4″ PVC coupling
- 3/4″ PVC caps (4)
- Hacksaw or PVC cutting tool
- Tape measure
- Felt tip pen

7 If you want, make a shorter stand by eliminating one group of PVC sections like that shown in **Figure 40.4**.

8 Hang your background material on the stand using hardware store spring clamps. **Figure 40.5** shows this PVC backdrop stand setup in a garage. This image is a screen capture from a video I produced that used the backdrop stand during production.

Tips & Cautions

- These PVC backdrop stands aren't super strong, so be careful about how much weight you hang from them. They are good to support a fabric backdrop (like a pressed bed sheet) or a sheet of seamless background paper, but definitely not strong enough to support a 12'x24' muslin background.

- By making all the PVC pieces of the background the same length, you won't have to worry specifically about where each piece goes during construction and disassembly.

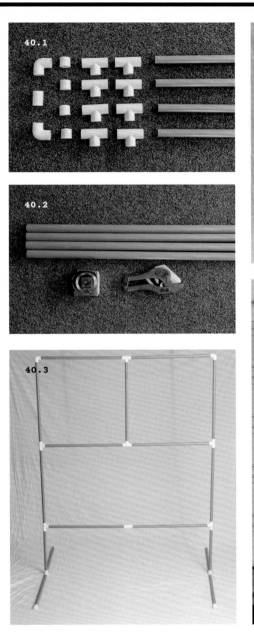

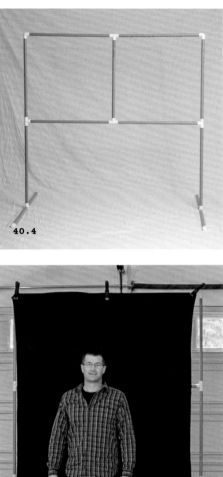

41. BACKGROUNDS: GREEN SCREEN

GREEN SCREENS ALLOW you to drop in different backgrounds after you shoot. You do this in Photoshop using layers and selecting the green areas, then replacing those areas with the image of your choice. You can use anything you want for your background image including sky, swaths of color, forest scenes, and so on.

Traditionally, the color green is used because it is very different from colors found on most human subjects. The difference in color makes it easier to select in Photoshop. You can actually use any color backdrop as long as there's nothing else on your main subject that is the same color as the background. Some photographers use blue screens, some green screens, and others choose screens that are different shades than the colors their subject is using.

Alternatively, if you are skilled at using Photoshop's selection tools, you don't have to worry about the color of the background as you'll be able to select the background and then replace it with your preferred background.

Construction Steps

1 Hang the backdrop on a background stand or affix it to a wall with gaffer tape. You can use the PVC background stand in project 40.
2 Use utility spring clamps to pull the green screen tight to reduce wrinkles (**Figure 41.2**). If you are hanging the backdrop on a wall, use lots of tape to pull the green screen tight.
3 Aim four utility lights or LED shop lights at the background (**Figure 41.3**). The goal is to have even lighting from corner to corner.
4 Place the subject six feet or farther from the background.
5 Set up studio lights for the subject. Your goal is to balance the brightness of the subject with the brightness of the background. It doesn't matter if they are off by a couple of stops, but the more uniformly the backdrop and the subject are lit, the easier it will be to select the background in Photoshop.

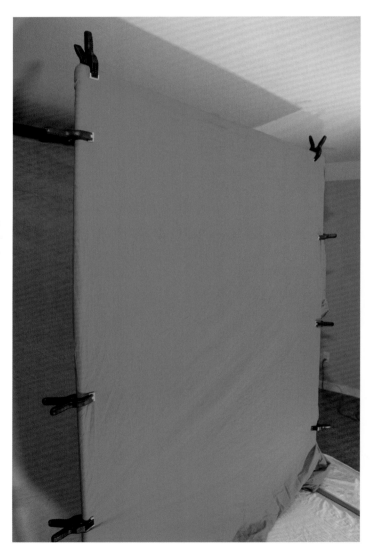

6 Take pictures.

7 After creating your images, use Photoshop to replace the green background. The general approach is to use a selection method like the Magic Wand tool or Color Selection tool. After selecting the green color, replace it with a different background such as clouds, a city scene, or anything else you decide to be interesting. There are hundreds of tutorials available on the internet that you can find be searching for "green screen photography."

Tips & Cautions

Make sure the background fabric is relatively wrinkle-free. If there are a lot of wrinkles, then there will be a lot of shadows on the backdrop, which will make it more difficult to select the background in Photoshop.

Parts List (Figure 41.1)

- Solid green or blue backdrop
- Background stand or a wall
- Utility spring clamps or gaffer tape
- Utility lights or LED shop lights (4)

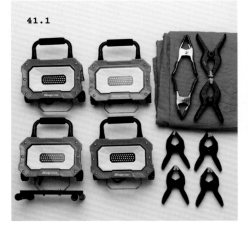

41.1

41.2

41.3

42. BACKGROUNDS: SEAMLESS PAPER

SEAMLESS PAPER IS designed to provide a wrinkle-free backdrop. It is supplied on a cardboard tube roll. There are many methods for hanging these rolls, including methods involving gears, pulleys, stands, and brackets. For a photographer just starting out, the cost of these commercial solutions can be too much. This project will help you create a very low-cost hanging method. May of the portraits in this book were photographed against the seamless paper backdrop from this project.

There are a variety of widths for seamless paper. The most common are 53″ wide, 84″ wide, and 107″ wide. For this project, I recommend using the 53″-wide paper, due to weight. The larger 84″–107″-wide rolls are too heavy to hang from a DIY PVC light stand.

Construction Steps

1 Cut the PVC pipe to approximately 6″ longer than the width of your seamless paper roll. If you are hanging a 53″-wide roll, you'll want your PVC pipe to be about 59″ long. This will leave 3″ on either end of the roll once it is mounted (**Figure 42.2**).

2 Cut a length of cord about two-feet longer than the length of the PVC pipe.

3 Melt of the ends of the cord with the lighter or candle to prevent fraying.

4 Thread the cord through the PVC pipe and tie loops on both ends of the cord (**Figure 42.3**).

Parts List (Figure 42.1)

- Utility spring clamps (2)
- Cord (such as 550 paracord)
- 3/4″ PVC pipe
- Background stand (project 40)
- Scissors or knife
- Lighter or candle

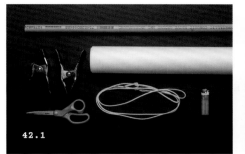

42.1

42.2

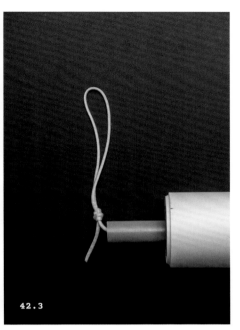

42.3

5 Place the PVC pipe and cord through the middle of the seamless roll.
6 Hang the system on a background stand using the utility spring clamps (**Figures 42.4** and **42.5**).

Tips & Cautions

- Hanging the paper using the utility spring clamps can be a little bit awkward. I recommend having someone else assist you with the process by holding one end of the paper roll while you place one of the clamps over the background stand.
- Pull the bottom of the paper tight to prevent it from rolling back up. You can do this by clamping the bottom portion to the background stand or by hanging clamps from the bottom of the paper.

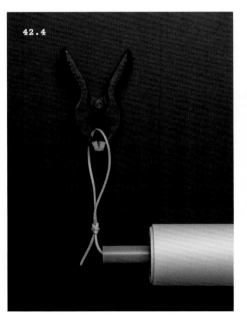

42.4

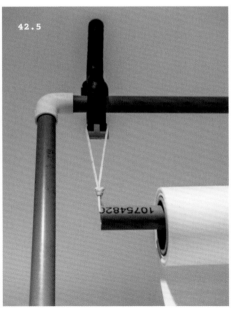

42.5

43. BACKGROUNDS: NEWSPAPER

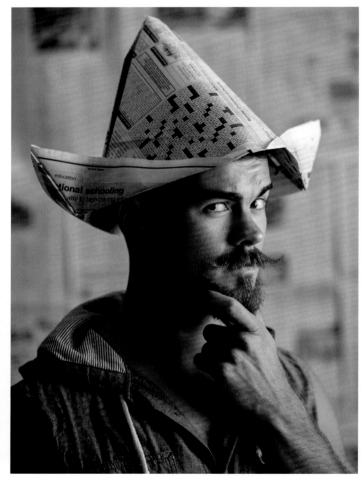

ONE OF THE least-expensive backgrounds you can create is newspaper on a wall. I love this technique and always have a fun time with it when photographing models. The technique is simple, but the results are great!

Construction Steps

1 Tape newspaper to the wall. Make the surface area much larger than you initially think you'll need. The model needs room to move around and pose (**Figure 43.2**).

2 Consider taping newspaper to the ground and extending the area 10 to 15 feet from the wall to create a full backdrop that allows the subject to stand on a floor of paper.

3 Light the studio as you normally would for any portrait session, and take photos (**Figure 43.3**)!

Parts List (Figure 43.1)

- Newspaper
- Tape

43.1

Tips & Cautions

- Make a newspaper hat for your model (**Figure 43.4**)!
- Try a variety of newspaper arrangements for this build. You can apply the newspaper in a repeating pattern, randomly put newspaper on the wall at varying angles, or only using the comics sections or the crossword sections.

- If you use one light for your subject, then the closer your subject is to the background, the brighter the newspaper will be. Conversely, if you position the subject farther away from the background, the newspaper will look darker in the resulting image. Consider using multiple lights in your studio so you can control the brightness of the backdrop with background lights.

44. BACKGROUNDS: VIDEO PROJECTOR FOR BACKGROUND IMAGES

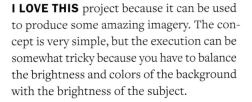

I LOVE THIS project because it can be used to produce some amazing imagery. The concept is very simple, but the execution can be somewhat tricky because you have to balance the brightness and colors of the background with the brightness of the subject.

Construction Steps

1 Hang a large white background, as shown in **Figure 44.2**. You can use a bed sheet, or a white wall, or a traditional white backdrop muslin.

2 Set up the projector on a table or on the floor. If you set it up on a table, you'll need to position the projector to the side of your model so the image beam misses their body. Be sure to adjust the left/right perspective settings on the projector so you don't get weirdly distorted background images. If you set up the projector on the floor, then be sure to position your model so they don't block any portion of the projected image.

Parts List (Figure 44.1)

- Computer
- Video projector

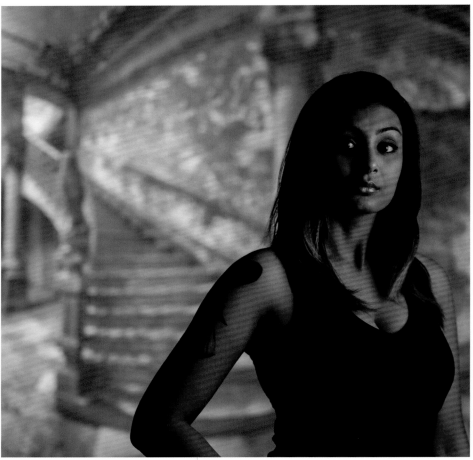

3 Connect your computer to the projector and turn on the system. Select your image for the background. I like using Adobe Lightroom to manage my background images and place them in a collection for quick access while I'm shooting on the set.

4 If you are projecting an image onto the background, then position your subject 6 to 10 feet (or more) away from the backdrop. If you are projecting a pattern or image directly onto the subject, position the subject right up against the backdrop.

5 Set up the lighting for your subject. The aim is to match the mood of the background scene (**Figure 44.3**). Balance the brightness of the background with the brightness of the subject and take the photograph (**Figure 44.4**). If you are projecting the pattern/image directly onto your model (**Figures 44.5** and **44.6**), then you won't necessarily need additional lighting equipment.

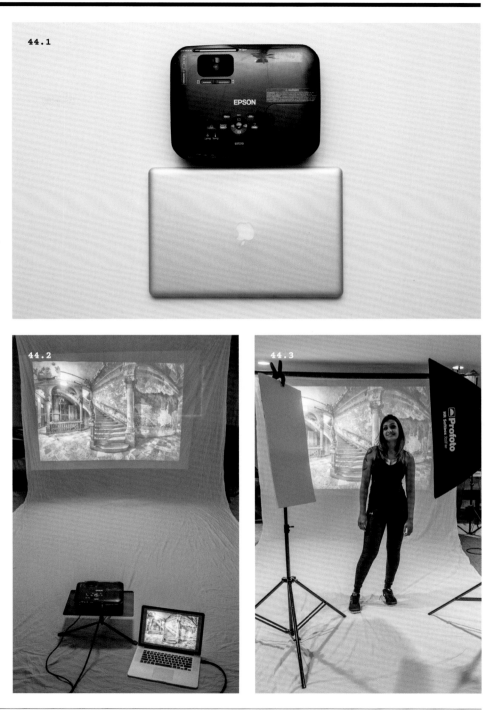

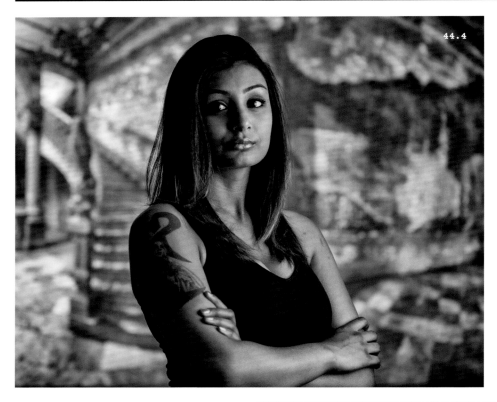

44.4

44.5

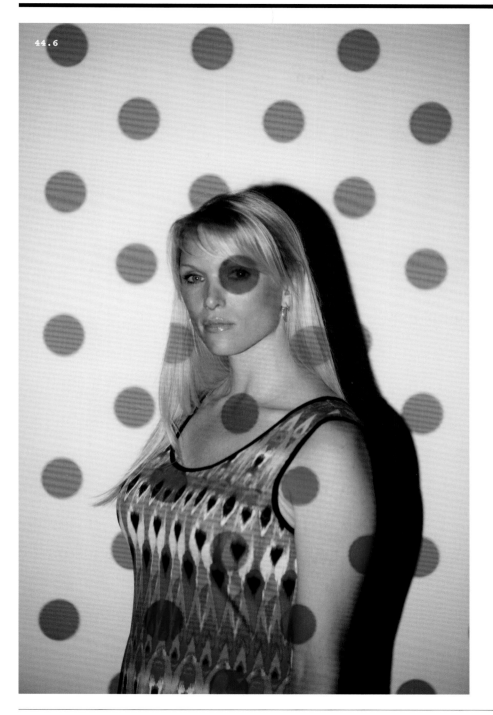

44.6

Tips & Cautions

- Consider the direction of the light in the background and how it will look when combined with the direction of the light on your subject.
- Photographs with a color subject against a black-and-white image in the background can have an old-timey feel to them.
- Slide film transparencies and a slide projector can be used to project the image onto the background rather than a video projector.

45. BACKGROUNDS: PAINTED PATTERNS ON PLYWOOD

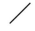

PLYWOOD IS A great building product and can be very useful for photo sets. For this project, I'll show you how to paint patterns on plywood to produce a nice background. You can use this background when shooting indoors or outdoors.

The key is figuring out the best way to stand up the plywood. I used spring clamps on a ladder and a light stand, but you could also just lean the plywood against a wall. Just make sure to secure it so it doesn't fall over on your subjects!

The upside of using plywood for the background is that it is fairly durable and relatively inexpensive. The downside is that it's heavy and can be difficult to move around.

Construction Steps

1 Select your paint colors. Decide on the pattern you want to create and paint it on the plywood (**Figure 45.2**). Be as precise or as sloppy with the application as you want.

2 After the paint dries, position the sheet of plywood in your studio. Find a way to secure it so it won't fall over. I suggest using utility spring clamps attached to a ladder or to heavy-duty light stands with bean bag weights on the legs (**Figure 45.3**).

3 Set up lights for your subject and take photos (**Figure 45.4**)!

Tips & Cautions

- The bigger the sheet of plywood, the more room you'll have to work with. If you are going to shoot larger groups, you might even consider using two sheets of plywood side by side.
- Once you've produced and used the backdrop, you can paint over it for a new backdrop. Also, you can use both sides of the plywood for two quickly accessible backgrounds for your photography.

Parts List (Figure 45.1)

- Plywood, 4'x8' or 4'x9'
- Paint
- Paint brushes and paint rollers

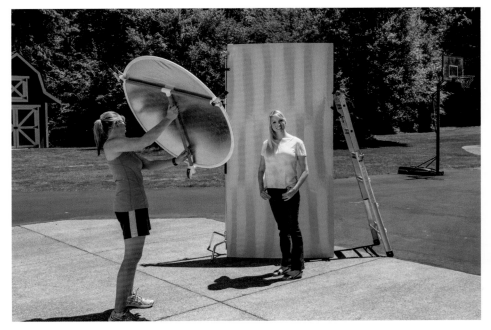

45.1

45.2

45.3

45.4

46. BACKGROUNDS: PVC WALL OF LIGHT

THIS PROJECT CREATES a frame that you can fill with light to produce a high-key look to your photography. Using PVC pipe and bed sheets, you'll form a mattress-sized frame, put fitted sheets over the frame, place lights inside the sheets. Voilà! A big, bright backdrop! You can also use this setup as a large, free-standing softbox.

A commercially available product like this costs between $450 and $750 depending on size. This DIY project will cost about $25 to $40 depending on how many of the parts you already own.

Construction Steps

1 Decide on the size of frame you want to make: twin, queen, or king.
2 Cut PVC pipe lengths based on the frame size. For a twin frame like the one in **Figure 46.2**, the outer dimensions are approximately 69″x36″x9″. Construct the frame as shown in **Figures 46.2** and **46.3**. (Note that you can also use 3/4″ PVC 3-way elbows, as shown in **Figure 46.4**, in place of the regular elbows and Ts to simplify the project.)
3 Use the two fitted sheets to cover the front and back of the frame. Insert the lights into the frame, as shown in **Figure 46.5**. Point them toward the back sheet so the light reflects off the back sheet and toward the front sheet. This helps prevent hot spots on the front sheet.

Parts List (Figure 46.1)

- 3/4″ PVC elbows (8)
- 3/4″ PVC Ts (8)
- 3/4″ PVC pipe (total length depends on the size of the frame you want)
- Hacksaw or PVC cutting tool
- Fitted sheets (twin, queen, or king size) (2)
- LED utility lights (or speedlights/flashes) (4)

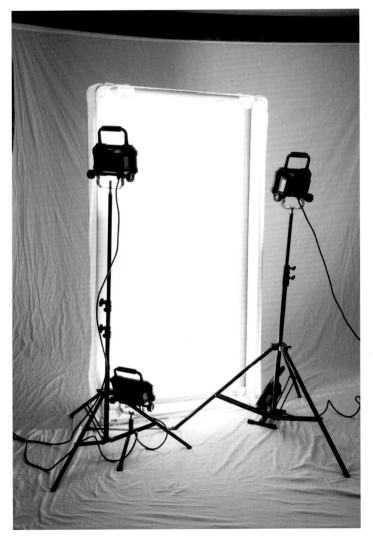

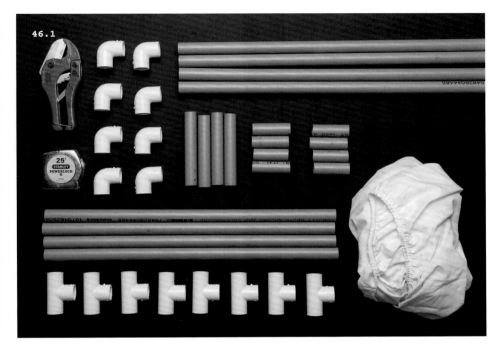

46.1

46.4

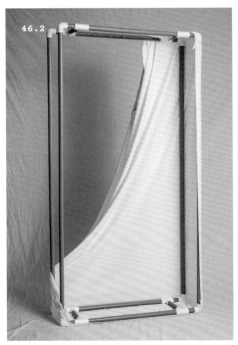

46.2

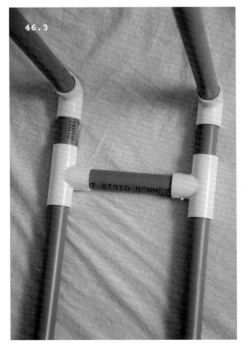

46.3

46.5

4 Position your subject in front of the wall of light. Set up studio lights for your subject, being careful to balance the brightness of the studio lights with the brightness of the wall of light.

5 Shoot the picture (**Figures 46.6** and **46.7**)!

Tips & Cautions

- I made this project in the dimensions of a twin bed frame, but I suggest making it in the dimensions of a queen- or king-sized frame. That will give you much more space for the model to move around.

- You can position this frame horizontally or vertically to suit your shooting style.
- Iron the front fitted sheet before placing it on the frame. This will help keep the surface smooth and prevent wrinkles from showing up in your photograph.

46.6 46.7

47. CARDBOARD GOBOS

THE TERM "GOBO" stands for "go-between." Gobos are used in the film industry and the photography industry to go between a light source and the wall in order to produce specific shapes. You can spend a lot of money on commercial products, or you can create your own with cardboard

For your light source, you can use utility lights or your own small flashes. For the images in this example, I used a Nikon flash with a beer-cozy snoot (project 14).

47.1

Parts List (Figure 47.1)
- Cardboard panels
- Razor blade
- Felt tip pen
- Utility clamp
- Light stand (2)
- Flash or utility light
- Snoot

Construction Steps

1 Cut the cardboard sheet to approximately 1′x2′.
2 Draw shapes on the cardboard with a felt tip pen.
3 Cut out the shape with a razor blade (**Figure 47.2**).
4 Clamp the cardboard to a light stand (**Figure 47.3**).
5 Set up flash or utility lights to shoot through the gobo and onto the backdrop. Use a snoot (project 14) and black paper flags to prevent light from spilling around the sides of the cardboard and onto the backdrop.
6 Set up studio lights for your subject and shoot the picture.

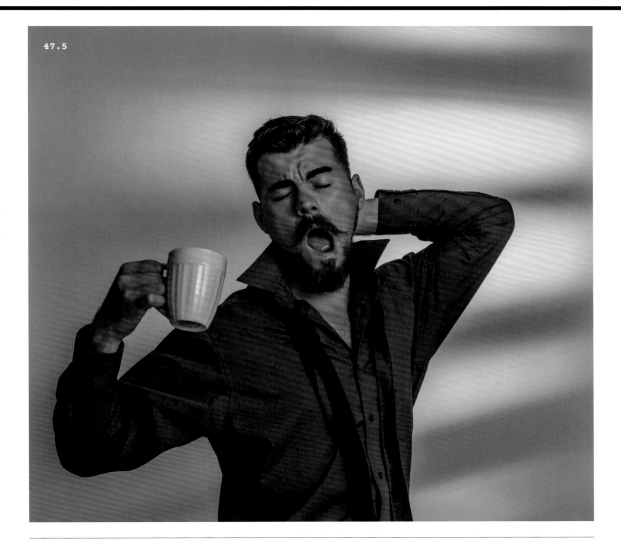

47.5

Tips & Cautions

- Use gels in your flash to change the color of the background. In **Figure 47.4**, I used an amber (CTO) gel to simulate the color of sunlight filtering through a window.

- I recommend shooting against a seamless backdrop (project 42) for the best results with a gobo. You can also shoot against fabric backdrops, but the gobo often isn't as well defined as it is against seamless paper (**Figure 47.5**).

48. CARDBOARD SOFTBOX

SOFTBOXES ARE WIDELY used as photographic lights because they produce a very soft, even light. They are flattering to the subject and they are easier to use than umbrellas for controlling the direction of light. The problem with commercial softboxes is they are often very expensive, costing anywhere from $75 for an inexpensive model to $500 for high-end models.

This project will produce a softbox for under $20—less, if you already own some of the parts. The neat part about this project is the setup is very lightweight, and it produces excellent-quality light. The downside is that the softbox is a bit fragile, so you'll want to use it in your studio. I wouldn't recommend taking on location.

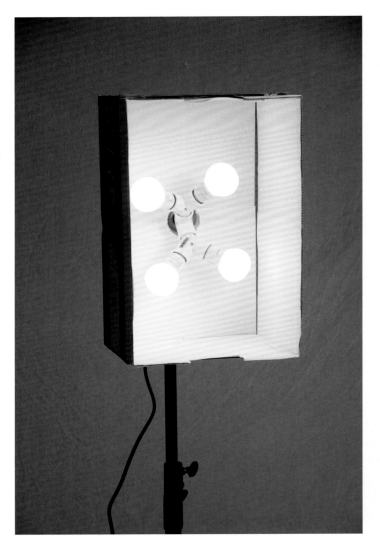

Parts List (Figure 48.1)

- Cardboard box (minimum size: 12"x12"x24")
- Tissue paper
- Copy paper
- Utility light clamp
- Twin-socket lamp adapters (2)
- Light bulbs (4)
- Tape
- Scissors

Construction Steps

1 Using tape, line the interior of the cardboard box with copy paper (**Figure 48.2**). This will provide the white reflective surface for the interior of the softbox.

2 Cut a hole in the center of the back of the cardboard box (Figure 48.2) to the same size as the light socket. Don't make it too large, or you won't be able to screw the reflector onto the socket to hold the system in place.

3 Cut off the majority of the reflector from the utility clamp using your scissors (the metal is very soft and will cut easily). You'll need the base part of the reflector to screw the light socket onto the softbox, so don't discard the base portion (**Figure 48.3**).

4 Insert the light socket through the back of the softbox (**Figure 48.4**), and screw on the reflector inside the box to hold the light fixture in place (**Figure 48.5**).

48.1

48.2

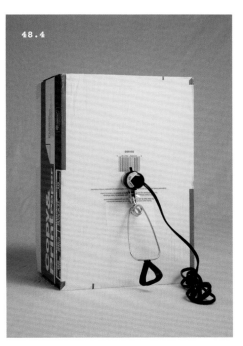

48.4

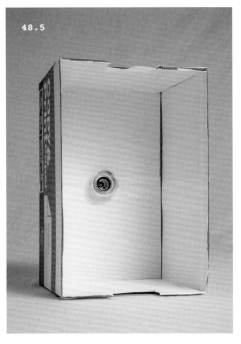

48.5

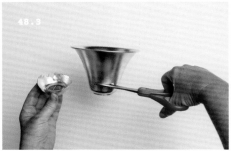

48.3

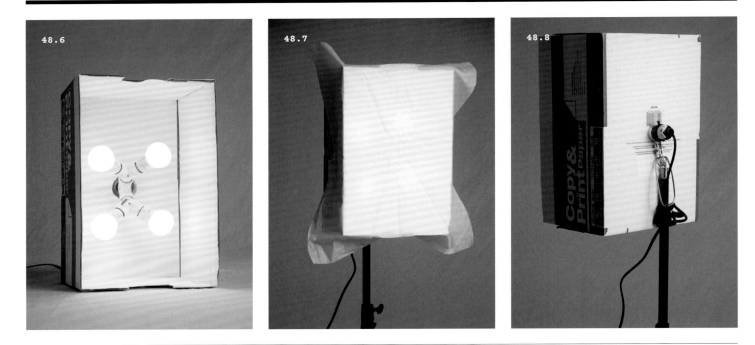

5 Put the twin-socket lamp adapters together to form a T with four light socket positions. Screw the light socket adapters onto the light socket base, as shown in **Figure 48.6**. Insert the light bulbs.

6 Cover the front of the softbox with tissue paper and affix it with tape (**Figure 48.7**).

7 Use the utility light's clamp to mount the softbox to a light stand, as shown in **Figure 48.8**.

8 Plug in the lamp and position the softbox for the photograph (**Figures 48.9–48.11**)!

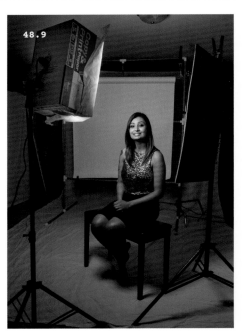

Tips & Cautions

- I strongly recommend using LED light bulbs—this will keep the temperature lower inside the softbox.
- You can also build this project out of foam core panels or out of corrugated plastic panels. These will both produce slightly more durable softboxes than cardboard.
- Different light bulbs produce different colors of light. Make sure you understand what bulb colors you purchased to ensure that they match colors with your background lights or the other lights in your setup.

49. LIGHT TENT: CORRUGATED PLASTIC

ONE OF THE best tools to use for small product photography is a light tent. They provide beautiful, soft light and are very controllable—you can put lights on the sides, top, back, and front. These little tents are perfect for photographing small items you'd sell online or for photographing jewelry.

Commercially available light tents cost anywhere from $35 to $150. This project will cost less than $10, not including the lights.

Construction Steps

1 Decide the size of light tent you want make. The example here is 18″ on a side. I've made light tents anywhere from 12″ to 36″ on a side.
2 Cut five corrugated plastic sheets in equal dimensions (i.e., an 18″ square).
3 Tape the squares together using gaffer tape to create a cube.
4 Place lights on the outside of the light tent.
5 Use black or white paper inside the light tent to form a seamless background. Use tape to affix the paper to the back side and the floor of the light tent.
6 Position an object inside the light tent and take a photo (**Figure 49.2** and **49.3**).

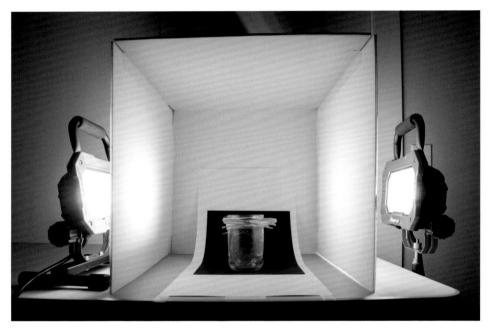

Parts List (Figure 49.1)

- Corrugated plastic sheets
- White gaffer tape
- Scissors
- Straight edge
- Measuring tape
- White and black copy paper

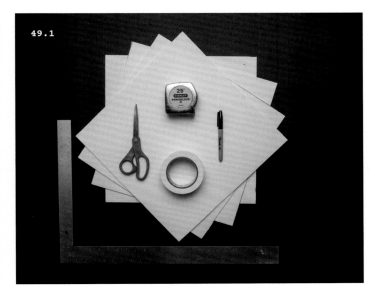

49.1

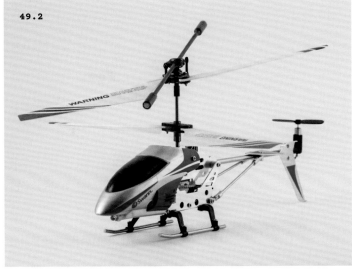

49.2

49.3

Tips & Cautions

- You can also make this project from a large white cardboard box. Basically, you'll cut "windows" out of the sides and cover those with tissue paper. If you don't have a white cardboard box, you can cover the inside of a brown cardboard box with white copy paper.
- You don't necessarily need to put a base panel on the light tent. In fact, sometimes it makes more sense not to install a base panel so you can use a longer piece of background paper that extends beyond the front of the tent.

50. PVC CLAMSHELL LIGHTING STUDIO

CLAMSHELL LIGHTING IS one of the go-to lighting styles for portrait photographers. It's dynamic, bold, and beautiful. Clamshell lighting fills in shadows above and below the subject. I love clamshell lighting and have been using this technique for years.

Most clamshell lighting setups involve two umbrellas or two softboxes; one positioned above the subject and the other positioned below the subject. This project uses a PVC frame covered with a white translucent material. The light comes from two speedlights, but you can use any light source for a similar effect.

Construction Steps

1 The first step is deciding how big you want your light panels to be. For this example, I designed my panels to be about 24"x 18".

2 Cut four segments of 3/4" PVC pipe 18" long. These will be the mounting arms for the white fabric.

3 Cut two segments of 3/4" PVC pipe 12" long. These will be the middle cross-arms.

4 Cut four segments of 3/4" PVC pipe approximately 6" long. These will end up being the vertical arms that define how much separation there is between the upper and lower diffusion panels.

5 Cut one segment of 3/4" PVC pipe approximately 3" long. This will be the short mounting arm to your light stand.

6 Drill a 1/4" hole in the PVC cap, then insert the bolt through the inside so the threaded end protrudes from the outside of the cap. Place a washer on the bolt, then thread on the 1/4" nut to hold the bolt in place (**Figure 50.2**). You'll end up screwing this to your light stand.

7 Put together the frame as shown in the chapter-opening image and in **Figure 50.3**.

8 Cut two sections of fabric to fit around the frame, and affix them with gaffer tape. Alternatively, you could sew sleeves onto the fabric panels and slide them over the ends of the frame.

9 Screw the 1/4" bolt onto your light stand (**Figure 50.4**).

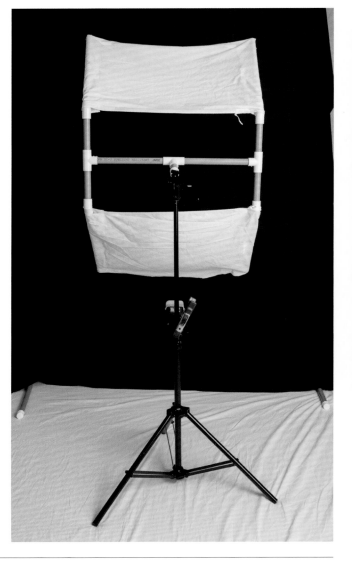

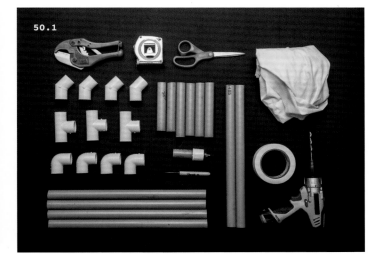

50.1

Parts List (Figure 50.1)

- 3/4" PVC pipe
- 3/4" PVC T (3)
- 3/4" PVC 45-degree elbow (4)
- 3/4" PVC cap
- 1/4"-20 bolt
- 1/4"-20 nut
- 1/4" washer
- 1/4" drill bit
- Electric drill
- Thin, white, translucent fabric (e.g., pillow case or bed sheet)
- White gaffer tape or sewing machine
- Hacksaw or PVC cutting tool

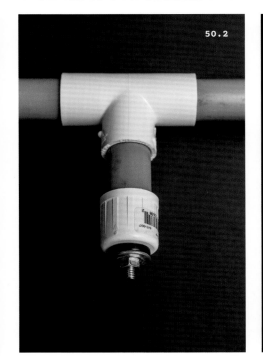

50.2

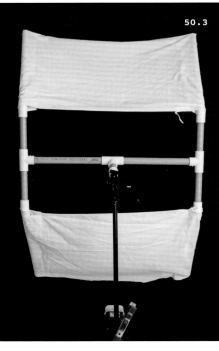

50.3

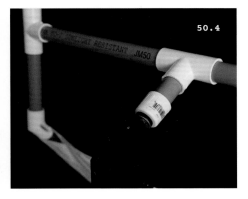

50.4

10 Position a flash underneath the bottom panel, as shown in (**Figure 50.5**). An easy way to do this is to use a utility clamp.

11 Use a light stand to position a second flash above the top diffusion panel, as shown in **Figure 50.6**.

12 Take the picture by shooting through the back of the frame as the subject looks directly into the clamshell panels (**Figure 50.7**).

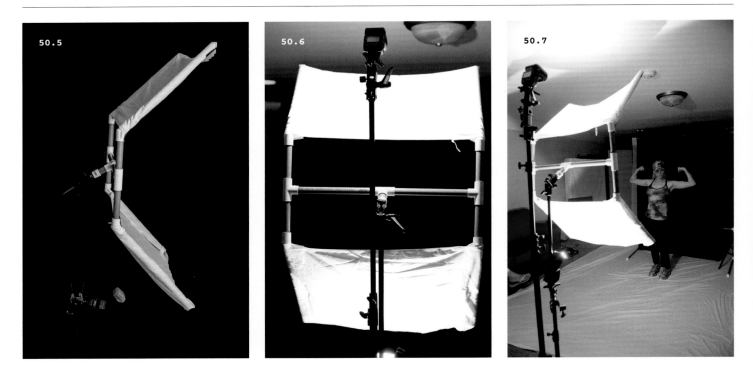

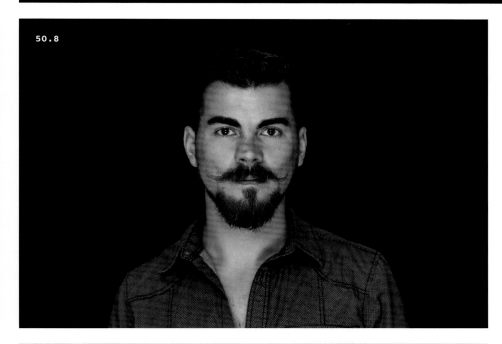

50.8

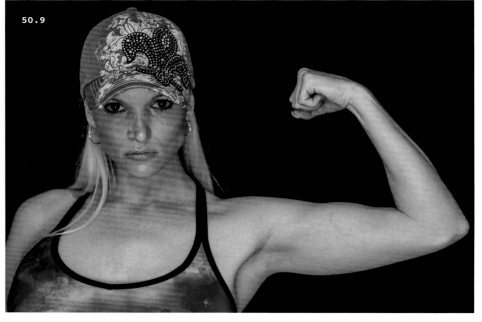

50.9

Tips & Cautions

Have your subject stand closer to the light for a softer, more evenly-lit look (**Figure 50.8**). Have your subject stand farther away from the light for a harder, more aggressive look (**Figure 50.9**).

51. FOAMCORE REFLECTOR

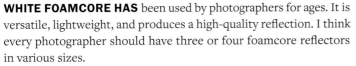

WHITE FOAMCORE HAS been used by photographers for ages. It is versatile, lightweight, and produces a high-quality reflection. I think every photographer should have three or four foamcore reflectors in various sizes.

These reflectors don't fold down as small as collapsible reflectors for travel, but foamcore reflectors are great for the studio, and they are relatively inexpensive. I used foamcore reflectors to create many of the images in this book, including **Figures 51.2** and **51.3**.

Construction Steps

1 Cut various sizes of foamcore from larger panel. I suggest 12″x12″, 24″x36″, and 48″x60″.
2 Position the panels, and take pictures.

Tips & Cautions

Mount the foamcore reflectors to light stands using utility spring clamps. You can handhold them or prop them up using chairs.

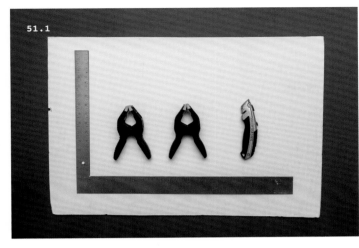

51.1

Parts List (Figure 51.1)

- Large foamcore panel from hardware or craft store
- Razor blade
- Straight edge
- Utility clamps

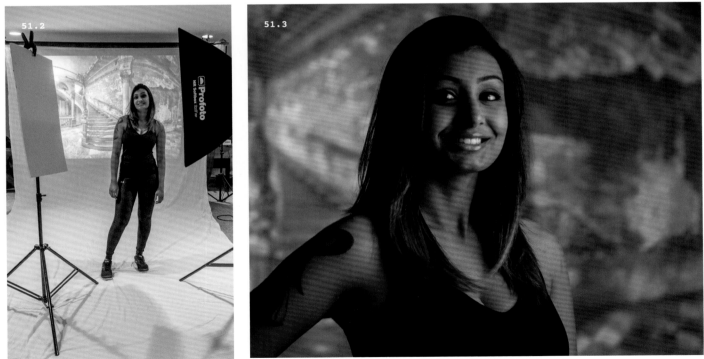

51.2

51.3

52. DIY CALIFORNIA SUNBOUNCE PVC REFLECTOR FRAME

SUNBOUNCE REFLECTORS ARE high-end light modifiers designed to the highest standards for commercial and advertising photography. They have integrated handles to allow for a variety of handholding and mounting positions. This DIY project shows you how to use one of your existing reflector disks in a similar fashion using a PVC frame and utility spring clamps.

Construction Steps

1 Cut PVC pipe lengths to form a T-shaped frame in the dimension of your reflector. The left and right pieces will be the same length. The middle piece will be longer.
2 Put the frame together, as shown in **Figure 52.2**.
3 Using spring clamps, attach the frame to the back side of the reflector panel.
4 Reflect the sunlight onto your model. Hold the reflector high to keep shadows from falling naturally on the subject's face (**Figure 52.3**).
5 Take the photo (**Figures 52.4** and **52.5**)!

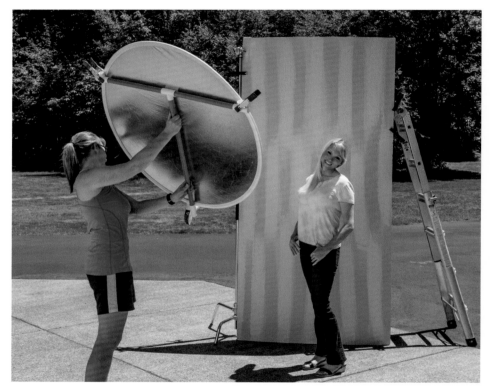

Parts List (Figure 52.1)

- 3/4″ PVC pipe
- 3/4″ PVC T (4)
- Measuring tape
- PVC cutting tool or hacksaw
- Utility clamp (3)
- Collapsible gold reflector

Tips & Cautions

Using gold reflectors on sunny days is *very* bright for your subject. I caution you to make sure that your subject doesn't look directly into the reflected light. Also, the radiant heat generated by the reflector can become uncomfortable after a while, so always check in with your models to make sure they are doing okay.

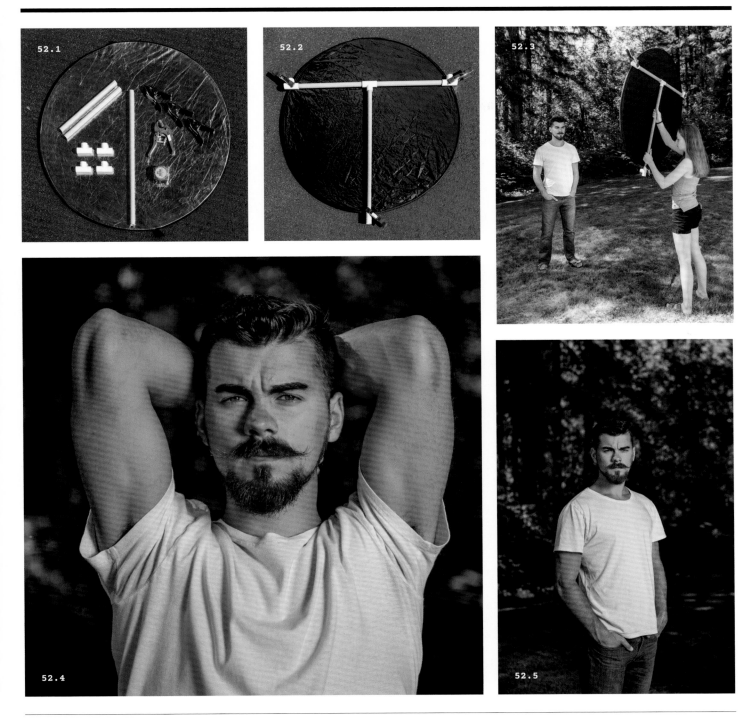

52.1

52.2

52.3

52.4

52.5

53. PVC FRAME TRIFLECTOR

TRIFLECTORS ARE USED in portrait lighting to create beautiful headshots. They also produce a really neat catch light in the eyes. As the name implies, they create three reflection surfaces. They are almost always placed underneath the subject's head with the main light firing above the head. The net result is four surfaces of light that produce a really nice flat lighting effect for a high-fashion look that is flattering for women and men.

Construction Steps

1 Decide how big you want your triflector panels to be. For this example, I designed my panels to be about 30″x18″.

Parts List (Figure 53.1)

- Light stand
- Cardboard panels (or foamcore or corrugated plastic)
- Gaffer tape
- Scissors/knife
- White copy paper
- 3/4″ PVC 90-degree elbows (4)
- 3/4″ PVC 45-degree elbows (4)
- 3/4″ PVC Ts (3)
- 3/4″ PVC cap
- 3/4″ PVC pipe
- PVC cutting tool or hacksaw
- 1/4″-20 bolt
- 1/4″-20 nut
- 1/4″ washer
- 1/4″ drill bit
- Electric drill

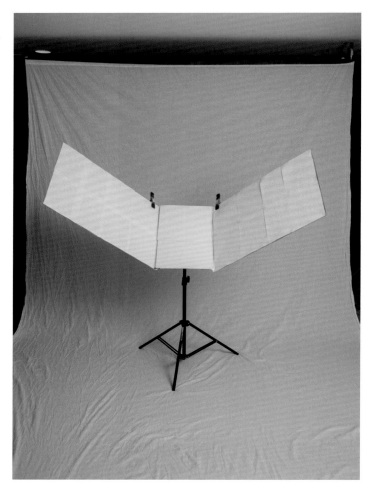

2 Cut four segments of 3/4″ PVC pipe, each 18″ long. These will be the outer arms for the left and right panels.

3 Cut four segments of 3/4″ PVC pipe, each 12″ long. These will be the middle cross arms.

4 Cut four segments of 3/4″ PVC pipe, each approximately 6″ long. These will be the interior arms that define the size of the center reflection panel.

5 Cut one segment of 3/4″ PVC pipe to approximately 3″ long. This will be the short mounting arm that will attach to your light stand.

6 Drill a 1/4″ hole in the PVC cap, and then insert the bolt through the inside so the threaded end protrudes from the outside of the cap. Place a washer on the bolt, then thread on the 1/4″ nut to hold the bolt in place (**Figure 53.2**). You'll end up screwing this to your light stand or to the brass stud in your light stand umbrella bracket (**Figure 53.3**).

7 Put together the frame, as shown in **Figure 53.4**.

8 Cut cardboard panels to the appropriate dimensions. For this example, I cut my panels to approximately 18″x30″ (**Figure 53.5**).

9 Tape the panels together with gaffer tape.

10 Cover the panels in white copy paper, using tape to secure it (**Figure 53.6**).

11 Clamp the reflection panels to the PVC frame using two utility spring clamps, as shown in Figure 53.6.

12 Position a flash with an umbrella or softbox above the triflector, as shown in **Figure 53.7**, and photograph through the lighting setup.

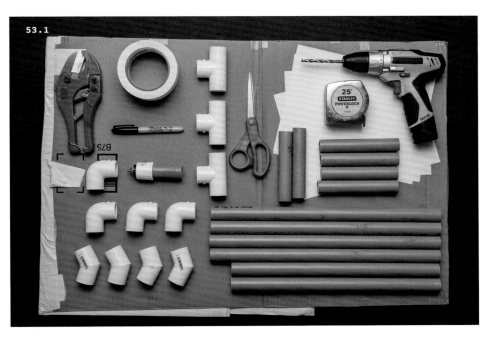

53.1

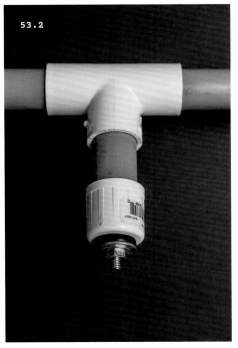

53.2

53.3

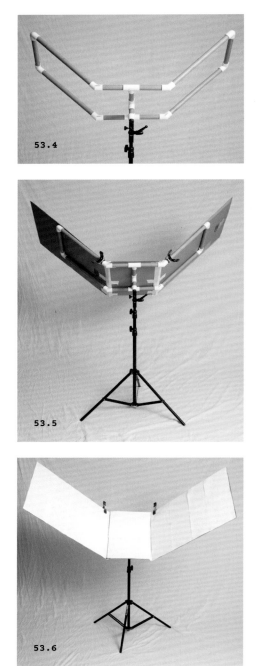

53.4

53.5

53.6

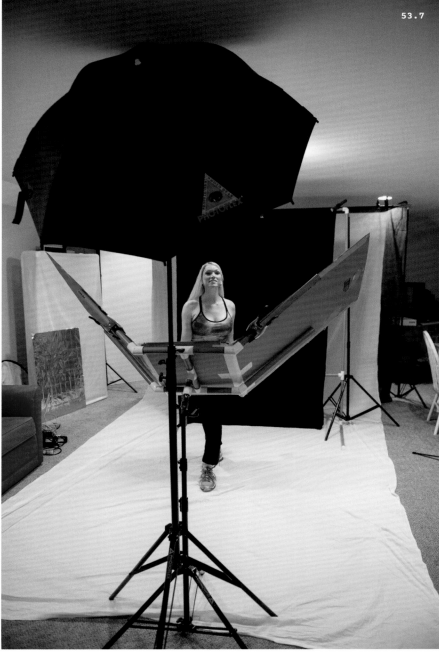

53.7

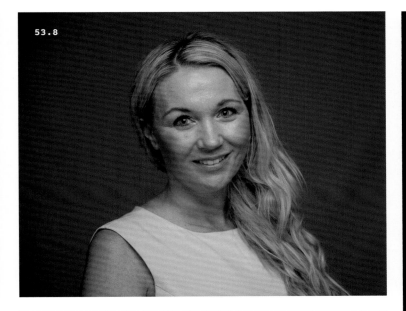

53.8

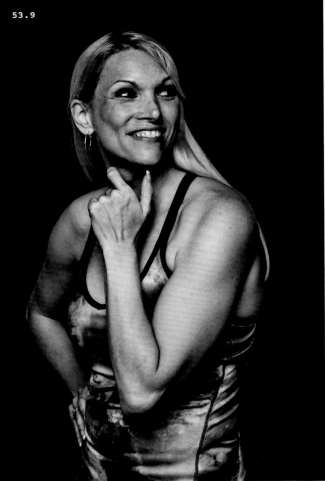

53.9

Tips & Cautions

- The closer your subject is to the reflectors, the softer the light will be (**Figure 53.8**). The farther the subject is from the reflectors, the harder the light will be (**Figure 53.9**).
- You can make your reflector surfaces out of any variety of white materials, including foamcore, corrugated plastic, or even other collapsible photographic reflectors.

54. PVC LIGHT STAND

LIGHT STANDS CAN be expensive, especially if you need to purchase a lot of them for your studio. This project uses PVC pipe to serve as a simple, rugged light stand you can use just about anywhere. I even designed an additional leg to hold a sandbag for stabilization.

Since this project is made from PVC, you won't be able to quickly adjust the height of the stand, but you can cutting different lengths of pipe for the top section to provide different height options for the stand.

Construction Steps

1 Decide how tall you want your light stand to be and cut a section of 3/4″ PVC pipe at the desired length. For this project, I made the long section of pipe approximately 56″.

2 Cut six sections of pipe for the base. Each section should be approximately 9″ long.

3 Put together the base, as shown in **Figure 54.2**.

4 Cut one length of pipe approximately 8″ long. This will be the first vertical riser extending from the base.

5 Cut two lengths of pipe approximately 10″

long. These will serve as the stabilization leg where you can place a sand bag for stability.

6 Put together the upper riser and stabilization leg as shown in Figure 54.2.

7 Drill a 1/4″ hole in the PVC cap, and then insert the bolt through the inside so the threaded end protrudes from the outside of the cap. Place a washer on the bolt, then thread on the 1/4″ nut to hold the bolt in place (**Figure 54.3**). You'll end up screwing this to the brass stud in your umbrella bracket (**Figure 54.4** and **54.5**).

8 Place the cap on the very top of the light stand, as shown in Figure 54.4.

9 Mount your lights and/or flashes to the light stand using umbrella brackets or 1/4″-20 threaded nuts, as shown in **Figures 54.5**, **54.6**, and **54.7**.

Tips & Cautions

Since this light stand is designed to easily disassemble, it is prone to falling over. Be sure to place a sandbag or camera bag over the stabilization leg to prevent this from happening.

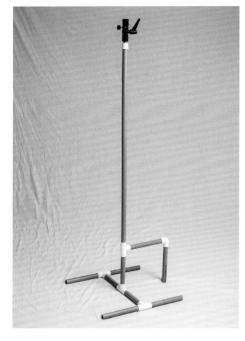

Parts List (Figure 54.1)

- 3/4″ PVC 90-degree elbow
- 3/4″ PVC Ts (4)
- 3/4″ PVC cap
- 3/4″ PVC pipe
- PVC cutting tool or hacksaw
- 1/4″-20 bolt
- 1/4″-20 nut
- 1/4″ washer (2)
- 1/4″ drill bit
- Electric drill
- Measuring tape

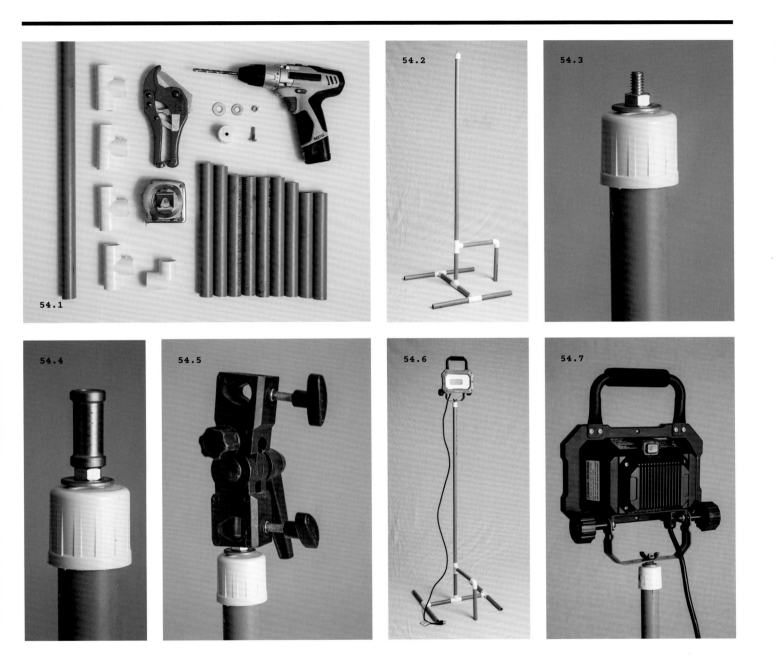

54.1

54.2

54.3

54.4

54.5

54.6

54.7

6

SPECIAL PROJECTS

CHAPTER 6

The projects in this chapter are somewhat specialized and don't necessarily fall into any specific category. I've created projects related to action cameras, DIY camera bags, straps, underwater photography, and more. I think you'll really enjoy these projects and quickly find a way to incorporate them into your photography.

55. ACTION CAMERA AERIAL SHUTTLECOCK

IMAGINE PRODUCING AERIAL images without having to spend money on expensive equipment like drones, R/C airplanes, or helicopters. This shuttlecock is very simple to build, but will require you to throw your action camera into the sky with all your might. This is a little unnerving for some, so proceed with caution!

Construction Steps

1 Cut the foam swimming noodle into short sections, about 18″ long. Use a felt tip pen to trace the shape of your fins onto two pieces of cardboard. Make the cardboard fins approximately 12″ long and 6″ wide Cut a small slot (3″ deep) out of one side of each cardboard fin (**Figure 55.2**).
2 Fit the two fins together, slot to slot, at a 90-degree angle. Use gaffer tape to fasten the two cardboard fins together, as shown in **Figure 55.3**.
3 Cut an x-pattern (3″ deep) into the back side of the section of foam (**Figure 55.4**), then insert the end of the fins into the shape.
4 Cut a block out of the center of the front side of the section of foam. The hole should snugly fit your action camera (**Figure 55.5**).
5 Insert the action camera into the section of foam and use rubberbands to tightly secure it into the cutout (**Figure 55.6**).
6 Turn on the camera and set it for either video mode or photo burst mode.
7 Press the shutter release button, then throw the system high into the air (**Figure 55.7**).

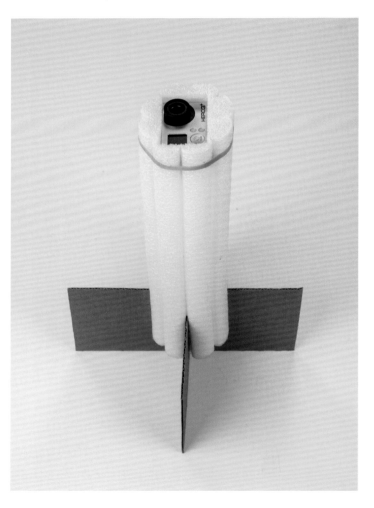

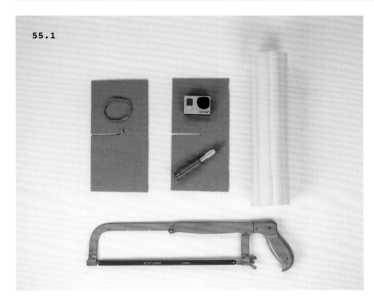

55.1

Parts List (Figure 55.1)

- Cardboard or corrugated plastic
- Foam swimming noodle
- Gaffer tape
- Scissors or razor blade
- Felt tip pen
- Hacksaw

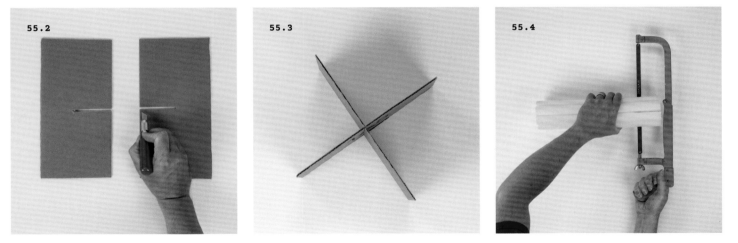

55.2

55.3

55.4

55.5

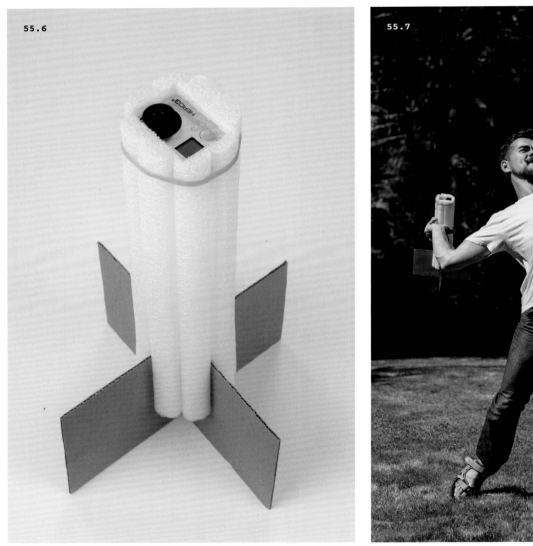

55.6

55.7

55.8

Tips & Cautions

- You'll be throwing your action camera high into the air, so there's a high potential for damage. I suggest throwing your camera over a big grassy field. If you throw it over pavement, then you will probably break your action camera when it hits the ground.
- **Figure 55.8** shows a typical image from this setup. Be diligent when throwing the shuttlecock into the air to make sure the camera is horizontal, or you'll get images with tilted horizons like **Figure 55.9**.

55.9

Share your best aerial shot using a DIY shuttlecock or glider mount!

Once you've captured a great aerial shot using a DIY shuttlecock or glider, share it with the Enthusiast's Guide community! Follow *@EnthusiastsGuides* and post your image to Instagram with the hashtag *#DIYAerial*. Don't forget that you can also search that same hashtag to view all the posts and be inspired by what others are shooting.

56. ACTION CAMERA AERIAL GLIDER MOUNT

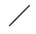

THIS IS A very fun project, especially if you are into model aircraft. This will allow you mount an action camera to a toy glider and create aerial photographs or aerial video on a serious budget!

Construction Steps

1 Assemble the wings and tail section of the glider.
2 Cut off as much of the nose as possible (**Figure 56.2**). The goal is to get the camera close to the wings in order to keep the center of gravity over the wings. Don't cut off too much, though, or you'll lose structural support for the wings.
3 Loop a long rubber band from the wings over the front of the action camera (**Figures 56.3** and **56.4**).
4 Check the balance of the airplane by balancing the thickest part of the wing on your index finger and thumb. If the plane is nose-heavy (it leans forward), tape very small weights or a metal bolt under the tail until the airplane is balanced (**Figures 56.5** and **56.6**).
5 Turn on the camera and set it for video or photo burst mode.
6 Press the shutter release and throw the glider high into the air (**Figures 56.7** and **56.8**).

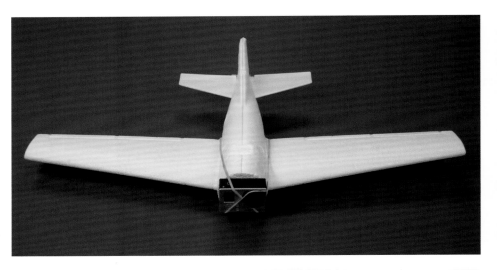

Parts List (Figure 56.1)

- Toy glider with 24" to 48" wingspan
- Saw
- Rubberbands
- Small weights (e.g., ball bearings or metal washers)
- Gaffer tape

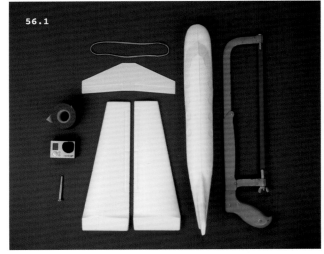

56.1

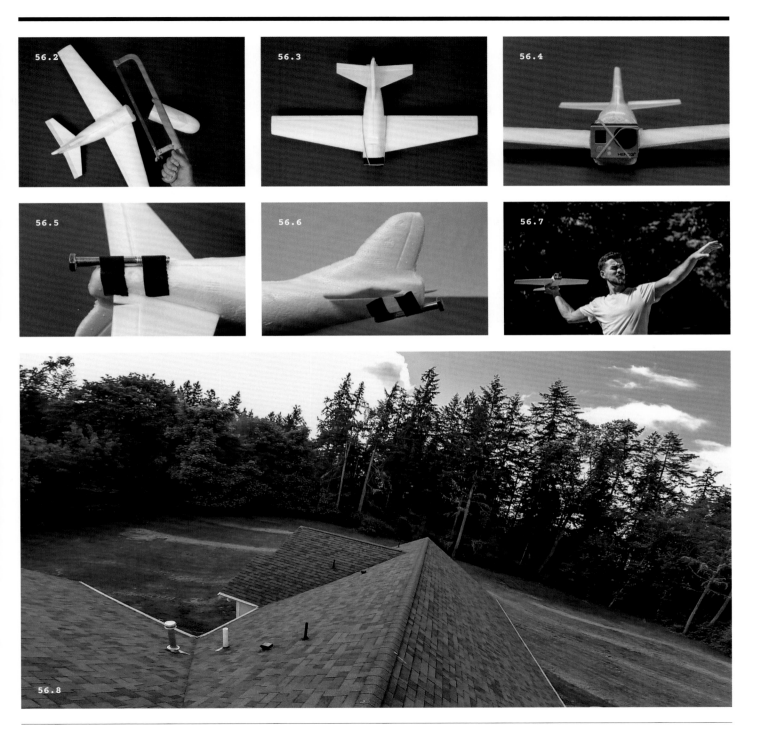

56.2

56.3

56.4

56.5

56.6

56.7

56.8

57. ACTION CAMERA BICYCLE MOUNT

THIS IS ONE of the easiest, most useful action-camera mounts you can build. I use this setup all the time to position my action camera in all sorts of configurations on my mountain bike.

Parts List (Figure 57.1)

- Small spring clamp
- 1/4"-20 screw, 3/4" long
- Washer
- Electric drill
- 1/4" drill bit

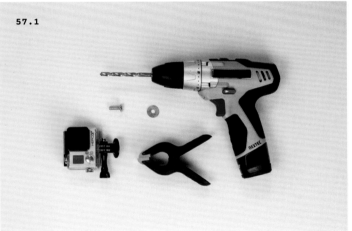

57.1

Construction Details

1 Drill a hole in the top of the spring clamp, as shown in **Figure 57.2**.
2 Insert a 1/4″-20 screw through the bottom of the hole so the threads are exposed on the top (**Figure 57.3**). Place a washer over the end of the screw.
3 Mount your action camera tripod mount to the screw (**Figures 57.4** and **57.5**).
4 Attach the clamp onto the handlebars or the frame of a bicycle, as shown in **Figures 57.6** and **57.7**.
5 Shoot video or take photos!

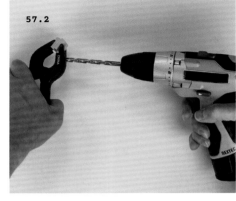

57.2

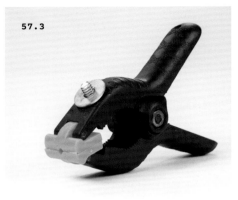

57.3

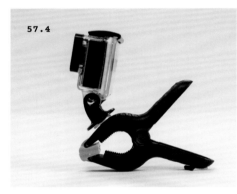

57.4

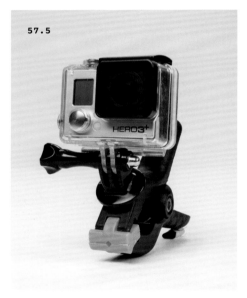

57.5

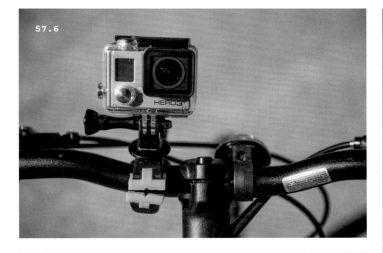

57.6

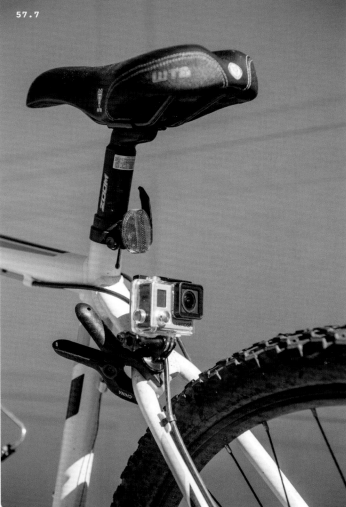

57.7

Tips & Cautions

- If you get the right size clamp, it will grip the handlebar tightly and won't slip. If you find the clamp moving around while you ride, then wrap the mounting point with a small strip of thin rubber. The rubber will also help dampen vibrations.
- You can use this setup to mount the camera low on the forks of the bike by the wheels. Just be very careful that the setup doesn't get caught in the wheel spokes.
- Most action camera plastic mounting kits have an extension arm that allows you to mount the camera at 90 degrees to the base. If you use this project on your seat post, you'll need to use this 90-degree adapter in order to mount the camera horizontally.

58. ACTION CAMERA CAR OR AIRPLANE WINDOW MOUNT

THIS PROJECT USES suction cups to mount your action camera on the inside of a car or airplane windshield. Use this setup to capture timelapse sequences or video of your mobile adventures. You can also reverse the direction of the camera to photograph or video passengers inside the vehicle.

Construction Steps

1 Cut the aluminum bracket or square stock to about 5″ long with a hacksaw (**Figure 58.2**).

2 Use a file to deburr the edges of the stock.

3 Drill two 1/4″-diameter holes through the stock to serve as the suction cup mounting points. Drill larger 5/8″ holes through the opposite side of the stock, as shown in **Figure 58.3**. These larger holes will be used as screwdriver access so you can tighten down the screws for the suction cups.

4 Drill a 1/4″ hole through one side of the stock (**Figure 58.4**). This will be used to mount the action camera. Drill a 5/8″ hole through the opposite side. This will be used to insert a screwdriver to tighten down the 1/4″-20 screw for the action camera.

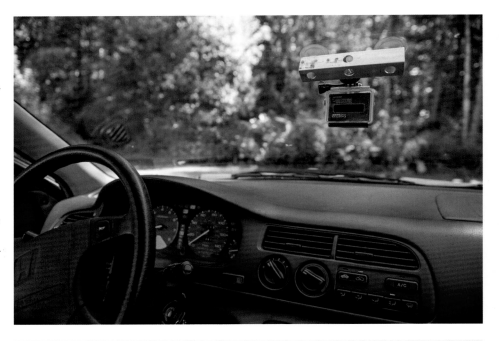

Parts List (Figure 58.1)

- Suction cup hangers
- Aluminum angle bracket or square tube stock or piece of wood, 5″ long
- Wood screws, 1/2″ long (2)
- Washers (6 to 10 depending on length of wood screws and suction cups)
- 1/4″-20 bolt, 3/4″ long
- 1/4″-20 nut
- Action camera mount
- File
- Screwdriver
- Electric drill
- 1/4″ drill bit
- 5/8″ drill bit

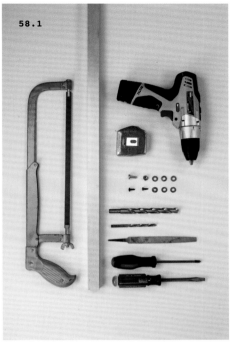

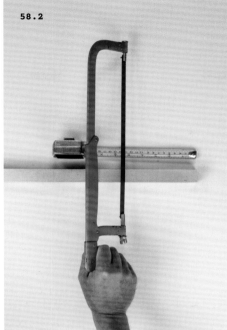

5 Insert the 1/4″-20 bolt and mount the action camera, as shown in **Figure 58.5**.

6 Mount the suction cups. Use washers to shim the wood screw to an appropriate length so that when it protrudes from the stock, it doesn't puncture the back side of the suction cup (**Figure 58.6**).

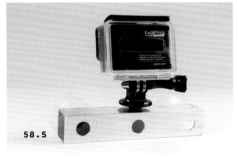

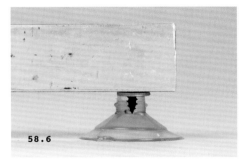

7 You might consider filing down the tip of the wood screw so the end isn't as pointy as shown in **Figures 58.7** and **58.8**.

8 Screw the suction cups onto the small wood screws, as shown in **Figure 58.9**.

9 Affix the suction cups to your car's windshield and position the action camera for the best view (**Figures 58.10** and **58.11**).

Tips & Cautions

Since this project uses relatively small suction cups, I don't recommend mounting this setup on the outside of the car unless you tether the rig with a cable or cord. Definitely do not mount this setup on the outside of an airplane!

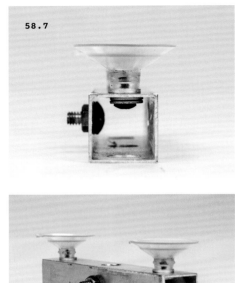

58.7

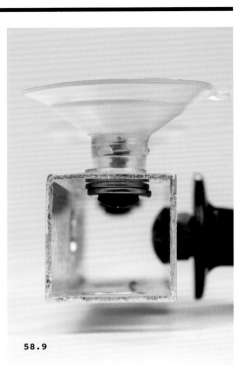

58.9

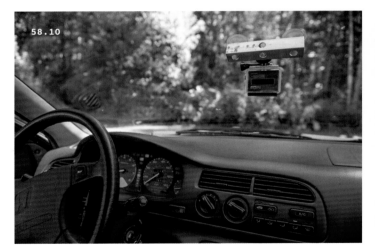

58.8

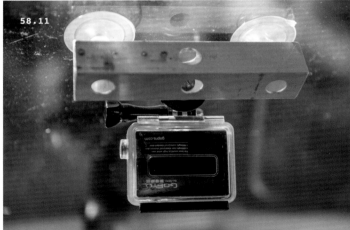

58.10

58.11

59. MILITARY SURPLUS CAMERA BELT

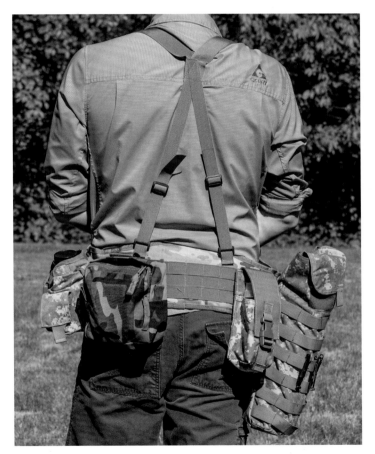

THIS IS A VERY USEFUL camera-carrying system that is inexpensive and durable. I purchased all the pieces for this project at a local military surplus store. There are quite a few options available for pouches and bags, so I encourage you to plan out exactly what you need before you go shopping.

Most surplus stores now have retail as well as surplus/used sections. I bought each of the pouches for this build from the used sections for $5 each. The belt system is officially called a MOLLE Tactical Waist Belt with Suspender for Outdoor Duty. MOLLE stands for Modular Lightweight Load-carrying Equipment. It is a NATO standard, used extensively by the British Army and the United States Army. The benefit of this system is that it uses PALS (Pouch Attachment Ladder System) webbing with rows of heavy-duty nylon stitched to packs, vests, and belts. These rows allow you to quickly and easily attach modular components like pouches, bags, hydration bladders, MREs, and so forth.

Parts List
- MOLLE Tactical Waist Belt with Suspender
- Various PALS bags and pouches

Construction Steps

1 Fit the belt and suspender system to your waist and torso.
2 Attach the PALS bags into an arrangement that suits your shooting style. **Figures 59.1** and **59.2** show five PALS bags that fit a 200–400mm f/4 lens, a speedlight, a 14–24mm f/2.8 lens, and an extra camera body.

Tips & Cautions

- Think of this as a shooter's bag (**Figure 59.3**). In other words, you don't want to store all of your camera gear in the bag. Rather, use the pouches to quickly change out lenses while your camera is slung over your shoulder.
- If you want more protection inside the pouches, use the same techniques I show in project 60, the DIY Camera Bag build.
- The one downside of the tactical waist belt is that it doesn't have PALS fastening points on the very front of the belt, in front of your hips. That means your bags won't be directly in the front, where you want them for easy access. The easy solution is to loop the pouch straps over the front of the belt, near the buckle (**Figure 59.4**). Just keep in mind that these pouches could slide off when you unbuckle the waist belt.
- Most military surplus stores carry different styles of fabric pouches. The fabric I purchased for this build was army green camouflage. You might also consider tactical black or navy blue camoflage if those better fit your style.

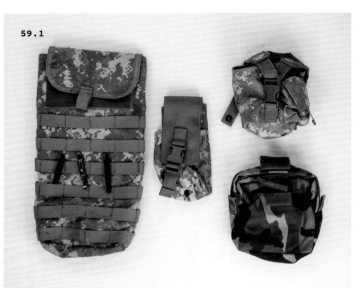

59.1

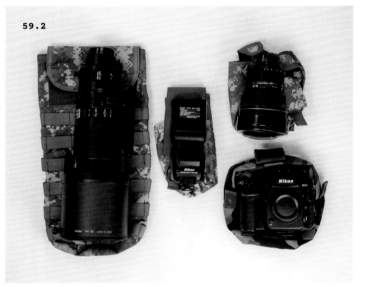

59.2

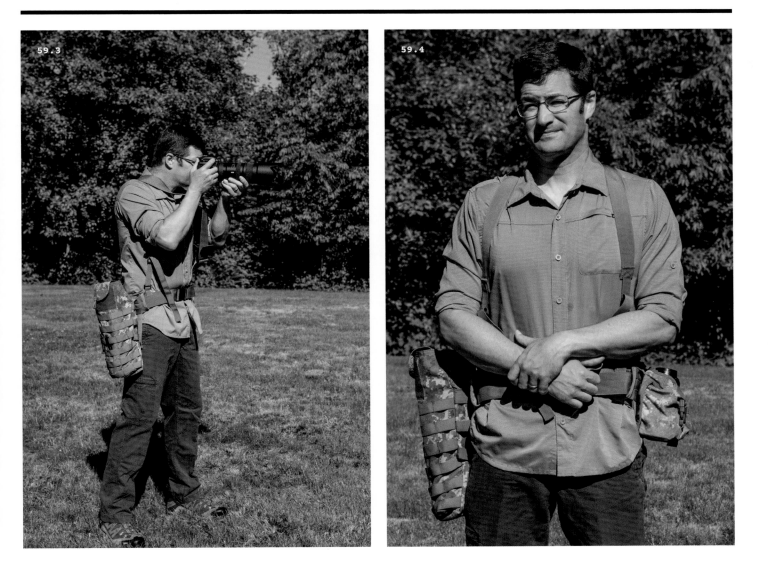

59.3

59.4

60. DIY CAMERA BAG

FOR THIS PROJECT, you'll use any surplus canvas-style bag you have laying around. Inside, you'll use closed-cell foam to cushion your lenses and cameras. This project works great for urban photography because the bag doesn't look like a camera bag. The rattier the bag, the better. I know a few photographers who use old baby diaper bags just because they look less desirable to thieves.

Construction Steps

1 Determine how many lenses will fit in the camera bag by measuring the inside and estimating lens dimensions (**Figure 60.2**).

2 To construct the lens pads/pouches, cut panels out of the sleeping pad that are about the same dimensions as the lenses you are protecting. Make the panels a bit smaller than you think, as the final product will expand when you put the lens inside.

3 Use gaffer tape to build the structures, as shown in **Figures 60.3** and **60.4**. You don't need to make all the inserts rectangular; make some cylindrical, as shown in **Figure 60.5. Figures 60.6**, **60.7**, and **60.8** show the completed foam pouches and how they relate to the size of the camera bag I used.

4 Put everything into the camera bag, as shown in **Figure 60.9**.

Parts List (Figure 60.1)
- Old briefcase, rolling bag, or similar bag
- Closed cell foam or camping pad foam
- Gaffer tape
- Scissors or razor blade
- Camera bag Velcro inserts
- Glue (Gorilla Glue or similar)

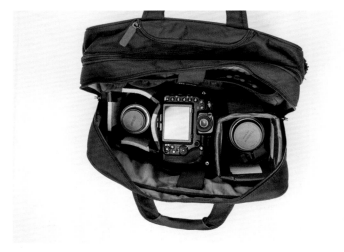

60.1

60.2

60.3

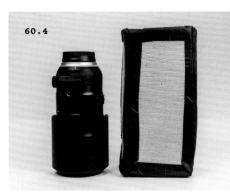

60.4

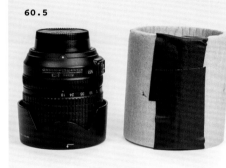

60.5

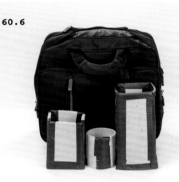

60.6

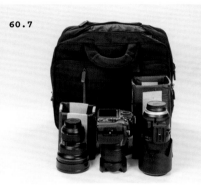

60.7

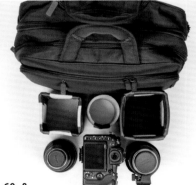

60.8

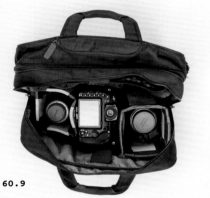

60.9

Tips & Cautions

- After creating the lens pouches with tape, you might consider using a needle and thread to sew up the seams to make them more durable. Over time, you might find that the gaffer tape loses some stickiness, so sewing through the tape will prevent the pouches from coming apart.
- You can make as many different pouches as you have lenses and cameras. The cool thing about this project is it is completely modular; it will adapt to any bag you want to use.

61. DIY SEATBELT R-STRAP

A COMMERCIALLY AVAILABLE R-strap will run you anywhere from $40 to $80 depending on model and features. This DIY project will cost you just a few dollars and works just as well.

Construction Steps

1 Cut the seatbelt to the desired length. Use 6.5′ if you have a shorter torso, 7′ if you have a longer torso.
2 Thread the snap swivel onto the belt.
3 Thread a 2″ tri-bar onto one end of the strap (**Figure 61.2**), then run the strap through one side of the 2″ plastic buckle (**Figure 61.3**) and back through the tri-bar.
4 Repeat step 3 for the other end of the strap.
5 Mount an eye bolt or tripod plate onto the camera, then attach the snap swivel to the bolt/plate, as shown in **Figure 61.4**. **Figure 61.5** shows the completed strap.

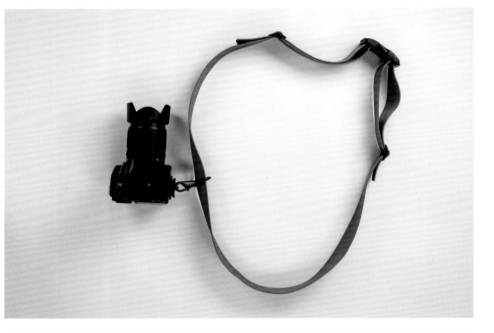

Parts List (Figure 61.1)

- Surplus seatbelt, 6.5′ to 7′ long
- 1/4″-20 eye bolt or tripod plate with built-in D-ring
- 2″ plastic buckle
- 2″ tri-bar (2)
- Snap swivel
- Scissors

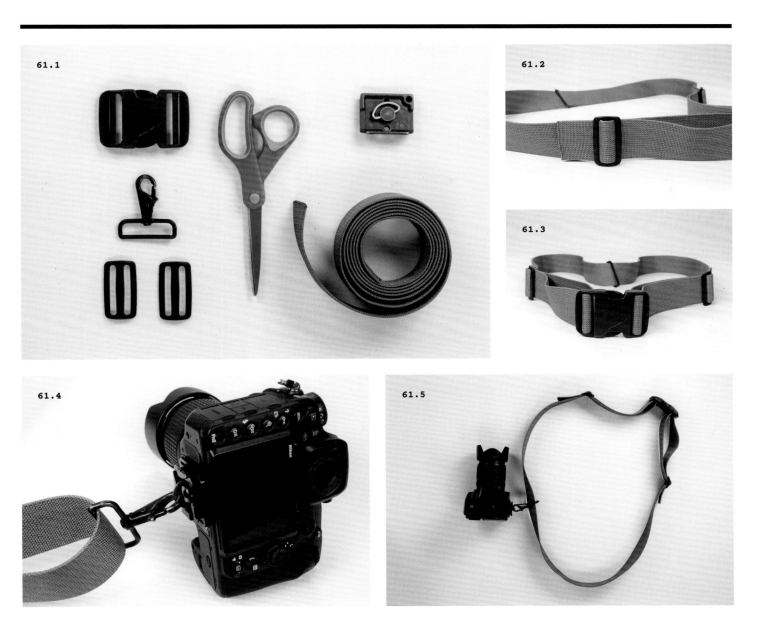

61.1

61.2

61.3

61.4

61.5

6 Loop the strap over your shoulder like a bandolier (**Figure 61.6**).

7 When you shoot, pull the camera up to your eye as shown in **Figures 61.7** and **61.8**. When you're not shooting, just let the camera hang on your hip.

Tips & Cautions

Adjust the length of the strap so the camera hangs right at your hip. You can use this strap on either the left or the right side of your body.

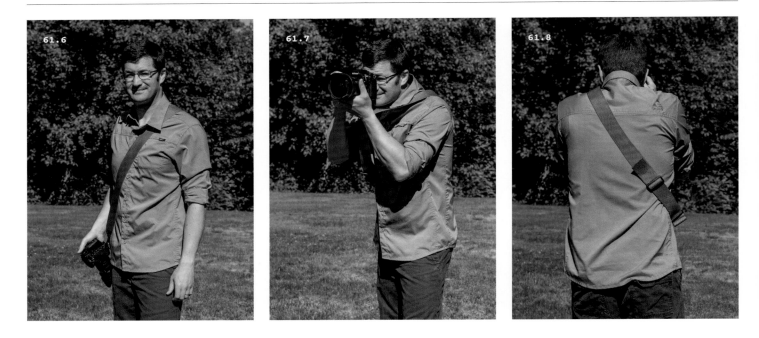

62. DIY SEATBELT CAMERA STRAP

BECAUSE THIS CAMERA strap is made out of 2″ seatbelt webbing, it is super durable and pretty comfortable. It behaves like a traditional neck strap, and you can actually use almost all the same strap materials as the DIY R-strap shown in the previous project.

Construction Steps

1 Thread a tri-bar over one end of the webbing, then through the snap swivel and back through the tri-bar, as shown in **Figure 62.2**. Repeat this process for the other side of the strap.
2 Attach the snap swivels to the camera body strap rings, as shown in **Figures 62.3** and **62.4**.

Tips & Cautions

Metal snap swivels are stronger and more durable, but you can potentially damage the camera and the top LCD screen by using them if you aren't careful with storage. You might consider plastic/nylon clasps instead.

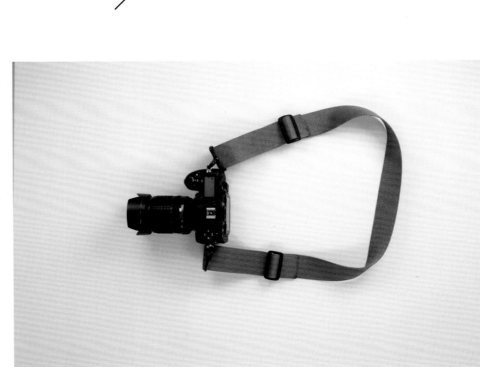

Parts List (Figure 62.1)

- Automotive seatbelt strap, 6′ long
- Plastic tri-bar (2)
- Snap swivel (2)

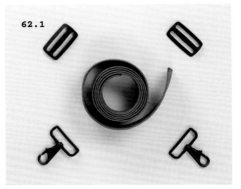

62.1

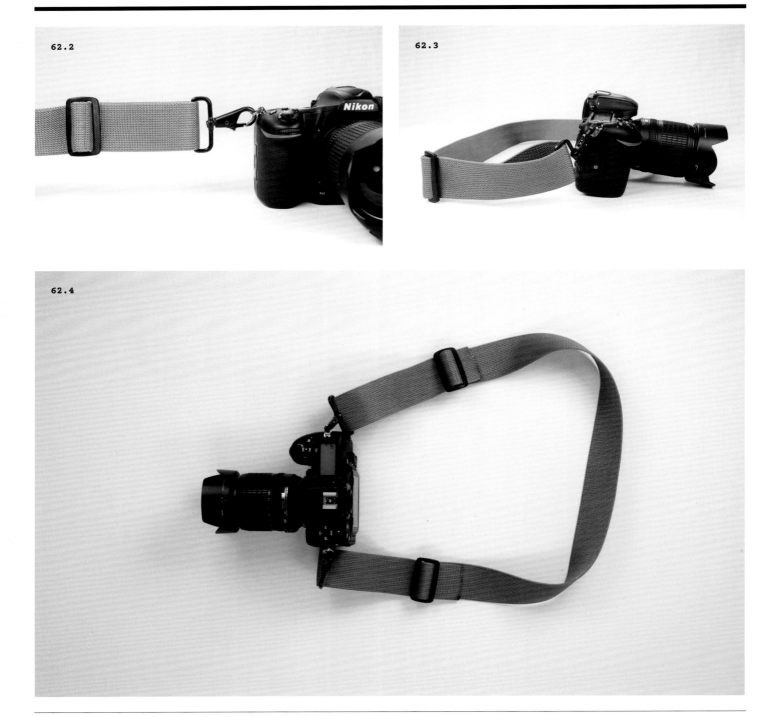

62.2

62.3

62.4

63. TRIPOD SLING

THIS DIY PROJECT takes advantage of parts you probably already have laying around at home, such as an extra camera strap and a few feet of cord.

There are lots of ways to connect a strap to a tripod. Many tripods actually have hard connection points. These are great places to connect mini carabiners, and they can simplify the overall strap system.

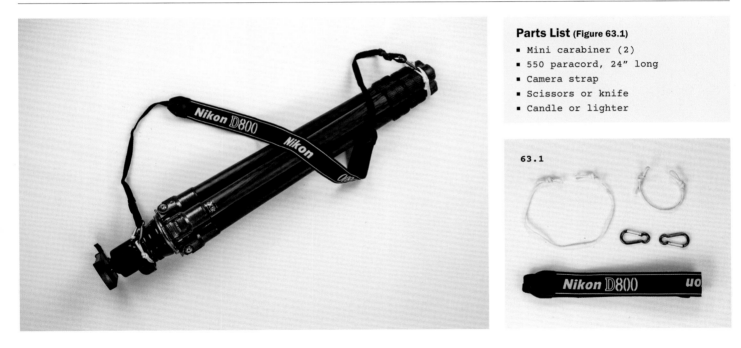

63.1

Construction Steps

1 Make loops at both ends of the camera strap, and attach mini carabiners to both loops.

2 Tie a loop at one end of the paracord. Wrap it around the base of the tripod head, then tie another loop so it is tight around the tripod head, and cut the cord once you've achieved the correct length. The goal is for the cord to be tight around the tripod head so the loops are pulled tight when the carabiner attaches to both loops (**Figure 63.2**).

3 Tie a loop on one end of a second piece of paracord. Wrap this piece twice around the bottom of the legs on your tripod, then tie another loop, and cut the excess off the cord if necessary. Again, the goal is for this cord to be tight around the tripod legs so the loops are pulled tight when the carabiner attaches to both loops (**Figure 63.3**).

4 Use a candle or a lighter to melt the frayed ends of the cord.

5 Connect the strap to the tripod by hooking the mini carabiners to the loops at the top and bottom of the tripod.

6 Sling the strap over your shoulder to carry the tripod, as shown in **Figures 63.4** and **63.5**.

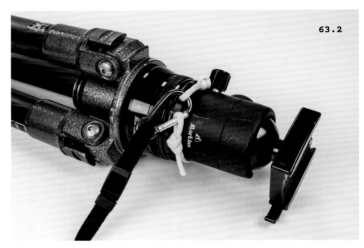

63.2

63.3

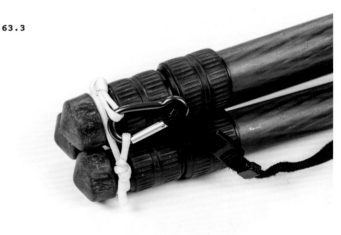

Tips & Cautions

Be sure to wrap the 550 paracord twice around the lower legs for better security. Two wraps will increase the ability of the cord to cinch down and hold the legs tightly. If you have a tripod with flip-lock levers on the legs, you might consider wrapping the 550 paracord around the legs in the middle of the flip-lock levers for more security.

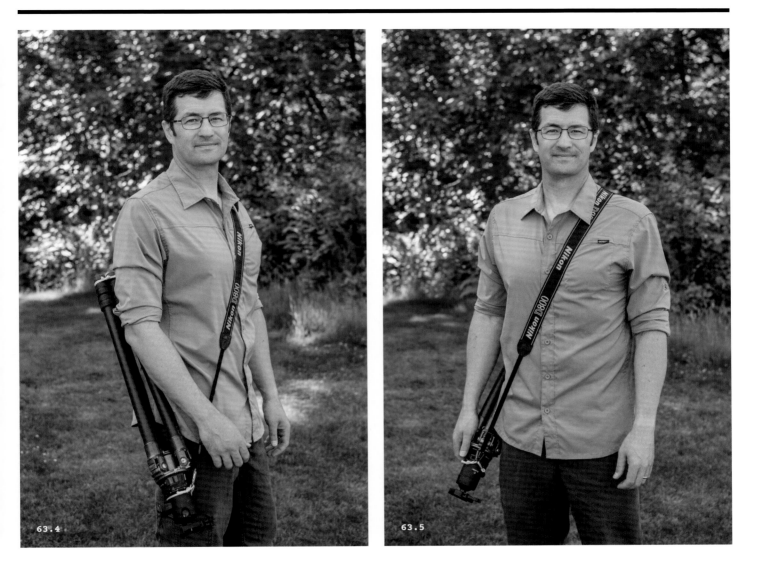

63.4

63.5

64. SHOULDER STOCK CAMERA MOUNT FOR TELEPHOTO LENSES

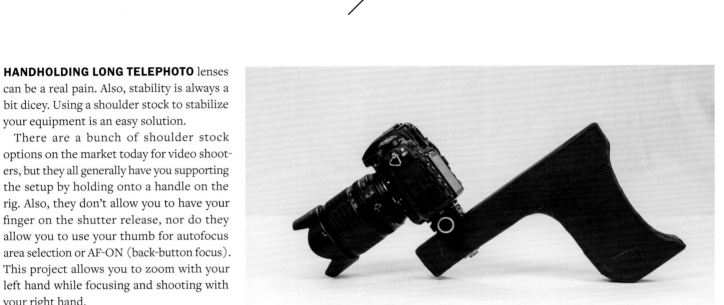

HANDHOLDING LONG TELEPHOTO lenses can be a real pain. Also, stability is always a bit dicey. Using a shoulder stock to stabilize your equipment is an easy solution.

There are a bunch of shoulder stock options on the market today for video shooters, but they all generally have you supporting the setup by holding onto a handle on the rig. Also, they don't allow you to have your finger on the shutter release, nor do they allow you to use your thumb for autofocus area selection or AF-ON (back-button focus). This project allows you to zoom with your left hand while focusing and shooting with your right hand.

Parts List (Figure 64.1)

- 2"x8" lumber board
- Reciprocating saw or saber saw
- Pencil
- Black gaffer tape (optional)
- Electric drill
- 3/8" drill bit
- 1/4"-20 bolt, approximately 2.5" long
- 1/4" washer
- Quick-release clamp

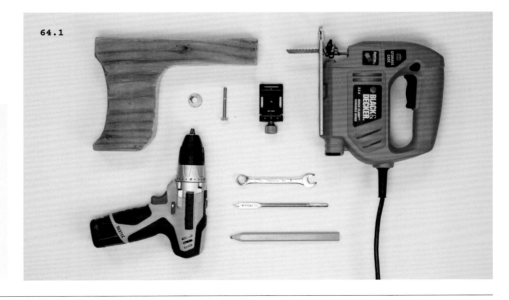

64.1

Construction Details

1 Draw the shape of the shoulder stock on the 2″x8″ lumber. You'll want to design it to fit your body shape and camera size. Your shape may be unique, but you'll want the length of it to be approximately 10″ and the height to be approximately 8″, as shown in **Figure 64.2**.

2 Drill three 3/8″ holes in the front of the stock, as shown in **Figure 64.3** and **64.4**. These will serve as different mounting holes for your camera depending on lens length.

3 Place a washer over a 1/4″ bolt. Insert the bolt through one of the holes in the stock and then attach the quick-release clamp, as shown in **Figures 64.5**, **64.6**, and **64.7**.

4 Mount the camera or lens to the quick-release clamp, as shown in **Figure 64.8**.

5 For a cleaner, more professional look, wrap the shoulder stock with black gaffer tape, as shown in **Figures 64.9** and **64.10**. This will provide grip and comfort.

6 When shooting photos, don't actually hold any part of the shoulder stock (**Figures 64.11**, **64.12**, and **64.13**). Hold the camera as you normally would, with your left hand controlling the lens and your right hand controlling the camera body.

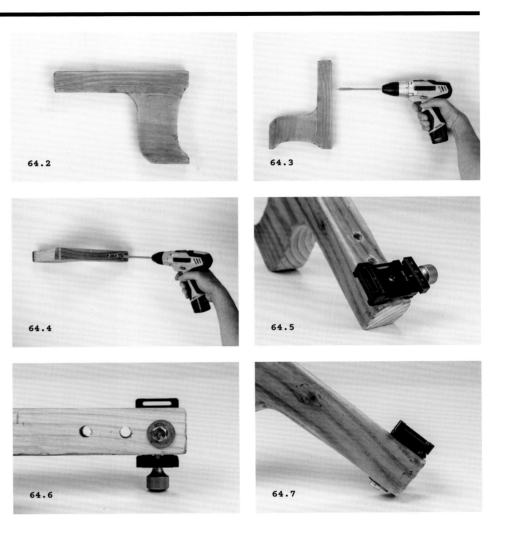

64.2

64.3

64.4

64.5

64.6

64.7

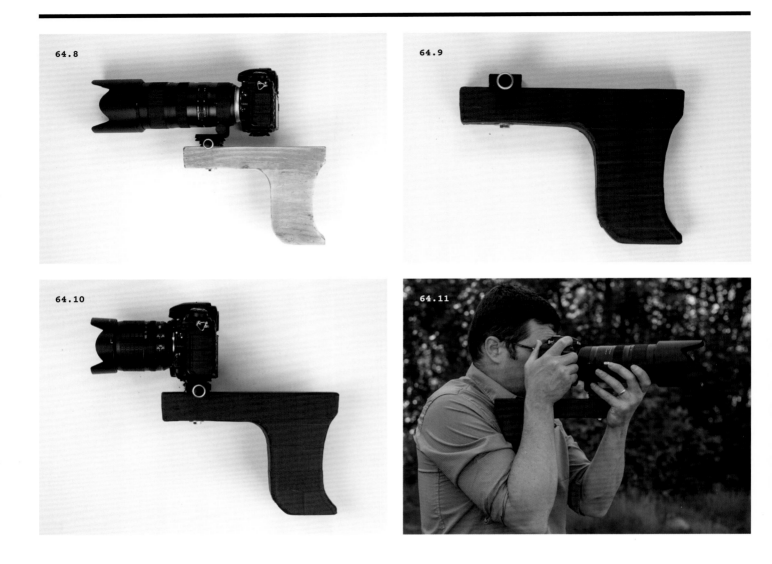

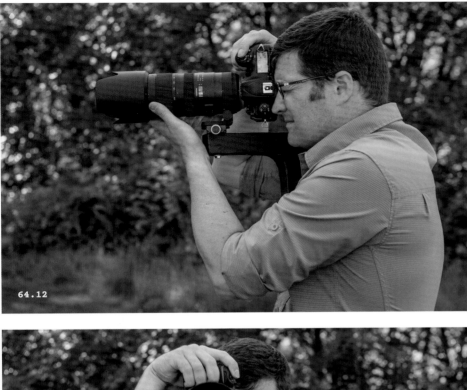

64.12

Tips & Cautions

- If you are shooting with longer lenses, like a 200–400mm f/4, a 400mm f/2.8, or a 500mm f/4, then you might need to make a longer shoulder stock than the model demonstrated here.
- Consider using a long lens quick-release plate for the base of your lens/camera. This will allow you to more accurately position the camera forward and backward for comfort and stability.

64.13

INDEX

Tips & Cautions

- Obviously, this project has the potential to do serious damage to your model or your action camera (**Figure 56.9**). I suggest making your first flights over tall grass in a very large field until you get the kinks worked out.
- If you want still photos with the camera pointed towards the ground, cut the front of the airplane off at an angle that allows you to point the camera downwards.
- You can also use rubberbands to mount the camera underneath the fuselage, directly under the wings. This definitely is a dangerous place to mount the camera because it will scrape against the ground when it lands. Therefore, you might build some type of foam protection bumpers around the action camera.

56.9

Share your best aerial shot using a DIY shuttlecock or glider mount!

Once you've captured a great aerial shot using a DIY shuttlecock or glider, share it with the Enthusiast's Guide community! Follow *@EnthusiastsGuides* and post your image to Instagram with the hashtag *#DIYAerial*. Don't forget that you can also search that same hashtag to view all the posts and be inspired by what others are shooting.